Bruegel

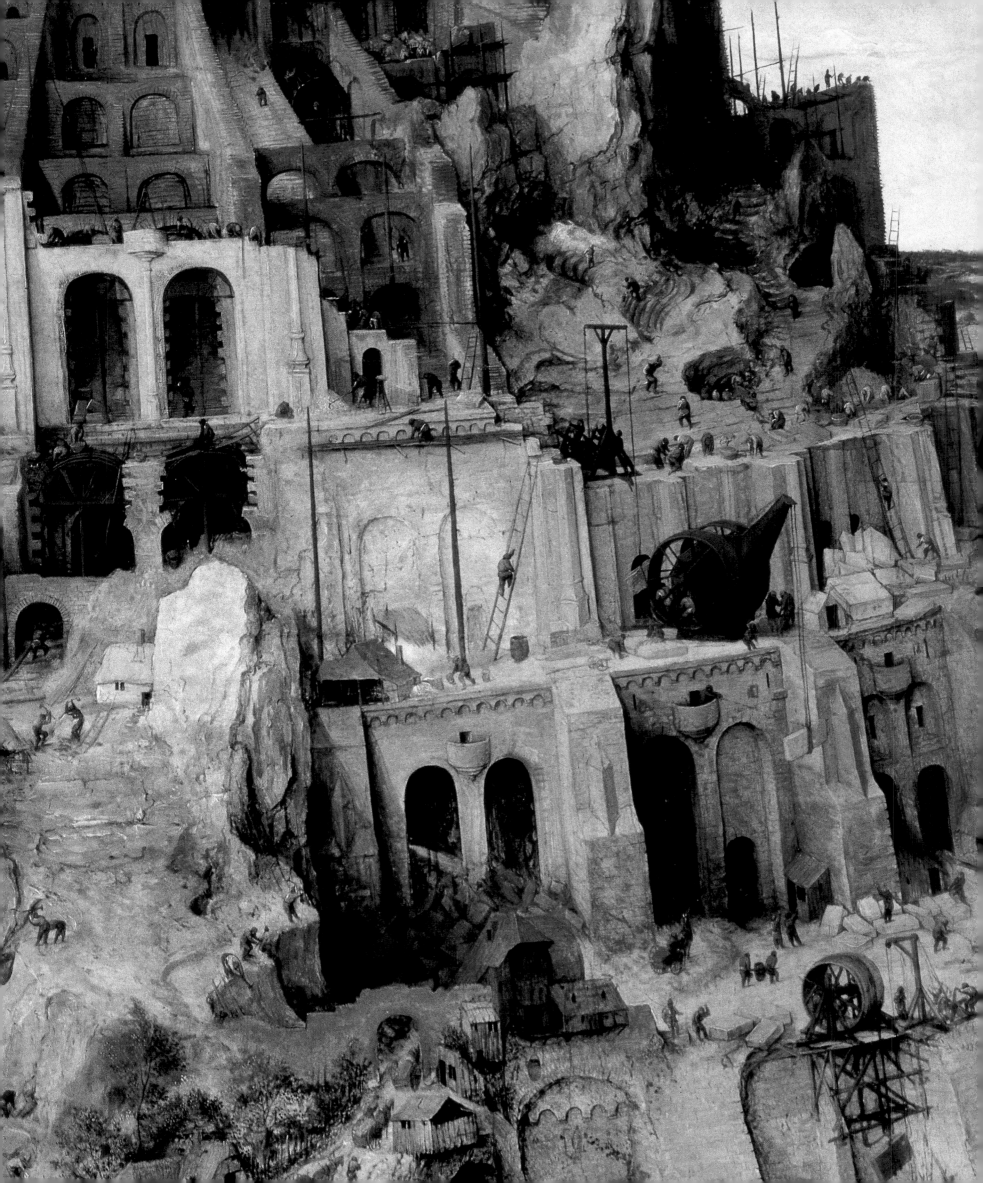

Christian Vöhringer

Pieter
Bruegel

1525/1530–1569

KÖNEMANN

Frontispiece
1 *Tower of Babel* (detail of ill. 79)

©1999 Könemann Verlagsgesellschaft mbH
Bonner Strasse 126, D-50968 Cologne

Publishing manager and art director: Peter Feierabend
Project management: Ute Edda Hammer
Project coordination: Jeannette Fentroß
Layout: Bärbel Messmann
Picture research: Fenja Wittneuen
Production: Mark Voges
Lithography: Digiprint, Erfurt

Copyright © 1999 for this English edition
Könemann Verlagsgesellschaft mbH
Bonner Strasse 126, D-50968 Cologne

Translation from German: Paul Aston in association
with Goodfellow & Egan
Editor of the English-language edition: Susan James in
association with Goodfellow & Egan
Project coordinator: Kristin Zeier
Typesetting and project management: Goodfellow & Egan,
Publishing Management, Cambridge
Printing and binding: Neue Stalling, Oldenburg
Printed in Germany

ISBN 3-8290-2579-3
10 9 8 7 6 5 4 3 2 1

Contents

TRUTH, WIT, AND EXAGGERATION

The opposite of this saying is also conjured up in Bruegel's drawing, in that smaller fish are preying on larger ones, and the monster fish dominating the picture is dead. The didactic character of the overall picture is underlined by the man in the boat, who with outstretched arm explains to the boy the situation around them. Many separate scenes act like an echo to the main message that "big fish eat little fish," but they are not restricted to this core pronouncement. It is a procedure that is repeated in most of Bruegel's multi-scene drawings and paintings.

Although little is known about the life of the Flemish painter Pieter Bruegel the Elder (ca. 1525/1530–1569), the figures from his paintings and drawings are both spontaneously and self-evidently identified with the presumed personal environment of the artist. He was the first to portray everyday scenes in rural Flanders in a manner true to life, and he did it so memorably that, long after his death, the concept of "Bruegel subjects" remained current for scenes from Flemish country life. Many people today still think of him as the "peasant" Bruegel. Another reason for his outstanding position in art history is the originality with which he transposed and intensified old and valued subject matter in everyday scenarios. He was the first to bring the three wise men into a snowbound Flemish village to worship the Christ Child. His pictorial world was continued within the painter dynasty by his sons Jan Brueghel the Elder (1568–1625) and Pieter Brueghel the Younger (ca. 1564–1638).

Thanks to their direct "visual language" and its capacity to fascinate, Bruegel's works have inspired many poets of the 20th century. Bertold Brecht (1898–1956), for example, admired Bruegel's clarity of visual thought and his detailed figures, and described as formative the impression that Bruegel's pictures made on him in his youth. The terseness of visual expression and the feeling for decisive shifts within the figurative scenes form contrasts to the depictions of peaceful landscapes and villages. The everyday environments appear locked in an immutable order, broken into by humans and supernatural creatures.

"If you get to the bottom of Bruegel's visual contrasts, you notice that he paints contradictions," says Brecht in his introductory notes to Bruegel, which were found after his death in a book of Bruegel in his possession and subsequently published. Alienation arises between the events of the scene and the apparently realistic pictorial structure; in other words, these are the famous "alienation effects" of Brechtian theory that implant themselves in the viewer's mind and tease, like puzzle pictures. This is particularly clear in works that illustrate proverbs or idioms.

A work that illustrates a proverb, and which Brecht himself extended into a parable, is the drawing of *Big Fish Eat Little Fish*, the basis of an engraving (ill. 2). A saying that was found even in many non-European languages for millennia culminates in Bruegel in a great fish eating and being eaten, events going on simultaneously and therefore nonsensically. The whole shorescape is involved. The penultimate member of the food chain is the monster fish of the title, which lies slit open on the beach. The gaping mouth of the fish and its slit-open stomach deliver up other fish, which have eaten yet smaller fish. As apparently the final predator, the man on a ladder is taking the fish apart. However, heading threateningly towards him in a nosedive is a flying fish with mouth open at the ready. Once again, Bruegel turns "might-is-right" inside out even while he is presenting it. The big fish is dead, and even a mussel beside it is attempting to obey the law of feeding and draw fishy nourishment. On the right, where fish are hung on a tree to dry, a half-human, half-fish creature unmistakably illustrates that human behavior is being presented exemplarily and for moral ends, as is the rule in animal fables.

As in *Big Fish Eat Little Fish*, it is often variations and exaggerations that are used to bring out the meaning of familiar words and objects in Bruegel's pictures. Visual language, translated artistically into the work, is being tested, as for example when the battle between Carnival and Lent is personified and their attributes are mixed up to the point of disintegration. After all, what is a bread shovel that is used to shovel herrings? Or a suckling pig with a sausage dangling from it (ill. 57)? It is often everyday things and actions, but also very familiar cultural items, that here appear misused, deliberately recombined, or reshaped. The truth for Bruegel almost always lies in exaggeration. Where, however, he means it seriously, he unexpectedly withdraws his objects and hides them in a wealth of action or somewhere on the edge of the composition.

Brecht was not the only writer to notice the paradox of graphic narration and reposeful depiction of space in Bruegel's works. In the early 1900s, the American author William Carlos Williams (1883–1963) wrote several poems based on paintings by Bruegel. What Brecht saw as painted contradiction or alienation is, in Williams' poem on Bruegel's *Fall of Icarus* (ill. 113),

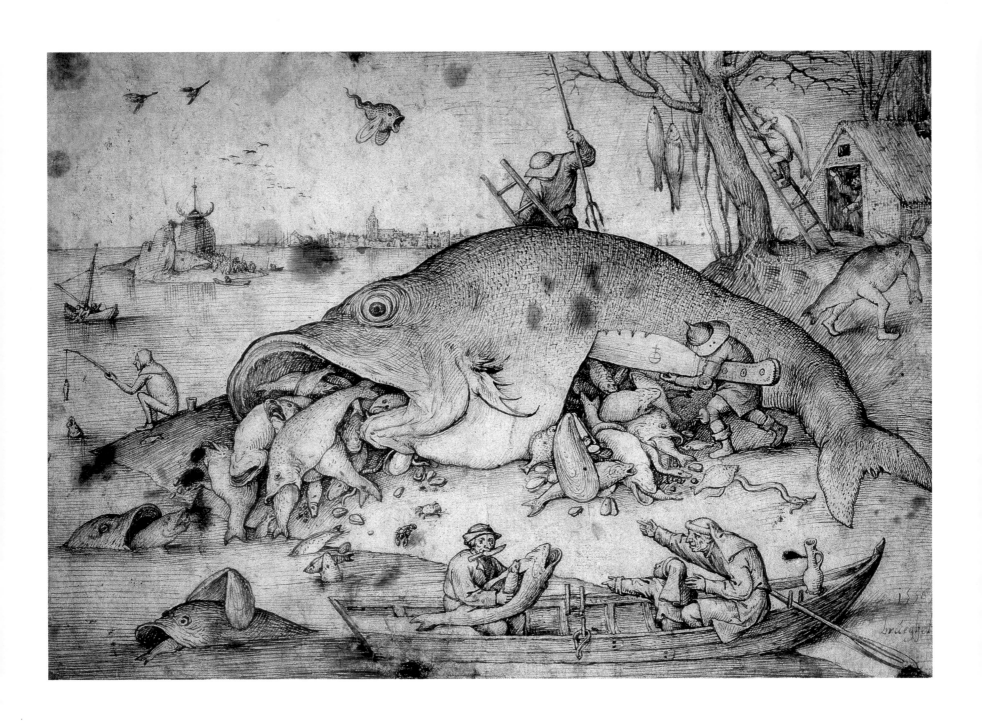

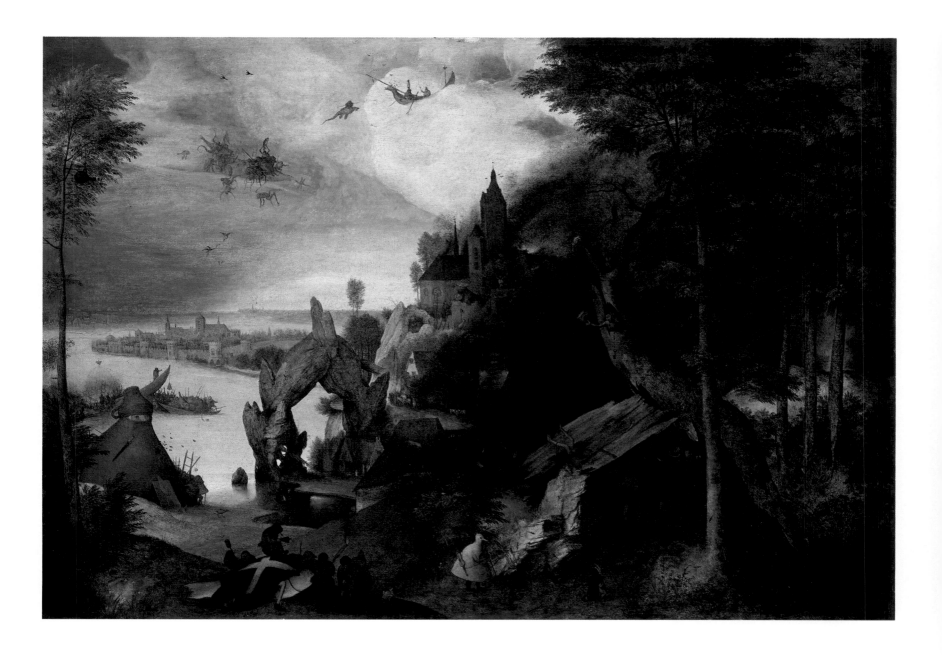

3 *Landscape with the Temptation of St. Antony*, ca. 1552
Oil on panel, 58.5 x 85.7 cm
Samuel H. Kress Collection, National Gallery of Art,
Washington

The sources tell of St. Antony enduring aerial battles and
disasters by night. The temptations of the hermit had always
acted as a challenge to painters to paint landscapes with a
great deal of variety. In this version of a hermitage in a dark
forest and fires on the castle rock, Bruegel (or an artist close
to him) is getting close to a picture of hell.

a pause to hold one's breath as a break between two
strophes. It records the moment in which Icarus plunges
headlong from the sky without involving the landscape
and its occupants in any way, and hits the surface of the
water; his head and trunk are already buried in the
ocean. It is no accident that poet and art scholar alike
yield to the lure of the detail, to make pictorial chunks
from Bruegel's work the subject of their works and trea-
tises. After all, shortly before his death the painter
himself enlarged sections from his own works. Often the
mutual alienation of details is deliberately combined
into a story or its effect enhanced into contrast.
Likewise, authors of children's books have linked
Bruegel's elaborately detailed scenes with historical
accounts or fairy tales and Biblical tales. Thus his
paintings have acted to this day as picture puzzles
prompting the production of many new stories.

Yet the work, customs, dress, and other objects
depicted by Bruegel have also been looked upon as
documents of an almost forgotten everyday life. So
much has been written, particularly about famous
pictures such as the *Flemish Proverbs* picture in Berlin
or *Children's Games* in Vienna, as if an objective text
underlying the works existed, describing the material
culture, popular wisdom, or play culture (ills. 60, 63).
Observers continue to talk as though the painter had
simply reproduced, as if he stood in the shadow of a
more powerful written culture and was serving merely
as a chronicler of past customs. Of course there were
collections of proverbs, such as that by the humanist
Erasmus of Rotterdam (1466–1536), and lists of games
were available in print. However, Bruegel's treatment of
the subjects is much more original than this. His works
are both unconventional and outstanding metaphorical

achievements, which can only compete with dusty records of sayings and games in order to surpass them. The same applies to his Biblical scenes, because they cannot be simply explained by quoting the relevant texts in the Bible and their exegeses.

Where did such artistic originality come from? Was it the native wit of a peasant from a village called Bruegel who observed his peers with both equanimity and humor? This interpretation has often been quoted, citing the life of Bruegel by Carel van Mander (1548–1606) in his *Schilderboek*, which dates from 1604. The painter, biographer, and early art writer says by way of introduction to Bruegel:

"Nature was wonderfully felicitous in her choice when, in an obscure village in Brabant, she selected the witty and humorous Pieter Bruegel to paint her and her peasants, and to contribute to the everlasting fame of painting in the Netherlands."

Equally, the figure of Hieronymus Bosch (1440/1450–1516), who became adept at placing grotesque figures as contrast to an expanse of landscape, may be seen as a model for Bruegel's inventiveness. Netherlands painting, perhaps even European painting as a whole, can hardly show two more unconventional artists than these. Bruegel's later birth, of course, excludes a direct pupil relationship, which would otherwise seem obvious from the closely-related subject matter, because Bosch was already dead when Bruegel was born. Nonetheless, contemporary observers were already recalling Bosch, as the posthumous praise of Bruegel by Domenicus Lampsonius in 1572 proves. Lampsonius' Latin text calls him a second Bosch. Van Mander also made the link: "He practised a good deal in the manner of Hieronymus Bosch, and painted many weird scenes and drolleries, on account of which he was often called 'Pieter the Droll'." And finally some of Bruegel's early prints, including *Big Fish Eat Little Fish* as already described and portrayed, even based their appeal on subject matter attributed to Bosch, worked on and further developed by Bruegel.

The earliest painting of Bruegel that clearly leads us to Bosch is the *Landscape with the Temptation of St. Antony* in Washington (ills. 3, 4). As Bruegel had already endowed his figure of St. Antony with Bosch-type features in his drawing of 1556 (ill. 5), doubts about the authorship of the Washington painting should trouble us no further. The most celebrated of the connoisseurs of early Flemish painting, the Berlin critic Max J. Friedländer (1867–1958), considered the

painting genuine, and the most recent wood datings of the panel do not indicate that it could only have been painted after his death, as has been dismissively asserted. The wilderness of St. Antony is an elaborate coastal landscape that is wooded to the right and rises to a cliff face and castle. On the left and center, however, water and sky predominate. Both the Bosch and Bruegel paintings show respectively earthly torture and, in the air, the most notorious of the numerous temptations by the devil and his demons. Both painters reproduce the great fish as a metaphor of human existence. The fish is a part of the temptations that lure the hermit away from the path of righteousness. Bruegel would show this once again in his *Triumph of Death* in 1562 (ill. 65).

The riddle of Bruegel's artistic wit vies with that of his education. A frequently copied drawing by Bruegel shows the *Artist and Connoisseur* (ill. 6), which tends to lead to a move away from the legend of the peasant artist. The very juxtaposition of artist and connoisseur presupposes a humanist understanding of art. In the Middle Ages, painters were not dependent on the understanding of a connoisseur. They formed part of a stable artisan tradition that was borne along by commissioning institutions and social strata such as the clergy, nobility, and, in later times, the burghers. Painters in Bruegel's day often painted themselves as the figure of St. Luke the Evangelist, of whom tradition says that he painted the Virgin Mary. But even Bruegel's artist, with the wildly straggling hair and bushy eyebrows, is not a self-portrait in the strict sense. It has sometimes been taken as a likeness of Hieronymus Bosch. Yet there is no reason why Bruegel should not be thinking of his own artistry if he is describing the artist's relationship with the connoisseur, or, indeed, if he had portrayed one of those who had influenced him. The artist is gazing with a penetrating eye, unaffected by the connoisseur looking over his shoulder, to the left, where the object he is painting is presumably located. The artist's appearance is naturalistic compared with the spectacled figure behind, which is painted with much less forceful a line: in this respect, he is like the peasant painter of van Mander's imagination. Conjecture appears to come full circle if Bruegel's artist is seen as a portrait of Hieronymus Bosch. Van Mander was able to ask, in the rhetoric of the art connoisseur Lampsonius:

"Hieronymus Bosch, what is the meaning of your face and your pale features? It looks as if you imagined all the spirits from hell were flying round your ears."

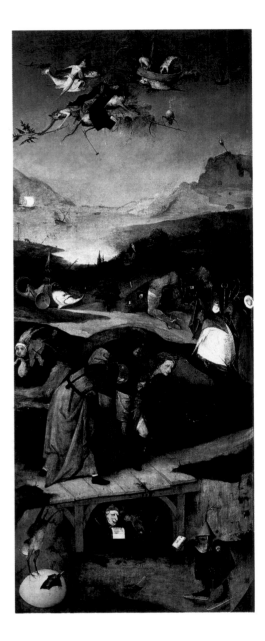

4 Hieronymus Bosch
Temptation of St. Antony (detail), ca. 1510
Oil on panel, 131.5 x 119 cm
Museu Nacional de Arte antiga, Lisbon

Bosch's underworlds, enriched with monsters and demons, have been traced back time and again to esoteric doctrines of the Middle Ages.
The three inside panels of Bosch's altar are dedicated to the temptations of St. Antony, while the outer panels of the closed altar show the *Arrest of Christ* (left) and *Christ Carrying the Cross* on the right. The inner panel on the left shown here depicts the aerial battle with demons. On the path with the narrow bridge, we see the fallen St. Antony being found by friends and accompanied home.

5 *Temptation of St. Antony*, 1556 (?)
Pen and brush drawing in grayish brown, 25 x 21.6 cm
Ashmolean Museum, Oxford

As in the painting of the same subject (ill. 3), St. Antony is led into
temptation on a coast. The bay has human shape, and cliff and cave
rear up to form a gigantic head in the center. This in turn is occupied
by a beached fish, in whose opened belly three men are quarreling.
On the right, the saint prays in front of his tree dwelling. He turns
away from the numerous monsters, who approach menacingly.

6 *Artist and Connoisseur*, ca. 1565
Pen drawing in grayish brown, 25 x 21.6 cm
Graphische Sammlung Albertina, Vienna

This drawing has often been copied. The painter shown has been
identified with Hieronymus Bosch, but also with a self-portrait of
Bruegel. Either way, there is a striking contrast between the painter,
who can hardly see beneath his bushy eyebrows, and the connoisseur
looking over the artist's shoulder with penetrating gaze.

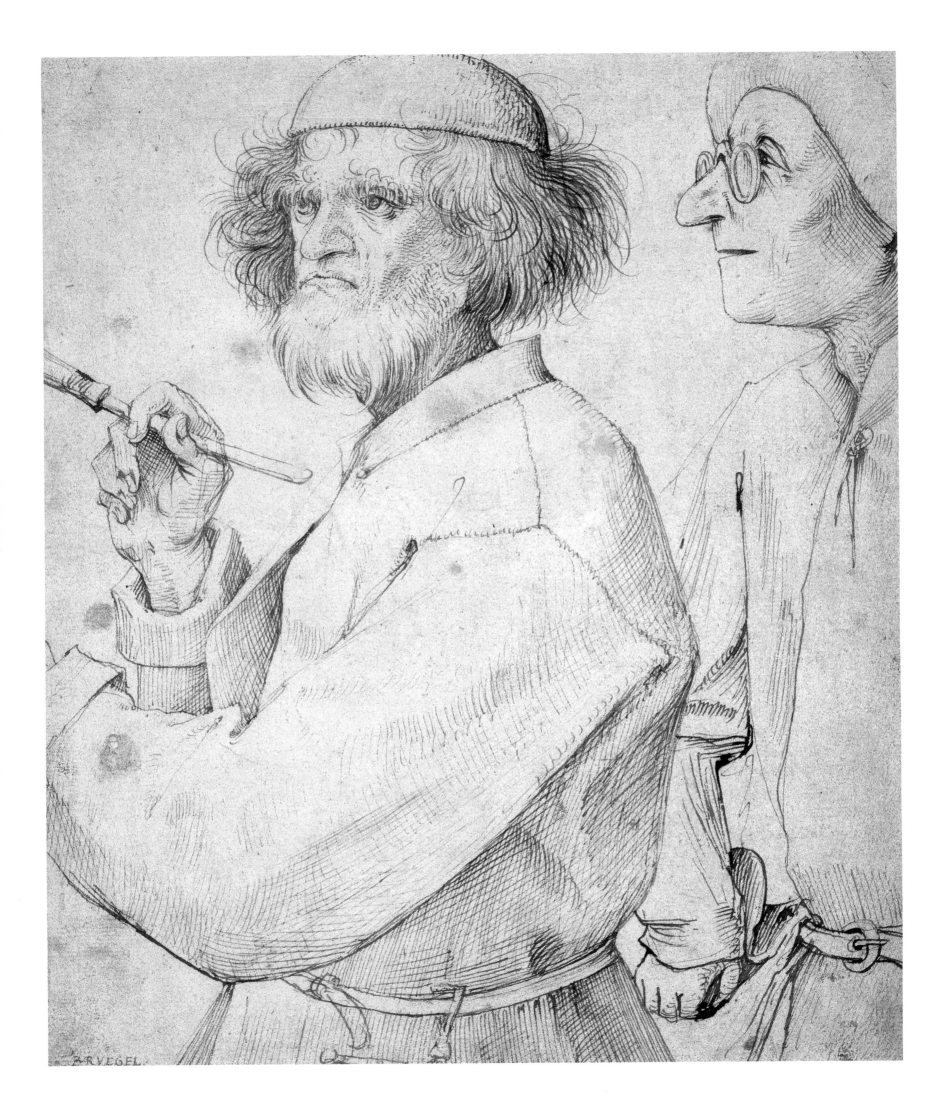

A JOURNEY TO ITALY TO DRAW

7 *Landscape with Italian monastery*, 1552
Pen drawing, subsequently watercolored, 18.5 x 32.6 cm
Kupferstichkabinett, Staatliche Museen zu Berlin –
Preußischer Kulturbesitz, Berlin

The construction of the landscape in parallel stages,
whereby at the same time the artist dispenses with
conventions of landscape composition such as a frame
of trees in the foreground and a distinct path taking the
viewer's gaze into the depth, suggests a drawing of a
specific landscape taken during the trip to Italy. No
precise identification of the simple monastery has so far
proved possible.

Working from the fact of his first demonstrable collab-
oration in 1549 and assuming he completed his
training as a painter when he was about twenty, Pieter
Bruegel the Elder was probably born shortly before
1530. Jointly with Pieter Balten (1525–1598) and
under the guidance of Claude Dorizi (1518–post
1561), he took over the commission for an altar
ordered by the Glovemakers' Guild of Mechelen,
which was completed in 1551. Bruegel's job was to
execute the *grisailles* (paintings in tones of gray) of the
outer wings. We are indebted to a legal dispute for the
fact that this work, although now lost, is not
completely forgotten. A portrait showing the artist
shortly before his death in 1569 suggests a man of
about forty-five, which would confirm a birth between
1525 and 1530.

The name Bruegel can be connected with two towns
in the Scheldt region, but apart from the similarity of
name there is no real evidence for his place of birth.
Carel van Mander wrote that he was born in Breughel
near Breda (Brabant), but there was no town there of
this name. Probably van Mander was following infor-
mation that he obtained from a historical description
of the Netherlands written by the Antwerp-based
Italian, Ludovico Guicciardini, in 1567, which says
that Bruegel came from the vicinity of Breda. At the
same time van Mander added his own explanation of
the family name as a place name without actually
confirming it.

The assumption of a rural origin was, of course,
closely linked to the peasant themes of Bruegel's paint-
ings and drawings, which won him fame early on; it
was assumed he painted his peasant origins ungar-
nished straight into the paintings. The fact that all the
places in which Bruegel can be proved to have worked
were flourishing and rapidly expanding Flemish
commercial cities, runs counter to the notion of a
peasant Bruegel as an artist who both came from the
country and worked there. The contrast between town
and country already formed part of the cultural self-
awareness of the towns, and visits to the country were
in fashion. It may be supposed, therefore, that van
Mander stylized "his" Bruegel in accordance with a
fashion that sought wit and joie de vivre in the country.

From whom Bruegel learnt to paint is a matter of
debate, but in any case he began his apprenticeship
before 1550. The collaboration with Balten could have
been possible within his apprenticeship, because both
of them were employed only indirectly. The previously
mentioned altarpiece for the glovemakers' guild is the
only commissioned piece of church art that Bruegel is
recorded as having done. Since the mid-16th century,
altar painting in the Netherlands had been in grave
crisis, as a ban had been imposed on new church
furnishings. From 1564 on, there were repeated
outbreaks of iconoclasm in the Netherlands. The
absence of traditional commissions was the external
cause for a profound change in the art business; new
patrons demanded new pictorial approaches in which
Christian themes might of course appear but would be
interpreted differently.

As Bruegel later married Mayken Coecke, van
Mander's suggestion that her father, Pieter Coecke van
Aelst (1502–1550), trained him was taken seriously. If
that were the case, never did a pupil wean himself from
his master's influence more rapidly and more radically.
Coecke painted in the fashion of the Romanists and
had little feeling for landscape compositions. He
became famous through his posthumously published
drawings on the culture and customs of the Turks,
which he had studied on the occasion of a journey to
Constantinople, and where he remained for a year and
learnt Turkish. Initially, he was sent there by a carpet
maker to look at the local carpet production. Shortly
before his death, Coecke was living in Brussels, but
Bruegel did not move there from Antwerp until the
1560s, after his marriage to Mayken. Coecke was of
course a universal artist and scholar of such standing
that Bruegel could have profited from it. However, in
learning his trade of painting, he must either have been
self-taught or had another teacher.

Comprehensible in craft as well as aesthetic
terms is Bruegel's connection with Matthys Cock
(ca. 1509– pre-1548), who did original work both as a
graphic artist working on printed illustrations for his
brother, who was the publisher Hieronymus Cock
(ca. 1510–1570) and also as a painter in the 1540s.
Cock displayed an interest in broad landscapes,

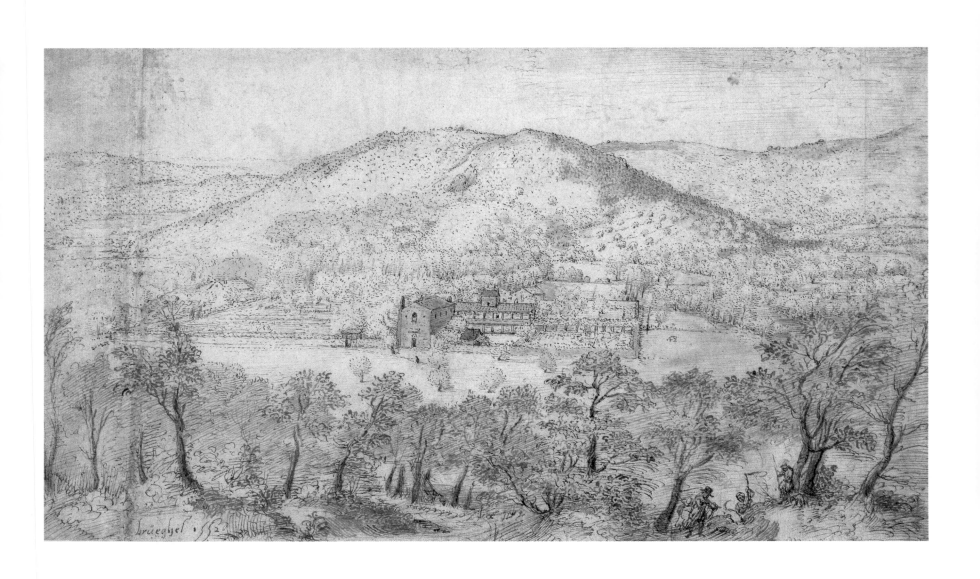

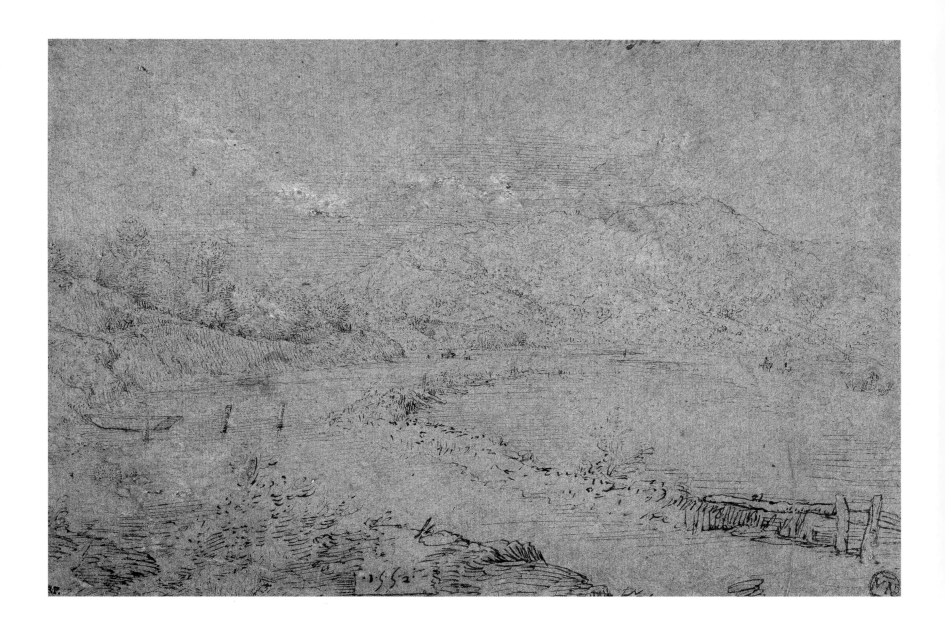

8 *River landscape*, 1552
Pen and brown ink drawing on blue-tinted paper,
17.6 x 26.4 cm
Cabinet des Dessins, Musée du Louvre, Paris

After numerous re-attributions in recent years, there are
not many drawings which are definitely by Bruegel's hand
that give the impression, as this one does, of being drawn
directly from nature. A particular feature suggesting this is
the deep horizon, which is clearly intersected by the
mountains in the background. Beside the luxuriant
background foliage, the emptiness in the foreground and
the renunciation of any artistic embellishment of the river
bank look almost revolutionary.

weather phenomena, and the subordination of figura-
tive events to an overall landscape impression. The
National Gallery in Washington contains a *Landscape
with the Martyrdom of St. Catherine*, which because of
the thunderstorm approaching from the right was orig-
inally attributed to Bruegel but is now considered
Matthys' work, dating from 1540. This picture does
indeed establish an otherwise rarely observable connec-
tion between Bruegel and the most important repre-
sentative of the "world landscape" (ill. 37), Joachim
Patinir (ca. 1480–1524). Like Bosch, Patinir was
already dead when Bruegel was born.

The mention of this painter cannot be combined
with an explanation of the works or the personal visual
experiences of Bruegel. It is certain that Bruegel spent
quite a while in Rome, while it has been thought that
further stages of his Italian trip can be discerned in his
drawings. The experiences that left their mark on him
were always attributed to crossing the Alps, so that
Nature was said to be his main teacher. Certainly, the
journey to Italy and the drawings he did on the way,
along with his reception of earlier painter colleagues,
allow access to Bruegel's art. It needs always to be
borne in mind of course, that nowadays these are fewer

drawings that are attributed to him with certainty
than was the case even twenty years ago. Even longer
ago, a division was made in his oeuvre both temporally
and technically into two separate decades: from 1550
he was a graphic artist, from 1559 to his death a
painter. Since then, many of his early prints have
turned out to be the work of a successor. The age of
the paper betrayed a later origin, or on closer inspec-
tion the drawings revealed no more than familiarity
with Bruegel's prints and paintings – they were too
close to being picturesque delights of nature and so
could not have been studies made en route.

Nonetheless, for someone viewing the drawings,
their closeness to Bruegel's real visual and travel experi-
ences form their supreme charm. Even compositional
reworkings cannot disguise Bruegel's confidence in
what he saw. The earliest dated view, which seems
highly elaborated and later revised by an alien hand in
a watercolor technique, is the drawing *Landscape with
Italian monastery* (ill. 7). The unusually broad,
symmetrically constructed landscape recedes in parallel
planes across a treeless zone with four figures and a
narrow strip of trees back to the monastery and its
gardens, which lie at the foot of a chain of hills. The

lack of a stretch of water and horizon overlapping across its whole width indicates a real landscape. A clearly visible horizon and stretch of water are musts in the craft of a standard landscape composition, to which Bruegel also, with few exceptions, remained loyal in his *Great Landscapes* done after 1556 (ills. 13-24).

Bruegel ventured southwards in 1552 after he had been accepted into the Antwerp guild of painters, and he certainly must have been on his travels during the following year as well. He was young and not yet professionally established, so that one may assume that he was commissioned to go abroad and thereby covered his travel. The beneficiary of the journey could have been Hieronymus Cock, who himself had been in Italy a few years earlier and had then opened a publishing house in Antwerp called Aux Quatre Vents (The Four Winds) to publish examples of Italian work. Roman printers and publishers who themselves came from the north seem to have been behind the venture. Cock's early publishing program consisted of reproductions of classical antiquities and views (*vedute*) of Rome, cities, public open spaces, and monuments. Interest in such subject matter derived from the familiarity or impressiveness of the historic monuments concerned. Bruegel did not particularly distinguish himself in this art, only two works being really relevant in this connection, although even they are not *vedute* in the strict sense.

Before Bruegel reached Rome, he crossed the Alps. Were the mountains really the great experience for the plainsman, as van Mander emphasized? Or is the enthusiasm for nature claimed for Bruegel only by way of an apologetic compensation for his astoundingly minimal interest in Italian painting? Whether there are really drawings that prove the various places on Bruegel's journey to Italy is doubtful. The outstanding Bruegel expert Hans Mielke has excluded once important early works from Bruegel's oeuvre. Drawings such as the one in the Louvre (ill. 8), which shows a river landscape, not only cannot be clearly identified as to landscape, they also carry neither signature nor date. Opinions on Bruegel's itinerary and artistic development remain just that; the lack of alternative pictorial arguments or absence of documentation nourishes speculation that the artist chose the Rhône as an object in these drawings. An unusual feature of the Louvre drawing is the close proximity of the artist's standpoint to the river and the almost total renunciation of a compositional demarcation of the viewer's standpoint, by which the river gains in attractive force. The low horizon could be a criterion for on-the-spot artistic observation, because it means that the artist has not created a viewpoint, which is easily assumed where something is depicted from above for the sake of a better overall view. Historically, an itinerary via Dijon is very probable, as this was among the most traveled of long-distance routes from the north and because the Burgundian town would have been a particularly rewarding stop for Bruegel, as a center of trade and printing.

In 1555, Cock used Bruegel's drawing *Forest Landscape with Bears Playing* (ill. 11), which is now in Prague, to make a *Temptation of Christ* (ill. 12). The fact that, apart from the change to a better-known subject, the publisher omitted the reference to Bruegel, can be interpreted as a test: he wanted to find out if works of this sort were sellable. If the trees by the water were themselves unconventional, the playful bears were probably altogether too daring. Either he did not wish to bring Bruegel's reputation as a newcomer into disrepute or he did not expect the name of an unknown artist to add to salability. The etching seems to have been a success, because in the following year Bruegel's series of *Great Landscapes* (ills. 13–24) appeared. Whether the *Great Landscapes*, circulated as engravings, were really the result of travel experiences could only be proved by drawings that were made en route, not by the anecdotes recounted by van Mander about mountains swallowed en route and disgorged at home. If there were sketches, they have almost all been lost. Each of the prints must have been the result of several sketches, revised in accordance with compositional rules.

The only engraving among them to count as a *veduta* is the view of the waterfall near Tivoli, which lies east of Rome on the edge of the Tiburtine Hills (ill. 13). This view is described with topographical accuracy. It was published after Bruegel's return to Antwerp from 1555, and bears by way of a caption, the title *Prospectus Tyburtinus* set in a strip across the bottom marked off by framing, a feature that characterizes the whole series. No reference is furnished as to the year of origination or the artist who drew the original drawing, only the engraver's name "H. Cock" being given on the bottom edge of the print. Anyone who knows the craggy landscapes of Tivoli may find the print unspectacular. The viewpoint of the artist is somewhere near the River Aniene, below the town between Tivoli and the Villa Hadriana. Should it really be believed, looking at this etching, that Bruegel, whose feeling for the impressions of nature was always praised, opted for precisely this subject matter in Tivoli? Certainly the picture was a success, being included in the famous city views by Braun and Hogenberg, and re-used by several publishers later. But any impression that the situation of the city, on a mountain peak ringed by the River Aniene, made on the artist passes him by – famous monuments do not bother him, neither the Villa d'Este, whose garden makes use of the steeply sloping site and the abundance of water, nor the Temple of Vesta are shown. The view features principally the *cascatelle grandi* (cascades), which debouch from the town into the Aniene north of Tivoli, being themselves fed from the water of Lake Aniene above the town. The houses are drawn freely, since the steep ascent could not have included them without projection, particularly as the terrain gains more than 330 feet in height over a distance of under 660 feet.

These observations on *Prospectus Tyburtinus* may highlight two questions that always arise in connection with Bruegel's work. Bruegel as an "artist of nature," as van Mander presented him in the first sentence of his *Life*, is not a precursor of travel photographers, whose itinerary can be traced from the slides that they take.

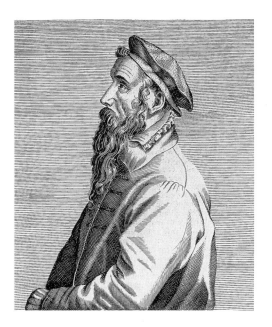

9 E. de Boulonois
Petro Bruegel Pictori
Copper engraving from: I. Bullart, *Academie des Sciences et des Arts*, Vol. 2, 6th section, Amsterdam, 1582

This portrait of the artist appeared after Bruegel's death: it shows a bearded man in profile, severe and venerable, and probably in his forties.

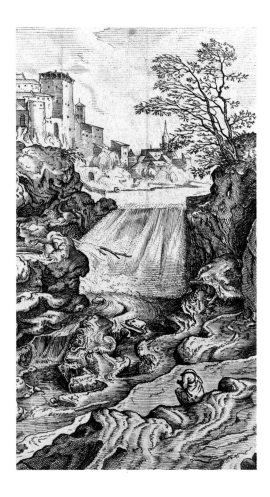

10 *Prospectus Tyburtinus* (detail of ill. 13)

Bruegel reproduced very few places he saw on his journey so exactly that it can be certain he viewed them himself. The town of Tivoli in Latium east of Rome is one of these. Even in antiquity it was already famous for its situation. Hadrian built his villa close by, and a temple still stands there. But Bruegel was not interested here in antiquity and its buildings. Its attractions for him are the steep cliffs, the water courses, and their famous cascades (*cascatelle grandi*).

Even if this was assumed, it was only because, unfortunately, there was a lack of more definite evidence: although views of Reggio di Calabria, Naples, Rome, Tivoli, and the Alps do constitute stages of a journey that could be highly likely in their sequence. Presumably most of the drawings done on his travels are now lost, and those that survive frequently go back to reworkings that Bruegel undertook after he returned. From a publisher's point of view, editorial considerations came first and foremost when any reworking was done, just as Bruegel's *Building the Tower of Babel* (ills. 1, 79, 80) contains an echo of the Colosseum – but translated to the North Sea coast. There are actually no real *vedute* of antiquities at all by Bruegel. Artists before him had already made a sales success of printed views of the Colosseum, and he could have used these as an *aide-mémoire* while painting just as easily as his own drawings.

The *Great Landscapes* consequently cannot be traced back to topographical travel views. It is also a matter of doubt whether they are to be considered as a series at all, if anything more is meant than a series loosely connected for sales purposes. In the trade, they were probably available individually. The captions indicate reproductions of legends of saints and Biblical tales, but classical themes are also represented, whose iconography has not yet been closely investigated. In all probability they were added to the design post hoc, and are therefore only vaguely and associatively connected with the pictorial idea. The captions and titles have no internal connection with each other, and appear disjointed.

What makes the prints a series is not their thematic connection with each other but their standardized format of about 32 x 43 cm and their compositional style. There is a similar relationship between a usually raised foreground extending in comparable fashion into the center ground and background. Small figures in the foreground always start the pictorial plane at a considerable distance from the viewer. In the case of more than half of the scenes, a single tree or clump of trees determines the perception of distances within the image by rising to the full height of the picture, and thus serving as a scale of comparison. Most of the scenes contain the course of a river running towards the horizon and flanked by mountains, which in some drawings loom over the horizon. Although there is, of course, no fixed plan, certain basic rules of landscape design are carefully observed: motivation of the view, provision of a reliable vertical axis, and also a horizontal one with trees and water. The employment of familiar landscape features such as windmills, gallows, farmsteads, and towers, confirms the depth of illusion and conveys an impression of distance that the viewer can relate to empirically and examine. Bruegel's graphic sense for the lucid composition of such collections of buildings in relation to the landscape does rather get lost in the prints, as after a certain amount of reduction in size and atmospherically-depicted blurring, the technical process creates a form that can be reduced no further. The most distant shapes can be resolved only by means of schematic

alteration: individual trees – recognizable from their lines and circles – are turned into groves, whose silhouettes are inserted across the course of mountain chains; sailing ships become jagged lines on the horizon. Other squiggles and jags may be still more remote groves or distant ships.

Due to a greater finesse of design, the landscape with the *Rabbit Hunt* (ill. 25), dated around 1560, is considered the only engraving that was actually engraved by Bruegel himself. The view over an orchard, where a rabbit catcher is hiding, into a valley with a curving slope to the right leading to a wooded castle peak, is similar to the setting of his *Landscape with the Temptation of St. Antony* (ill. 3). And indeed, the hatchings and very fine striations are much more differentiated than those seen in previous landscape prints. This would mean that a glimpse of Bruegel's unadulterated graphic style can be obtained, without the alienating intermediate stage where the image is transferred to the copper plate by the routine hand of a skilled engraver. This would, of course, have been a considerable achievement for a layman: after all, simplifications in the translation of drawings on to copper plates are caused in the first place by the technique and are not a question of expression or style. A drawing by Bruegel that would allow a direct comparison is not available. Although the print has, as usual, a bar for an inscription, it is left blank. The date after Bruegel's name in the bottom left corner was rendered unreadable by hatching, perhaps because the wrongly written 1506 could not easily be corrected to 1560, but this is not to say that a dating to 1560 is definite.

That Bruegel was acquainted with Giulio Clovio (1498–1578), the famous book illuminator from Macedonia, appears to prove a prolonged stay in Rome. For decades, the latter's principal patron was the Roman Cardinal Farnese (1468–1549). Perhaps, however, a closer note should be taken that according to Clovio's biographers he worked for the Medicis in Florence in 1552 and 1553 and was not in Rome until after those dates. Was Bruegel in Rome later, or does the friendship refer to Florence? Clovio possessed some works by Bruegel, and an inventory of his possessions mentions a tempera painting that the two of them were said to have painted together. Investigation of this reference to their cooperation showed that the two of them must have worked on illuminating a Latin book of hours. The *Farnese Book of Hours* (ill. 26), now in the Pierpont Morgan Library in New York, features on the *bas de page* (bottom of the page) coastal landscapes with wash backgrounds, which Charles de Tolnay ascribed to Bruegel. In a simplified classification of artistic skills, landscape was already considered the domain of the north, and figures that of the south; in consequence, Clovio was not considered capable of painting the landscapes. Yet the book is dated 1546, which means it was painted before Bruegel's journey to Italy. Moreover, we know of comparable views by Clovio that are similarly flat and transparent, and go over abruptly into blue backgrounds like those of the *Farnese Book of Hours*.

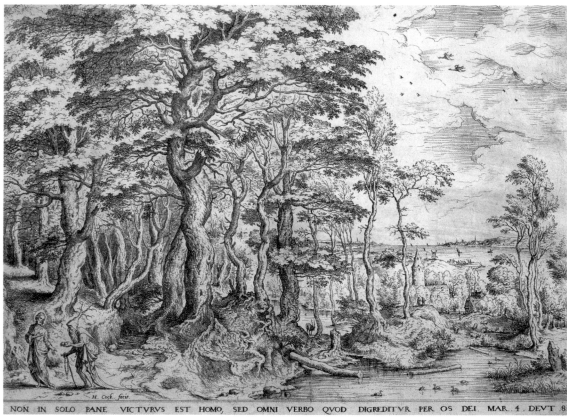

NON IN SOLO PANE VICTVRVS EST HOMO, SED OMNI VERBO QVOD DIGREDITVR PER OS DEI. MAR. 4. DEVT 8

11 *Forest Landscape with Bears Playing*, 1554
Pen and ink drawing, 27.3 x 41 cm
Národní Galerie, Prague

The bears were coupled with the saying "the mother bear gives her young shape by licking them," which is to be interpreted as exemplary care that leads to perfection.

12 Hieronymus Cock, after Pieter Bruegel the Elder
The Temptation of Christ, post-1570
Etching, 32.2 x 42 cm
Cabinet des Estampes, Bibliothèque Royale Albert I, Brussels

With regard to the arrangement of figures in Bruegel's graphic work, this print and the *Forest Landscape with Bears Playing* (ill. 11) are very informative: they demonstrate that the same landscape design could be used in many ways. In the one picture, profane iconography is offered, in the other a Christian legend. It is very probable that in the case of the etching the publisher was involved in the choice of subject matter and caption, and determined the arrangement of figures. Many printed graphics by Bruegel were, like this one, produced only after his death in 1569. Among them are prints that were changed and reprinted several times. They thus carry different captions in different circumstances.

13 From the *Great Landscapes* series, *Prospectus Tyburtinus*, 1556
Copper engraving, 32 x 42.5 cm
Cabinet des Estampes, Bibliothèque Royale
Albert I, Brussels

The *Prospect of Tivoli*, a town lying east of Rome on the edge of the Tiburtine Hills, made Bruegel known to a broader public. The locality of the waterfall near Tivoli is Bruegel's only topographically recognizable and named view in the series.

14 From the *Great Landscapes* series, *S. Hieronymus in deserto*, 1556
Copper engraving, 32 x 42.5 cm
Cabinet des Estampes, Bibliothèque Royale
Albert I, Brussels

St. Jerome in the Desert, as the Latin title translates, was traditionally shown in the middle of a deserted landscape that was not, however, depicted as a desert. Ever since Dürer's famous engraving, St. Jerome as a Father of the Church had also been frequently shown in his study, that is as a scholar. The original drawing is lost.

15 From the *Great Landscapes* series, *Nunindæ rusticorum*, 1556
Copper engraving, 32 x 42.5 cm
Cabinet des Estampes, Bibliothèque Royale
Albert I, Brussels

Nunindæ rusticorum or 'road to the weekly market' is not the original title for this drawing, if one bears in mind the Belgian cart or pack mule of the untitled Alpine landscape. The view between and beyond a succession of small forested hills is nonetheless unparalleled in the *Great Landscapes*.

16 From the *Great Landscapes* series, *Magdalena pænitens*, 1556
Copper engraving, 32 x 42.5 cm
Cabinet des Estampes, Bibliothèque Royale
Albert I, Brussels

Magdalena pænitens, or *Penitent Magdalene*, was a popular devotional subject from the 15th century onwards. The personage of the saint is composed of sundry, historically authenticated people. She possibly unites Mary of Magdala (Migdal), out of whom Jesus drove seven devils (St. Mark 16, 9) and who was later also a witness of the Resurrection, with the sinner who showered tears on Jesus' feet (Luke 7, 37).

17 From the *Great Landscapes* series, *Alpine landscape* (no inscription), 1556
Copper engraving, 32 x 42.5 cm
Cabinet des Estampes, Bibliothèque Royale
Albert I, Brussels

The composition offers no explanation as to why this should be the only picture without a title. The train of pack mules, the steep ravine, or the rock faces would have provided ample occasion for a learned inscription on the travails of trade journeys.

18 From the *Great Landscapes* series, *Solicitudo rustica*, 1556
Copper engraving, 32 x 42.5 cm
Cabinet des Estampes, Bibliothèque Royale
Albert I, Brussels

The title *Solicitudo rustica* (otherwise known as *Rustic Care*) refers to the two peasants with their scythes, one leaning against a tree to the right, the other sitting under the tree sharpening a scythe. The landscape, with several waterways, towns, castles, and mountains, creates no impression of remoteness, as it appears everywhere to be densely populated.

19 From the *Great Landscapes* series, *Insidiosus Auceps*, 1556
Copper engraving, 32 x 42.5 cm
Cabinet des Estampes, Bibliothèque Royale
Albert I, Brussels

This print is inscribed *Insidiosus Auceps* or *Crafty Fowler*, a title which refers to the man in the plumed hat on the right, who is carrying various birds on a frame. There is no visual hint as to the cunning with which he caught them. The sparse tree could have been meant for his occupation as a traveling vendor would probably not have earned very much.

20 From the *Great Landscapes* series, *Fuga deiparæ in Ægyptum*, 1556
Copper engraving, 32 x 42.5 cm
Cabinet des Estampes, Bibliothèque Royale
Albert I, Brussels

Fuga deiparæ in Ægyptum or *Flight into Egypt* was the most popular subject of religious landscape painters before Bruegel. It recurs in his work in 1563 as a painting, and his earliest drawing from 1553/54, the *Rest on the Flight into Egypt* (ill. 30), displays the same thematic link.

21 From the *Great Landscapes* series, *Euntes in Emaus*, 1556
Copper engraving, 32 x 41.5 cm
Cabinet des Estampes, Bibliothèque Royale
Albert I, Brussels

In the last chapter of St. Luke, two disciples went to a village called Emmaus near Jerusalem. Three days after the Crucifixion, they doubt their belief because nothing has happened that resembles the promised redemption. A stranger who joined them on the road participates in their conversation. Only when he has finished replying to the doubts that they raise do they recognize him as the resurrected Jesus.

22 From the *Great Landscapes* series, *Plaustrum Belgicum*, 1556
Copper engraving, 32 x 42.5 cm
Cabinet des Estampes, Bibliothèque Royale
Albert I, Brussels

The covered wagon, called *Plaustrum Belgicum* or *Belgian cart*, is on the way down to a Flemish village. However, the hilly landscape does not reflect the usual scene of Flemish topography, so a specific Belgian town is ruled out. An isolated rock rears up in the bay, where many ships are to be seen.

23 From the *Great Landscapes* series, *Pagus nemorosus*, 1556
Copper engraving, 32 x 42.5 cm
Cabinet des Estampes, Bibliothèque Royale
Albert I, Brussels

Pagus nemorosus is a "shady place," here distinguished by a thicket in the foreground and a ford through knee-deep water. No literary or topographical reference is known.

24 From the *Great Landscapes* series, *Milites requiescentes*, 1556
Copper engraving, 32 x 42.5 cm
Cabinet des Estampes, Bibliothèque Royale
Albert I, Brussels

The soldiers have chosen what is probably a rather unusual place to stop; in fact they are virtually besieging the spot. Instead of recuperating in the village, they sit to the right and left of the road, one of them putting down his spear. The landscape is characterized by a wide, overhanging tree in the center of the picture.

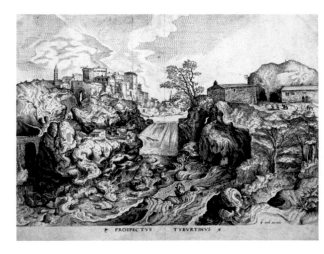

13

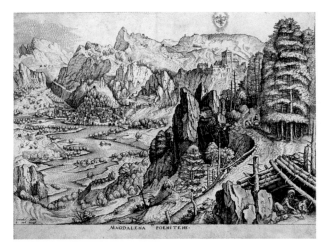

16

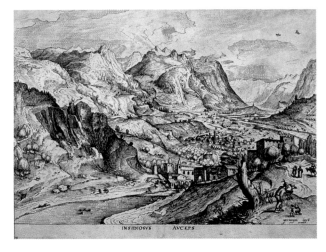

19

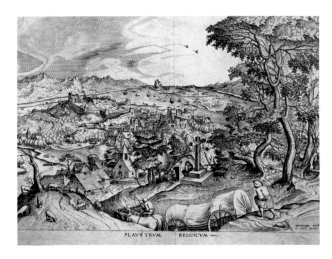

22

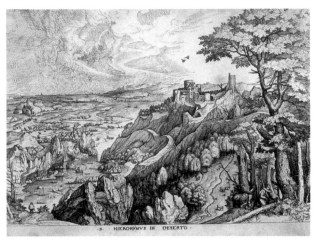

·S· HIERONYMVS IN DESERTO·

14

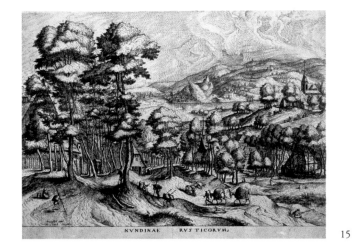

NVNDINAE RVSTICORVM.

15

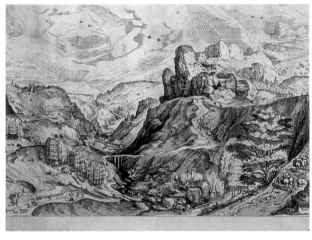

17

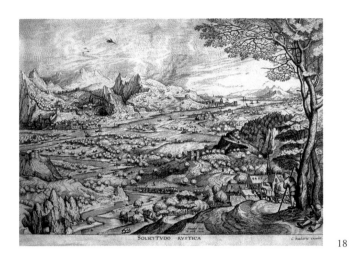

SOLICITVDO RVSTICA

C Bockiers excudit

18

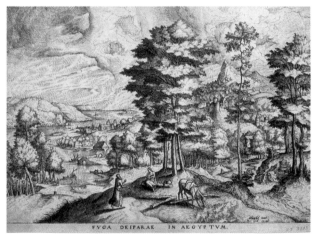

FVGA DEIPARAE IN AEGYPTVM.

20

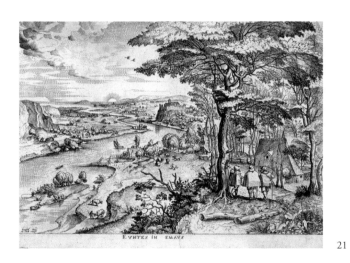

EVNTES IN EMAVS

21

PAGVS NEMOROSVS

23

MILITES REQVIESCENTES

24

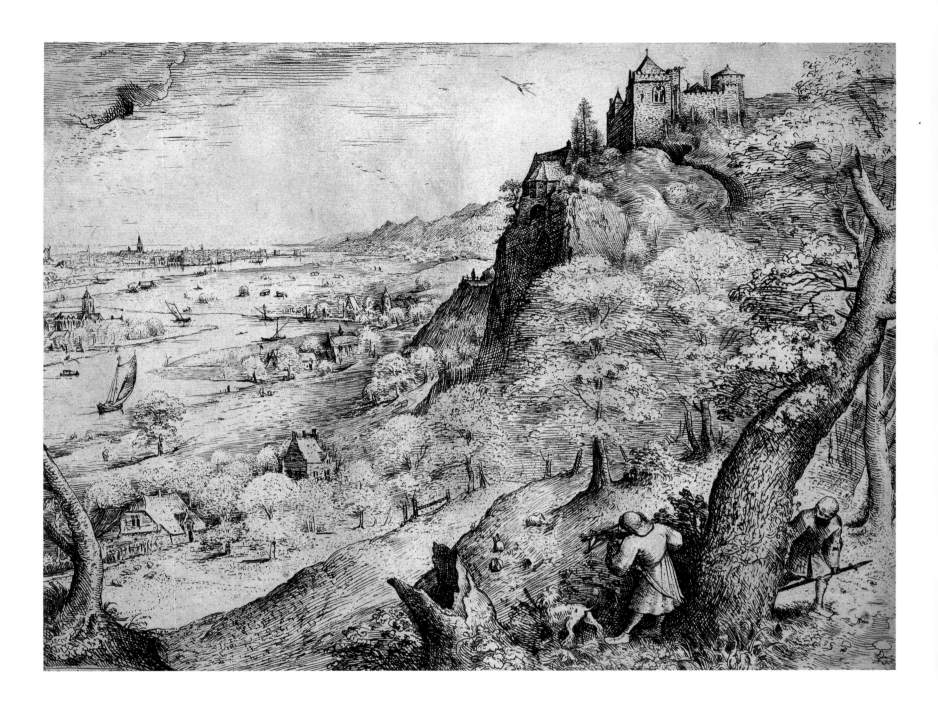

25 *Rabbit Hunt*, 1562 (?)
Etching, 32 x 42.5 cm
Cabinet des Estampes, Bibliothèque Royale
Albert I, Brussels

The origin of this etching raises questions not only because
of the extraordinary fineness of line and variety of
hatching, the dating is also doubtful. Compositionally, the
print is close to the early landscapes, though spatially
better motivated. Thus the hill on the right increases in
denseness up to the castle, without simple overlappings
being formed by sundry spatial wedges.

A post-1560 painting of the Bay of Naples, called
Sea Battle outside Naples Harbor (ill. 27), which is now
in the possession of the Galleria Doria Pamphilii in
Rome, suggests that Bruegel's journey took him to
southern Italy. It is probable that he traveled as far as
Reggio di Calabria, at the tip of the Italian boot, and
from there possibly on to Sicily. There is a large-format
engraving of the Straits of Messina showing a sea battle
(ill. 28); very recently, an associated original drawing
has come to light. In both cases, the topographical and
townscape similarities are not so striking that the
drawing could only have been done on the spot. It is
quite conceivable that Bruegel worked from existing
drawings whose scenery and landscape that he embel-
lished with atmospheric touches. Basically, raised view-
points overlooking the water demand a mental
translation of the coastal scenery by the artist. Whether
this interim stage is based on real observation of the
places from the water or from the land side, or
otherwise from views and maps, cannot be established.

Certainly the mole at Naples has been proved to have
been rectangular, not curved as Bruegel shows it.
However, the curve fits the composition better than
the original rectangular shape, which would have upset
the sweeping line of the coast, and therefore the devia-
tion must be seen as a compositional feature. Such a
reworking cannot serve as proof that Bruegel did not
know Naples personally.

If the notion that Bruegel must have seen landscapes
and regions with his own eyes is followed, he would
also have to have been to Norway: in the *Rest on the
Flight into Egypt* (ill. 30), Joseph is looking down from
on high over a distant prospect of fissured islands and
coastal ridges, while the horizon wraps itself left and
right round a promontory. There are steep cliffs, and
yet the impression that the region is populated and can
be traveled through is given. The refugees resting in the
foreground reappear simultaneously in the distant
center ground. The drawing itself bears no date, but
has been dated among his earliest works to 1553/54,

during the period before Bruegel's experience of the Alps. The composition must accordingly be dependent on graphic conventions that could be learnt in a workshop. And indeed, the obliquely placed foreground with the tree recalls similar arrangements in Cornelis Massys (1505/08–1560), or miniatures by Simon Bening (1483–1561). Both of these lack, of course, Bruegel's sense of dramatic juxtaposition, the amplitude of space arching over from the foreground, as well as the panoramic expanse.

In the drawing in Berlin, Joseph sits semi-recumbent on the slope looking out over the distant landscape. This makes him a figure of identification for the viewer, and can be taken as a visual metaphor for the relationship between rest and the enjoyment of landscape. Attempts have even been made to make him the founding figure for Bruegel's Stoicism. Artist and viewer would, therefore, face the world in Stoic contemplation, in the same way that Joseph reclines on the slope meditatively observing it. In this view, the counterparts of this contemplative attitude to the world would be busy peasants, as an expression of the active life in contrast to the passive one. Yet what is offered as landscape seems easily to escape the moral dichotomy: work is not depicted anywhere. Everything appears grouped around the town on the slope, visible in the center of the picture. The town is made up of clear, rectangularly-shaped buildings that recall the monastery in Bruegel's *Landscape with Italian monastery* (ill. 7) discussed earlier, that is to say, they are simi-

larly Mediterranean in character. A subtle light is cast over the town, which Bruegel achieves by adding touches of a reddish color. To the left a reddish halo extends across the water, which gradually fades to the right. The sun, which is lying low on the horizon as an invisible source of light and is just out of sight outside of the picture, must account for this. Possibly even in this, which may be considered his very earliest drawing, this heralds the quality that was later to make Bruegel famous – especially after his *Months* series appeared in 1656 – the creation of a sense of mood in the landscape.

26 Giulio Clovio
Farnese Book of Hours, 1546
Tempera on parchment, 10.2 x 17.8 cm
Pierpont Morgan Library, inv. M 69, fol. 104v/105, New York

Repeated attempts have been made to prove that Bruegel collaborated on books painted by Giulio Clovio. Certainly the two artists knew each other and even painted a small picture together. However, the *Farnese Book of Hours* was already finished when Bruegel came to Italy. Landscapes in the margins, such as those shown here, are executed in a looser style, but the atmosphere of Bruegel landscapes structured into increasing, different spatial depths is altogether absent from Clovio.

27 *Sea Battle outside Naples Harbor*, ca. 1563
Oil on panel, 39.8 x 69.5 cm
Galleria Doria Pamphilii, Rome

This view of the Gulf of Naples was not created until after
Bruegel's trip to Italy. Presumably he visited the place
himself, but for this painting he drew on older printed
prospects of the city.

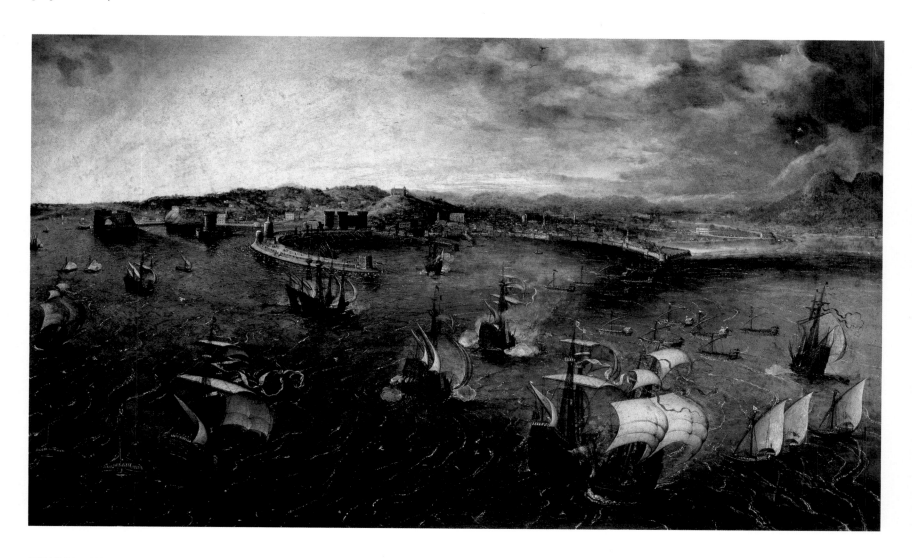

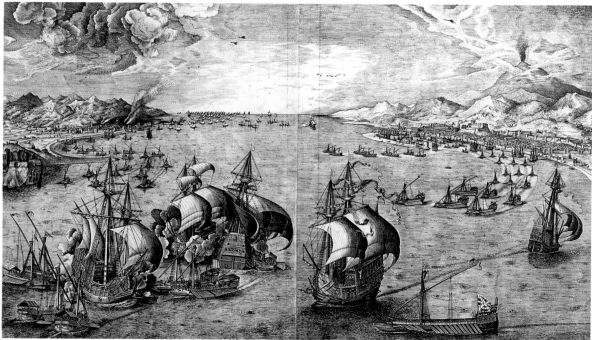

28 (left) *Sea Battle in the Straits of Messina* (detail), 1561
Copper engraving, 42.5 cm x 71.5 cm
Gabinetto dei Disegni e delle Stampe, Galleria degli
Uffizi, Florence

This is Bruegel's largest printed work, and as was
commonly the case with maps, consists of two sheets
joined together. More recently a smaller drawing without
ships by Bruegel has come to light, which shows the towns
opposite each other across the strait.

29 (opposite) *Sea Battle outside Naples Harbor* (detail
of ill. 27)

The depiction of ships follows contemporary fashion.
More than a dozen engravings of much less art-historical
importance have been preserved on which Bruegel
is named as the draftsman in question. They show
naval ships and merchantmen almost to full page size,
but Bruegel did not produce a single view of any
historic battles.

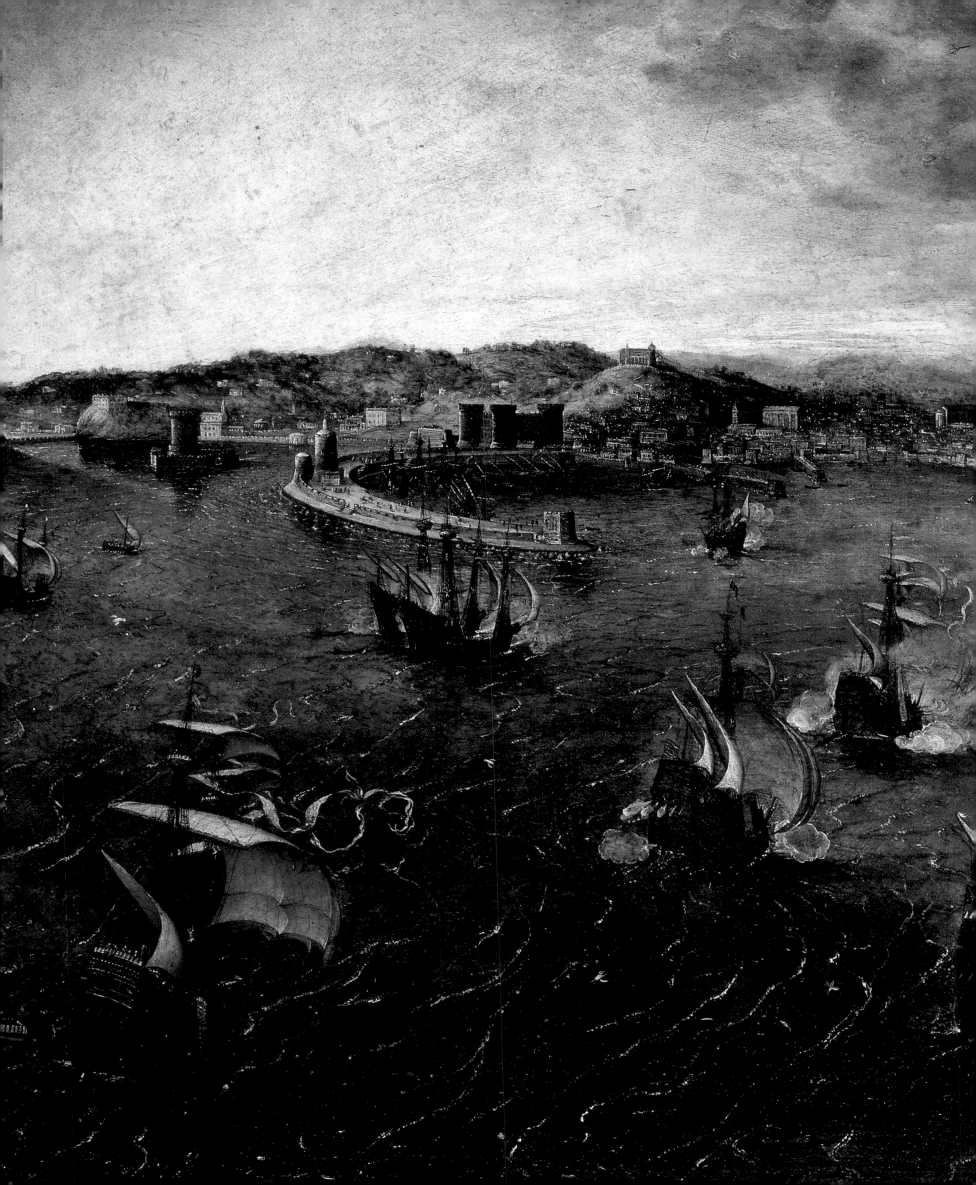

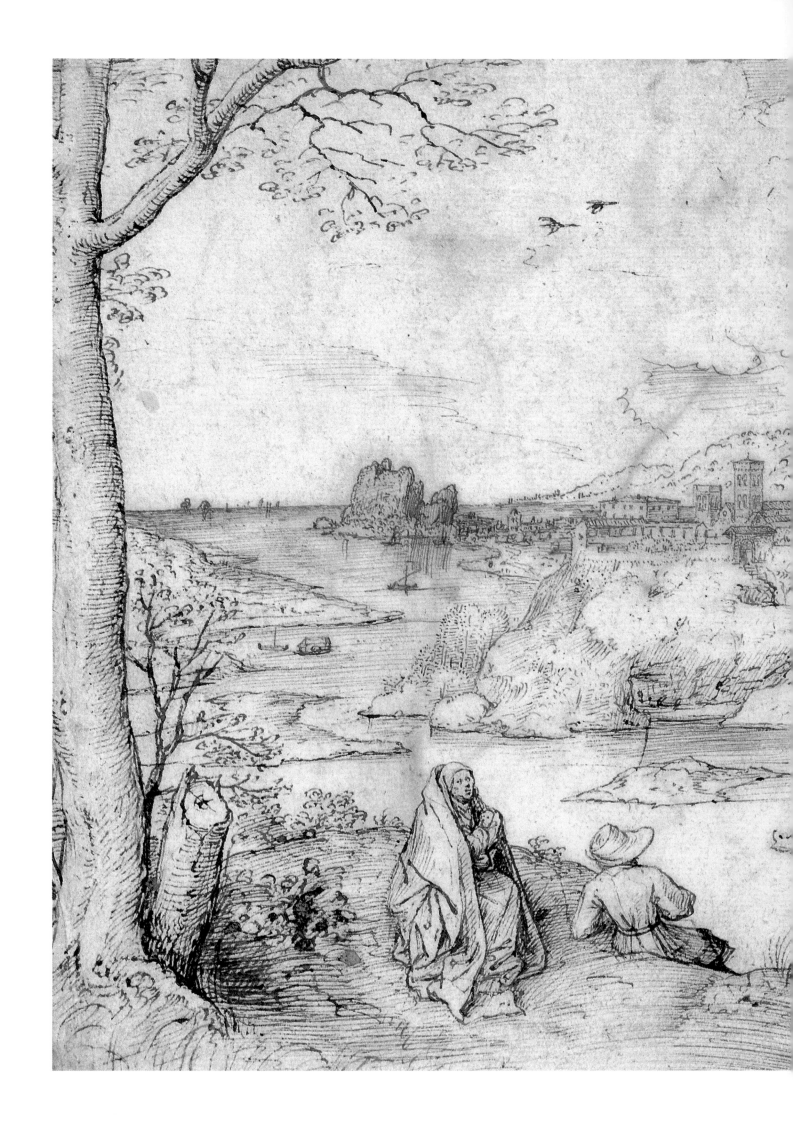

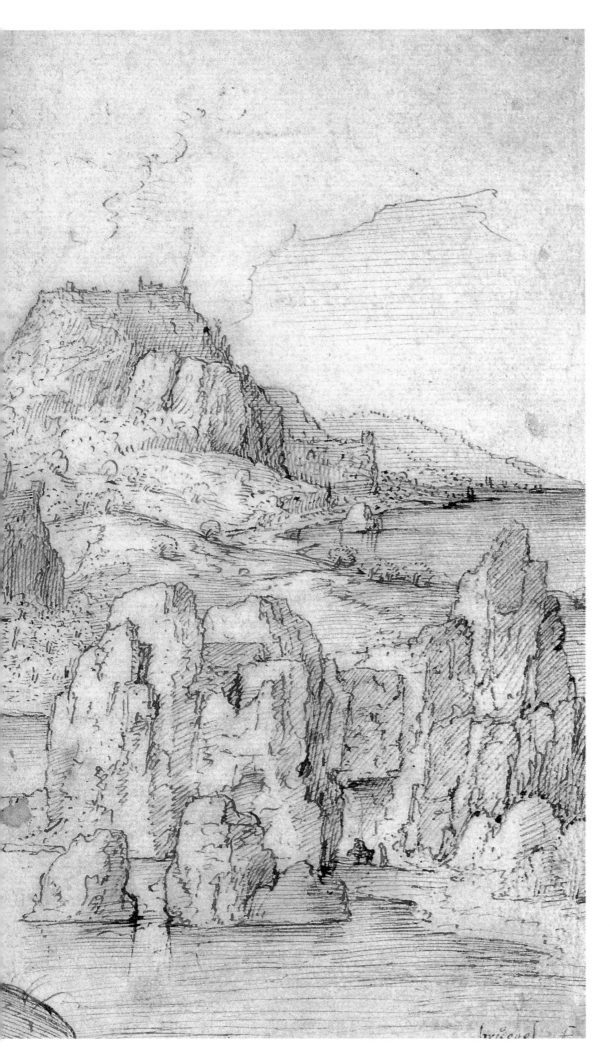

30 *Rest on the Flight into Egypt*, 1553/54
Pen drawing in brown and reddish ink, 20.3 x 28.2 cm
Kupferstichkabinett, Staatliche Museen zu Berlin – Preußischer
Kulturbesitz, Berlin

The Holy Family's rest is among the most successful of devotional
subjects of the late Middle Ages. Usually Mary sits on a bank while
Joseph deals with the donkey or food. Bruegel's narrative is more
incidental, with repose being subordinate to the effect of the
landscape. Mary is resting in her traditional pose, her cloak acting as
a border between her, the child, and the broad expanse of landscape.
Joseph, however, is shown like a casual migrating apprentice from
other pictures by Bruegel. With his back to us, he looks into the
distance, whereby he becomes a figure of identification for the
viewer, and can be taken as a symbol of the relationship between rest
and enjoyment of landscape.

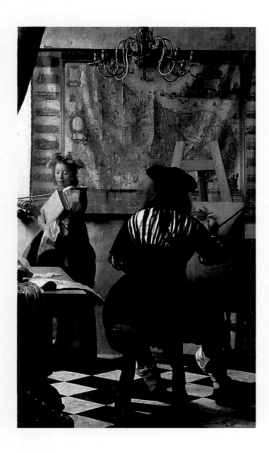

31 Jan Vermeer van Delft
Painting (detail), 1660–1670
Oil on canvas, 120 x 100 cm
Kunsthistoriches Museum, Vienna

Vermeer has Clio, the muse of History, posing for the
painter in front of a map showing the seventeen provinces
of the Netherlands. The country no longer looked as it did
in Nicolas Visscher's map, following the division in 1581:
the geography shown was already history in Vermeer's day.
The map features as an attribute of Clio even in a picture
of the painter, thus allegorizing history.

In the days before airplanes, the desire to "see the world
from above" was linked with sweaty ascents. Most painters
who presented a landscape from above showed fictional
landscape views, as if they had viewed real places and
regions from the top of a tower or mountain peak.
Bruegel's little painting with *Two Monkeys* (ill. 135) uses the
result of such imaginative effort as a background –
Antwerp seen from above, from the Scheldt, even though
only flat terrain surrounds the city. The *Suicide of Saul*, with
the surroundings of the mountain of Gelboa, is likewise an
example of geographical fiction (ill. 74). Neither Bruegel
not Abraham Ortelius, who had drawn a map of the Holy
Land at the time of the Old Testament, ever went there.

For a nation of seafarers, cartography was fundamental.
Voyages of discovery had from time to time gradually filled
in some of the gaps in the imprecise data of existing
cosmographies. Nonetheless, the old maps by Ptolemy of
Alexandria (90–168 A.D.) went on being reprinted until
well into the 16th century. In 1406, his principal work
Geographia was translated into Latin. It was first printed in
Vicenza in 1475, though various editions also included
contemporary maps. Yet new books of maps were eagerly
awaited, and not only for practical and commercial reasons.
Of course the first map of 1507, in which the cartographer
Martin Waldseemüller (1470–1518/1521) documented
the discovery of America almost correctly and named the
territory after the Italian seafarer Amerigo Vespucci
(1451–1512), was even then a collector's item. Many
maps were hand-colored, embellished with allegories, or
elaborated with text.

No names are more intimately associated with the radical
change in geography and cartography than those of
Abraham Ortelius (1527–1598) and Gerhard Mercator
(1512–1594). Both had their publishers in Antwerp, where
in the mid-16th century there were in all six important
printer–publishers doing business in land and sea maps.
Copyright was of little account at that time. Privileges that
served the same end had time limitations and had no effect
outside the dominion where they were cultivated. Buying
and copying was thus a lucrative business. Ortelius himself
began as a map dealer, where he gained his competence as
an editor of his own, though not really original, books of
maps. Made rich and famous as a cartographer as a result
of his world atlas *Orbis terrarum* (1570), the humanist
included Bruegel posthumously in his *Liber amicorum*. He
was classically educated, learning not only Latin and Greek
but also Hebrew. His correspondence forms part of the
sources of Lowlands humanism, as he was in contact with
important thinkers, publishers, and clerics throughout
Europe. Despite his well-known liberal attitude in religious
matters, he was nonetheless appointed cartographer royal
by Philip II in 1573. Yet his flight to England in 1577
confirms that he was not sure of this protection. He has
been described as not belonging to any church, without
intending to suggest that he was an atheist.

Abraham Ortelius lost his father while still young, and
as a young orphan was soon forced into working in the
antiquities business continued by his mother. As a map
painter, he became a member of St. Luke's Guild in
Antwerp in 1547, where Bruegel may have become
acquainted with him. His own interests soon attracted
him to old coins, which he collected but also sold and
later even published in a book. In the 1550s, he went to
Italy several times on business, and his first maps
appeared in the following decade. Initially there was
nothing unusual about these, as they were market-
oriented and made use of existing map materials.
However, even at this time he must have been working on
an ambitious project, the *Theatrum orbis terrarum*, his
world atlas, which appeared from 1570 in ever increasing
print runs and new editions. This work was indeed some-
thing new of its kind: the map formats were standardized,
and the added geographical descriptions and a list of
place names were comprehensive. Ortelius named various
colleagues who had provided indispensable help for place
names according to region. His correspondence is also
extremely interesting in this respect. His great project
came to fruition in the 1580s. It is a succession of histor-
ical maps that followed geographers of antiquity, such as
Strabo the Greek (63 B.C. to 26 A.D.), who was also
thought highly of by the Romans, and statements by clas-
sical authors and, not least, quotations from the Bible.
This work is appended as an accessory, or to give its Greek
title, a *parergon* to the great *Theatrum*. In these maps of
Italy, Greece, and Israel, it becomes increasingly apparent
how important it was to Ortelius in his cartography that
he should not only provide a correct geographical repro-
duction but also reflect a humanist view of the world.

Mercator, whose friend he was, provided substantially
more accurate graduations and could thus define places
more precisely according to degree of longitude and lati-
tude. For navigation, his work, which did not appear until
1590, was the better choice. The legend goes that, out of
consideration for his younger friend, Mercator delayed the
publication of his own work. On the other hand, the
protracted genesis even of Ortelius' maps makes it quite
clear that scientific cartography was no speedy business
at that time.

Sought-after collectors' items were above all the large-
scale wall-maps. The size of the largest paper, folio, was
determined by the process of paper-making; the *papier
mâché* had to be movable by a single person in a wooden
frame. The result was a sheet that measured approximately
60 x 70 cm. Still larger maps were created by joining several
sheets together. However, as these were difficult to handle
and also were fragile, they were frequently glued on to
either walls or cloths, which ultimately led to their rarity
today. The first reason was, of course, that glued maps
could not be removed undamaged, the second being that
the glue itself damaged the paper. These maps often occur

in 17th-century paintings as part of the furnishings of a room. Cartographic subject matter also became popular in frescos for villas. Oriental carpets, tapestries, stained glass windows, and wall-maps themselves were indications of great wealth, but unlike the others, the maps indicated "objectively" a degree of cosmopolitanism and education on the part of the possessor. Vermeer's allegory of painting is undoubtedly the most famous example of this (ill. 31).

Cartography attracted particular attention in the area of history painting. The motto *Geographia oculus historiæ* (geography is the eye of history), with which Ortelius prefaced the parergon to his atlas, found opinions divided. History seemed most directly accessible in historical places, in that the *genius loci*, or spirit of the site, imbued the present location with its famous history. Both Bruegel's gaze on regions that he cannot have observed from such a vantage point and Ortelius' design for a world atlas, few

places in which he knew personally, are directly comprehensible as reality-based conceptions. Their view of the world seems so close to the modern perception that its divergence from symbolic representations of the world as a disk with Jerusalem and Christ as the center must, in conclusion, be particularly emphasized. For the collective consciousness of 16th-century society, the circumnavigations of the globe and new models of the real face of the world taken from them must have been a great challenge. Hell could no longer begin at the edge of the earth; the earth was not even perceived as the center of the universe any more. With this age of expeditions and discoveries, the age of Reason also seems to begin. It calls for thinkers such as Giordano Bruno (1548–1600) or Galileo Galilei, but also for artists whose pictures build bridges between old and new ways of seeing, and thus offer a half-way stage in the mental absorption of the "new world."

32 Abraham Ortelius
Theatrum orbis terrarum, The Ancient Map of the World Book illustration, London 1606 (facsimile, London 1973) Staatsbibliothek zu Berlin – Preußischer Kulturbesitz, Berlin

The map is supposed to illustrate how antiquity viewed the world. It is included among the historical maps that Ortelius added as a supplement or parergon to his great atlas. All these representations arose after a comprehensive study of classical authors, and also the Old and New Testaments. In the 16th century, there was great historical awareness of the nature of global images as models to imitate and the importance of voyages of discovery.

EARLY PAINTINGS

33 *Landscape with the Parable of the Sower*
(detail of ill. 34)

When Jesus gets up to preach, he attracts such a large crowd that he resorts to a boat that serves as a floating pulpit. In its present "restored" condition, the figure of Jesus will be sought in vain. The figure may have been lost in cleaning, as the whole upper part has suffered greatly.

In the early work of Bruegel there is a preponderance of drawings and prints compared to paintings. This imbalance in favor of graphic work may go back to the crisis in painting in the Netherlands, and the offer to Bruegel to work with a publisher of prints and begin a new type of career as an "inventor of pictures" for an educated urban public. However, among pictures reckoned as early works, according to the present state of our knowledge, there are also Biblical landscapes, of which few have been preserved and which in comparison with the multi-figured and large-figured paintings of later years appear positively unprepossessing. However, in terms of landscape they are just as fascinating, for example the early drawing *Rest on the Flight into Egypt*, and in color and atmosphere even richer than the later paintings.

Many panel paintings have been lost because they did not match the favored Bruegel type that collectors had discovered already during his lifetime and definitely shortly after his death: the peasant Bruegel or "Pier den Drol" (Peter the Droll). It is possible that with his drawings Bruegel may have discovered a clientele who were rich enough to go on later to commission works in oil. In particular, the newly-rich burghers of Antwerp and Brussels seem to have possessed an increased thirst for display, which Bruegel's urban views and landscapes and his modern re-interpretations of traditional subjects satisfied. The early landscape paintings by Bruegel occupy an intermediate position. Compositionally they are close to the global landscapes of Joachim Patinir, but they link them with New Testament parables that had not been previously depicted in this way.

The earliest dated painting by Bruegel, the *Landscape with the Parable of the Sower* (ill. 34), is now in San Diego, California. It shows a hilly landscape that leads from a shady slope across a river running diagonally towards a chain of mountains. The farmer in the foreground is busy sowing on poor soil. Other figures are found in the fields and trees in the far distance, or talking and picking fruit. A man is relieving himself. The actual subject matter, the New Testament parable of the sower, can only be discerned from the background, where a crowd of people by the river indicates the preaching Jesus (ill. 33). The sermon is about a peasant, who appears in the foreground of the picture as a parable. Earlier illustrations preferred to deal with the more popular of the farming parables, which was easier to moralize: the parable of the devil who sows weeds in the furrow of the hard-working farmer. God's reply to the latter's question as to what the farmer should do with the weeds, was that he should look after them all until harvest day, that is the Day of Judgment, had arrived.

The opening words of the parable – "Behold, a sower went forth to sow" – draw attention to the parable style, because talking in parables means talking visually. Bruegel attempts to recreate this "picture" with his painting. Jesus continues, "And when he sowed, some seeds fell by the wayside, and the fowls came and devoured them up. Some fell upon stony places where they had not much earth, and forthwith they sprang up because they had no deepness of earth; and when the sun was up, they were scorched, and because they had no root, they withered away. And some fell among thorns, and the thorns sprang up and choked them. But other seed fell into good ground, and brought forth fruit; some a hundred-fold, some sixty-fold, some thirty-fold. Who hath ears to hear, let him hear" (Matthew 13, 3 ff.).

Bruegel expands this exemplary tale with further harvesting motifs. Someone is picking fruit, and in the left center ground a rider is passing the time of day with a reaper, who stands out in his white smock. As an analogy to his shady furrow, the sower is furnished with a broken wheel rolled into the front of the cottage: a negative attribute of the goddess Fortuna. The minuteness of these scenes and motifs lends the overall pictorial scheme a sense of balance, and parable and painting coincide in this. The three-part parable continues with a discussion of why Jesus speaks in parables and compares the situation of the disciples with that of the Old Testament prophets. The latter spoke wisely without really understanding – the Savior had not yet come nor the seed sprung up. Real understanding happens in the Christian view only by virtue of the arrival of Jesus and with the fulfillment of the Old Testament by the New Testament.

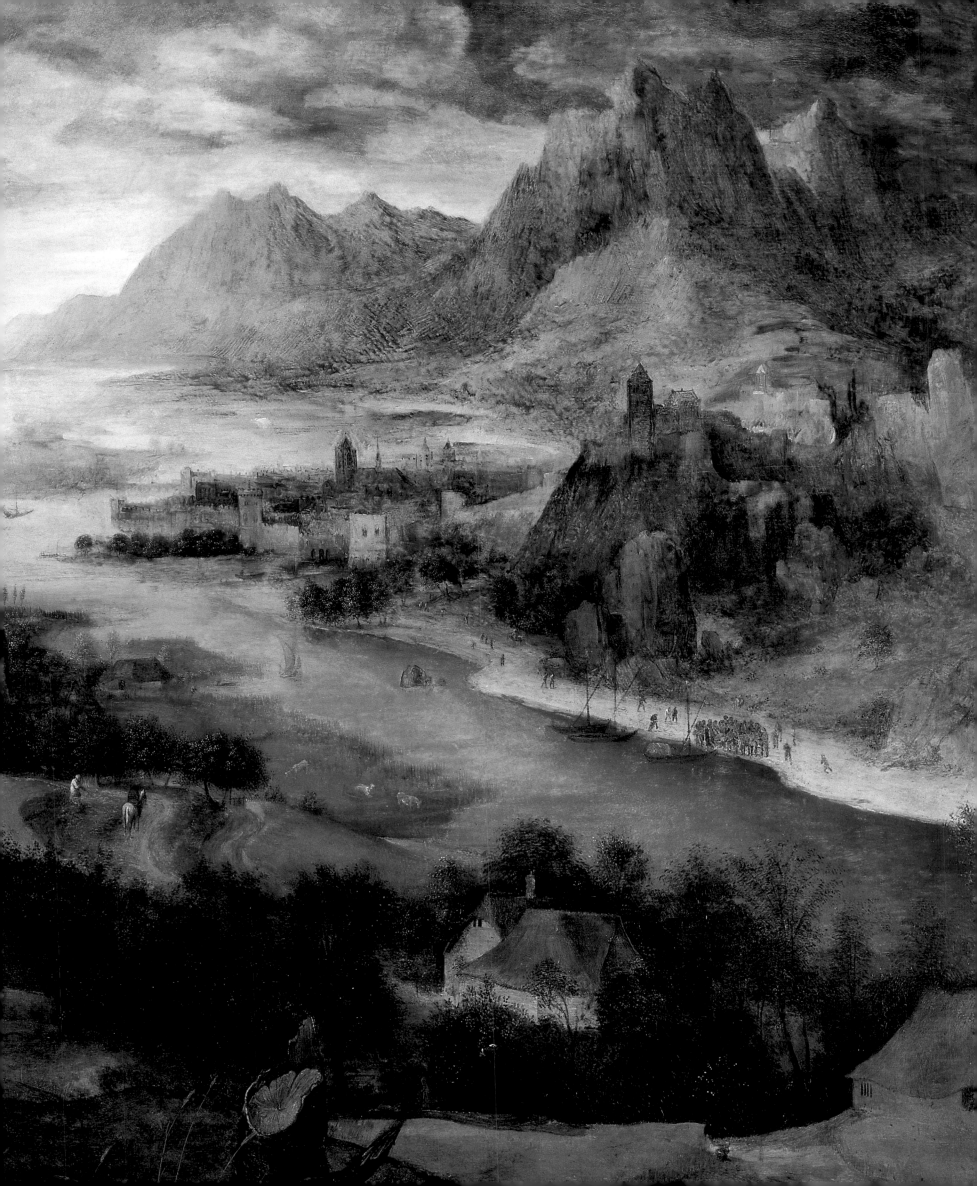

34 *Landscape with the Parable of the Sower*, 1552
(or 1557)
Oil on panel, 70.2 x 102 cm
Timken Museum of Art, San Diego

Paintings about the parables of Jesus first appeared in the
16th century, previously only the important events in his
life having been painted. The parable is about corn and its
variable yield: sometimes the seed falls on stony ground,
sometimes by the wayside, sometimes on fertile soil,
entirely as the Lord wills. On the left, a peasant with a
sowing apron walks down his shady field. It is no mere
chance that a broken wheel (of fortune) stands outside his
house. To the right at the rear, in contrast, someone will be
reaping a fine harvest even though he clearly squats idly at
the edge of the field. The parable refers to the Word of
God, which like the crop does not always bear fruit. It
urges the believer to be patient.

St. Matthew begins his Chapter 13 with Jesus sitting
"by the seaside." Bruegel does not take this literally
because he shows a river. But he does show the "ship"
in which, according to the gospel, he finally "went and
sat" so that the unexpectedly large crowd that "resorted
unto him" could hear him better, and thus makes a
recognizable allusion to the Biblical situation. Alas, the
viewer's eye seeks in vain the figure of Jesus in the boat.
This may have been lost during the course of a later
restoration, which unfortunately affected the whole of
the background.

In Bruegel's depiction, the relationship between the
sermon and its parable content, which is both unfolded
and enshrouded in mystery simultaneously, involves the
whole landscape, and is particularly forward-looking
for Bruegel in its neglect of the figure of Jesus. He
followed the same procedure later in moving Saul or
Icarus to the margin of landscapes. Their "powerlessness"
is thus presented all the more dramatically (ills. 74,
113). In the parable of the sower, the essential point is
to give revelation time to germinate and bear fruit that

will come with Jesus. Landscape and viewer waiting for
the fulfillment form an alliance in which the landscape
artfully conceals the speaking in parables and thus in
turn, like a parable, holds the sense in suspension. The
landscape itself becomes a parable.

In the *Flight into Egypt*, dating from 1563 and now in
London, Bruegel adopts the widespread motif of the
road that passes the heathen statues (ill. 36). The statues
were said to have been thrown off their plinths by the
Savior's arrival. The group of subjects associated with
the Holy Family's flight into Egypt to escape Herod's
troops was very popular in the 16th century, even
though the treatment in the gospel (Matthew 2,
13–23) is very brief. More details are contained in the
apocryphal Arabic Infancy Gospel and in the Gospel of
Pseudo-Matthew. The rest on the flight, the miracle of
the corn, and the escape route past the falling heathen
idols were often painted. The flight from King Herod's
persecution was a prime subject for landscape painters,
although it was never the regions they passed through
historically that were depicted but cultivated landscapes

with improved variety and denseness, a type of landscape called "world landscape" since the beginning of the 20th century. Often, Mary is shown sitting on a grassy bank with Joseph to one side busy with domestic duties. In a small painting by the Flemish painter, Gerard David (1460–1523), from around 1520 in the National Gallery in Washington, for example, Joseph is knocking edible chestnuts from a tree. Yet Bruegel gives as the only clue to the subject of the picture – apart from the Family – the idols falling from a wayside shrine. None of the miraculous effects reported in the Pseudo-Matthew gospel are depicted, which Patinir could still combine all together in a "simultaneous picture." Bruegel's composition obeys the rules of overview landscapes, which use a high-placed foreground as a stage to motivate expansive views into the distance. Bruegel avoids two dangers of this pictorial approach: he conveys this 'stage' by means of the landscape, by having it recede on the left into several spatial planes, that is it intersects the distant prospect less abruptly than on the right. In the foreground, he avoids excessive proximity, which could endanger the development of atmospheric depth in the landscape; the pictorial plane is far enough away from the viewer to be in keeping with the small-scale figures.

Van Mander himself reports of Patinir that he was a landscape specialist and had his figures painted by the Flemish painter Joos van Cleve (ca. 1485–1540/41). Such specialization indicated a radical change in the art trade, which now hardly worked at all on a commission basis but offered independently produced works for sale in a competitive market. In the first half of the 16th century Patinir was one of the best sellers, so that others recognized similar sales opportunities for themselves. The "world landscapes," among which Bruegel's *Flight into Egypt* can be reckoned, appear schematic in many ways (ill. 36). Patinir's rock faces, which he is supposed to have studied in the vicinity of Dinant, often recur. Still greater is the adherence to a standard ground coloration: the picture is always structured brown, then green, then blue, moving from fore to background. Of course, various fields and meadows, rivers and towns are strung together accurately as charming details, as if to say "this is habitable country." Yet nowhere do we get real distance, which might also convey either the weather or the season.

The *Magpie on the Gallows* (ill. 39) is usually considered a late work because it carries a dating alongside the signature which is read as 1568. The date, however, may easily have been a misunderstood touching up by an alien hand, relying on van Mander's mentioning the picture as part of the artist's legacy to his wife, which thus moved its creation into the period shortly before Bruegel's death. However, the small format of the landscape, together with the steep overview composition, put it temporally in the 1550s, in the vicinity of the early landscapes.

In the small landscape painting with its exceptional, almost square format, Bruegel offers the viewer no less than six scenes. First the viewer's eye strikes a large gallows in the middle, which divides the picture into two very unequal pictorial halves. On the left of it then can be seen a group of three sturdy peasants holding hands and dancing. Details such as the small swinging bag and bobbing folds of the heavy, red skirt fabric indicate music with a swift rhythm and a bouncy melody. Behind the dancers Bruegel shows a bagpiper trudging up the path. From here, the eye either trails on down the path towards the little town in the center ground where, despite the diminutive format, the eye easily makes out the busy street scene. Or, alternatively, the music carries the ear round two stubby pastures to another dancing couple and the two men standing with their backs to us. One of them is carried away by the music and is tapping his foot. The other, in bright red trousers, is pointing to the distant landscape. There, a river winds round a broad valley, and boats are sailing towards a town at the foot of steep mountains, which are already enshrouded in the haze of distance.

On the right below the gallows, at the bottom of the slope, stands a farmstead with a water mill, behind which stretch river and valley. Although large areas of the picture are dominated by the course of the color perspective – which moves from brown, through green, to whitish blue – the representation is extremely vivid even in its coloration. Bruegel's style assists in this, especially the shimmering points of light striking the leaves, the churned-up earth of the path, and also the few brilliant colors. They achieve prominence by the contrast they make with the brown tones that dominate the picture: a white jacket, bright red trousers, the shiny blue of an apron, a white coif. In the center ground, too, Bruegel distributes these colors with minimal space as well as great compositional skill.

With all this liveliness dotted around the landscape, the great gallows, which dominates the near ground, appears to forfeit its menacing quality. The timbers are so twisted that the gravity of the execution site becomes lost. Neither the magpie sitting on it nor the dancers, nor indeed the man relieving himself in the left foreground corner seem to worry about the gallows, the animal skull, or the cross. So far, no conclusive interpretation linking the events in the foreground has been offered. Van Mander suggests the moral "anyone who chatters like the magpie sitting here on the gallows will end up on the gallows." This is a far-fetched interpretation, because no danger threatens the magpie from the gallows, and even the dancers are not influenced by their presence. The dancers could come from Bruegel's proverbial vocabulary and be "gallows birds" (ill. 63, no. 116), but ultimately, even the landscape provides no support for a negative interpretation of the execution site.

35 Simon Bening
Hennessy Book of Hours, March
Calendar miniature, MS II, 158, fol. 9v.
Cabinet des Manuscrits, Bibliothèque Royale
Albert I, Brussels

The subject of the farmer with a sowing apron is connected with the parable of the sower (Matthew, Chapter 13). This picture is frequently found in lay prayer books (books of hours), although without the relevant text from the New Testament.

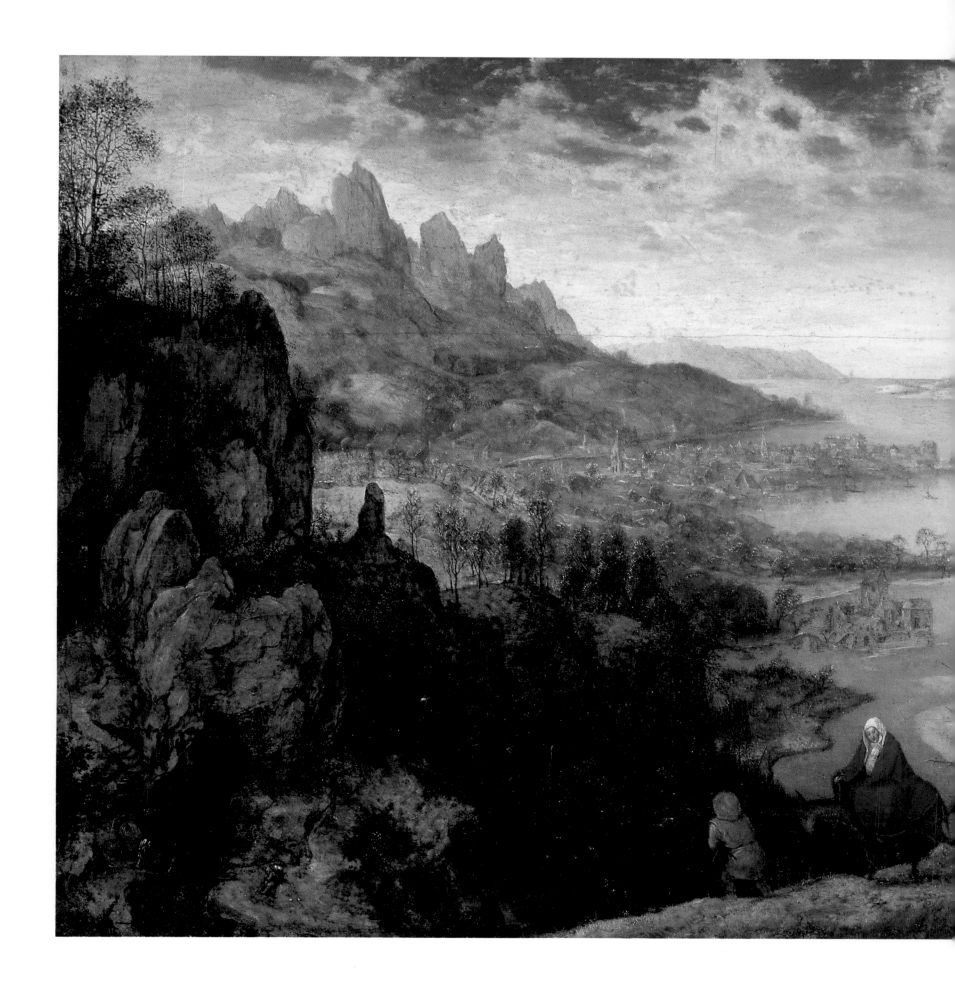

36 (left) *Flight into Egypt*, 1563
Oil on panel, 37.2 x 55.5 cm
Courtauld Gallery, London

Thematically, the *Flight into Egypt* is connected with the *Massacre of the Innocents* (ill. 84). While the Family is escaping the threatened massacre, Herod is systematically killing all babes and sucklings in order to circumvent a prophesy of a new king. Formally, the two pictures have nothing in common. Instead of winter, it is probably spring or the fall in this picture. Nor does anything refer to Egypt, although the fall of the idol from the wayside shrine is intended to signal the Christianization of a heathen country.

37 (below) Joachim Patinir
Rest on the Flight, ca. 1520
Gemäldegalerie, Staatliche Museen zu Berlin – Preußischer Kulturbesitz, Berlin

Patinir's landscapes, which as here reproduce the Earth in all its variety in saturated colors, became the archetypal "world landscapes," a term devised in around 1900 to express the cosmological content of these devotional pictures. More recent interpretations claim that this is a way of representing a world of continuous pilgrimage. The viewer's eye wanders through the landscape searching for a road to faith.

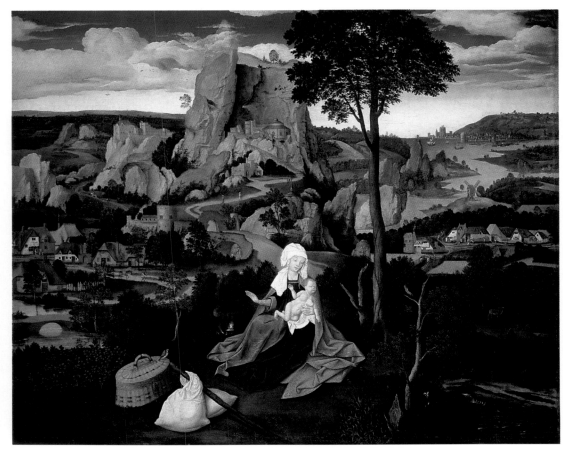

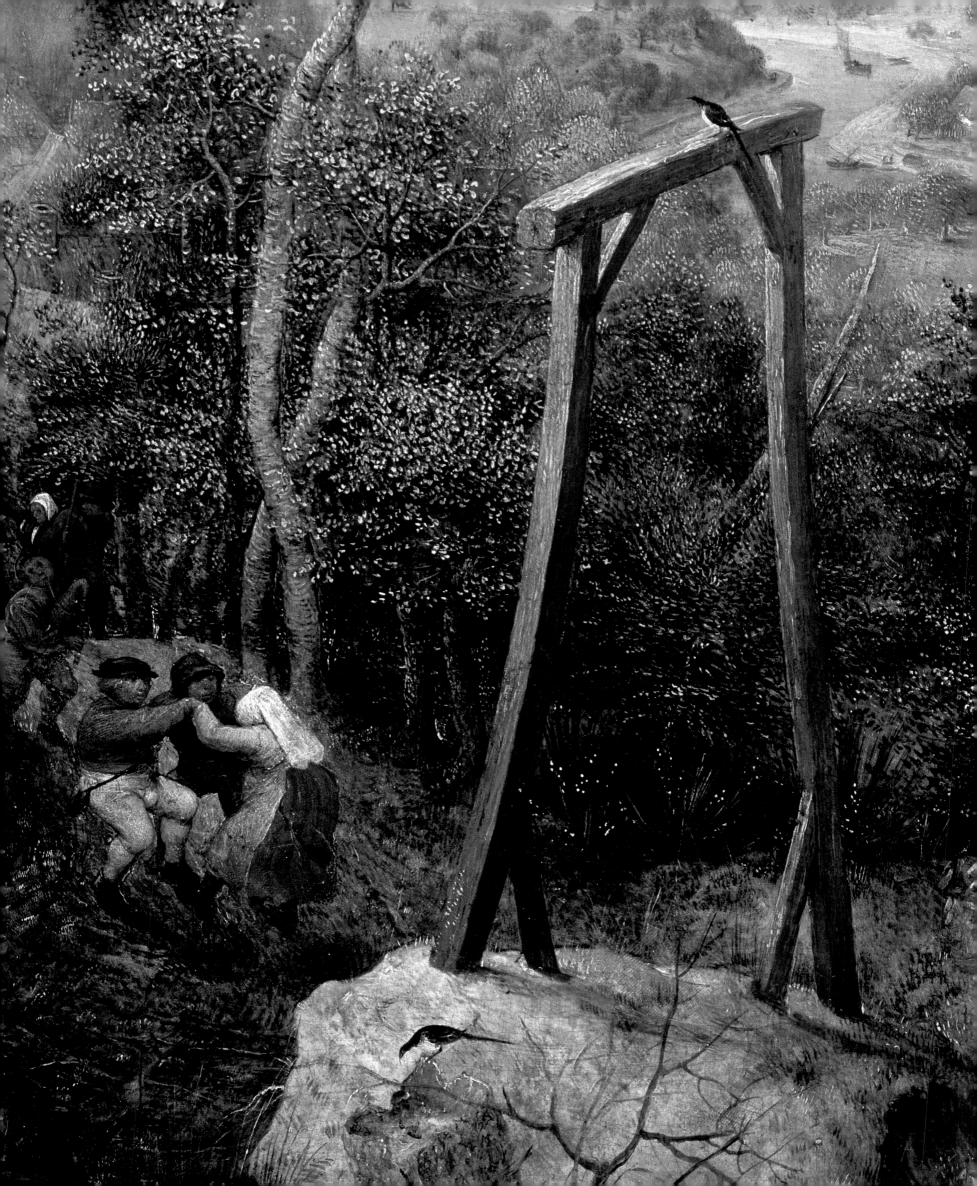

38 (opposite) *The Magpie on the Gallows*, (detail of ill. 39)

Few of Bruegel's titles date from his own time, but this is one of them.
Van Mander's *Life* named the picture in 1604 and wrote that the bird
on the gallows embodied malicious gossip; he said Bruegel
bequeathed the painting to his wife as he lay dying, with the intention
of warning her against malicious aspersions. Besides the magpie, the
dance beneath the gallows also has a proverbial character (ill. 63).

39 *The Magpie on the Gallows*, 1568
Oil on panel, 45.9 x 50.8 cm
Hessisches Landesmuseum, Darmstadt

The magpie is not the only motif in this landscape to offer itself as a
starting point for an interpretation: "shit on the gallows" and "play
on the pillory" complement one another, two popular turns of
speech shown by Bruegel in his *Proverbs* picture (ill. 64, nos. 82 and
116). But the moralizing sayings are contrary to the experience of the
landscape in the picture.

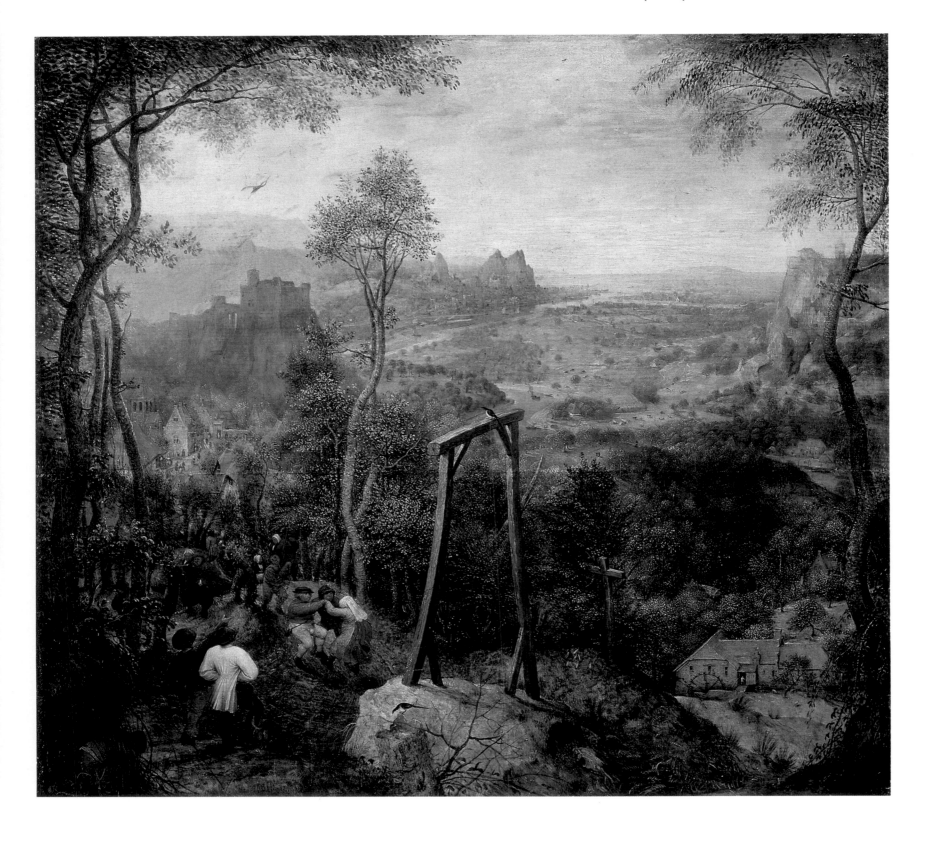

POPULATED PLACES – FANTASTIC FIGURES

More than any other virtue, Prudence belongs to the domestic sphere. She stands on her attributes of ladders and buckets between the prudent laying in of household stores on the left and care of the health of body and soul on the right. Meanwhile she holds a coffin and gazes in a mirror – not from vanity, but to know herself better.

Bruegel's works as a graphic artist, painter, and drafter of drawings for prints have each been the subject of separate monographs. This was an inevitable consequence of the volume of the different groups of works, but it tended to hinder an understanding of Bruegel's work as an artist and his many-sided talent, with its force of imagination that ignored technical frontiers. His drawings, of course, no more refer just to what is drawn any more than prints and paintings refer solely to internal features within the given technique. It is rather the case that the early landscapes share important features with the *Great Landscapes* series, which were sold as prints. Without the second extensive group of printed graphics, the *Virtues and Vices*, which Bruegel published through Hieronymus Cock in 1555 and 1557, we could scarcely understand the multi-figured masterpieces of around 1560, often described as "encyclopedic" – such as the *Battle Between Carnival and Lent* (ill. 57), *Children's Games* (ill. 60) and the *Proverbs* (ill. 63).

In the series of printed graphics, Bruegel expanded in many ways the old subject of virtues and vices, which in the Middle Ages had been personified as women. Thus, he endowed each of them with the surroundings of fantastic landscape features, and updated the attributes by which they had been recognizable for centuries. Yet his most important step was to furnish them with expansive landscapes, which in a way serve as psychic settings of the given trait. What the Greek philosopher Plato (428–347 BC) had described as a quartet of cardinal virtues (Temperantia, Prudentia, Fortitudo, and Iustitia) had been extended in the Middle Ages by the addition of three Christian virtues (Fides, Spes, and Caritas) to make a pantheon of seven (Temperance, Prudence, Fortitude, Justice, Faith, Hope, and Charity). The corresponding vices were Sloth (Acedia), Avarice (Avaritia), Despair (Desperatio), Discord (Discordia), Gluttony (Gula), Intolerance (Intolerantia), and Idolatry (Idolatria). However, both sets were added to and were not necessarily arranged in pairs. In medieval art, personifications of them were extremely common in sculptural programs on cathedrals, book illuminations, and both fresco and panel paintings.

Bruegel's handling of the figures dispenses with medieval limitations and analyzes the allegories handed down by playing with everyday experiences that are either vicious or virtuous. Every figure unites contrary aspects, or juggles with praiseworthy or deplorable qualities or conditions. This also demonstrates social understanding, since it is reasonable to perceive Hate, for example, as the lack of Love or indeed Avarice as the lack of Generosity.

The allegorical representations have ample space, and the traits to be described fill the pictorial landscape as a whole. Thus *Prudentia*, prudent foresight, stands between two houses in which provision is being made for harder times, namely the winter and the next world (ill. 40). On the left, an old man on his deathbed is preparing for his last hour, with doctor and priest in attendance. In the house opposite, meat is being salted and barreled, while various stores are being laid in. The personification in the center is supporting a coffin with her left hand, while in her right hand she holds a mirror. Her head is crowned with a sieve. She is capable of distinguishing between good and evil (indicated by the sieve), is familiar with death (the coffin), and, not least, capable of self-understanding (as shown by mirror). That Prudence stands on ladders beside a variety of buckets refers to the fire-extinguishing that Bruegel depicted in *Spes* (Hope) in the same series. In the foreground, a pious woman is extinguishing her cooking hearth with shrewd foresight. The landscape of *Fortitudo* (ill. 45) promotes both military preparedness and the strength of Christian faith. A four-towered fortress with draw-bridge and moat marks the center ground, while in front simple foot soldiers take up the struggle against the underworld; on the left, a hole in the ground disgorges monsters. Opposite, women fight off all kinds of domestic beasts with brooms, flax bobbins, and kitchen knives.

It was principally in respect of the vices that Bruegel drew on Bosch's motifs. In many early drawings by Bruegel, the latter is even named as the actual *inventor* of the subject matter. Cephalopods, flying fish, and menacing torture chambers appear in close succession. Even the deathbed scene on the left in *Prudentia* has a

H. cock excu. PRVDENTIA. Bruegel Inuento.

SI PRVDENS ESSE CVPIS, IN FVTVRVM PROSPECTVM OSTENDE, ET
QVAE POSSVNT CONTINGERE, ANIMO TVO CVNCTA PROPONE.

41 *The Seven Virtues, Fides*, 1559
Copper engraving, 32.4 x 42.8 cm
Cabinet des Estampes, Bibliothèque Royale
Albert I, Brussels
Fides (Faith) stands on an open coffin that symbolizes the
Resurrection of Christ, and which is surrounded by the
Instruments of the Passion (*Arma Christi*). The location of
this figured scene is a well-patronized church featuring a
sermon (right), wedding (front left), baptism (further
back), and communion.

42 *The Seven Virtues, Spes*, 1559
Copper engraving, 32.3 x 42.7 cm
Cabinet des Estampes, Bibliothèque Royale
Albert I, Brussels

Bruegel's Spes (Hope) feeds entirely on defeats and
catastrophes: shipwreck, captivity, fire, and floods are good
reasons to hope for a positive turn of fate. The
personification combines old attributes, such as the
anchor, with rural implements including a sickle, spade,
and beehive. Those on the wrecked ship stand in
existential contrast. The floating anchor on which Spes
is standing appears as an act of mockery defying the
sinking wreck.

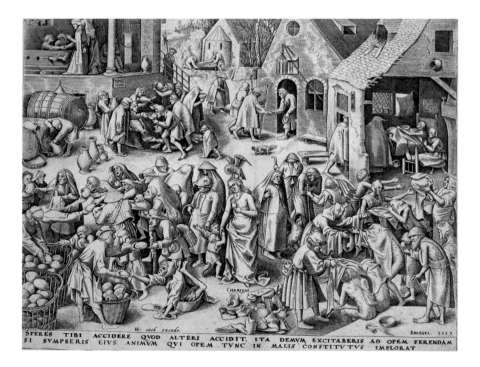

43 *The Seven Virtues, Caritas*, 1559
Copper engraving, 32.3 x 43 cm
Cabinet des Estampes, Bibliothèque Royale
Albert I, Brussels

Caritas (Charity) is a woman with a self-sacrificing
pelican on her head and a child in each hand. On the left,
bread is distributed to the hungry, further back thirst is
being quenched, and on the right clothes are being
provided and a sick person visited.

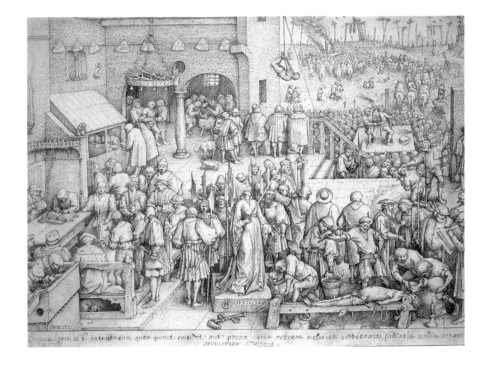

44 *The Seven Virtues, Iustitia*, 1559
Copper engraving, 32.4 x 42.7 cm
Cabinet des Estampes, Bibliothèque Royale
Albert I, Brussels

Justice is the virtue that the artist most noticeably
questions. He shows her with her traditional attributes of
bound eyes and the scales and sword of justice. However,
in her surroundings, armies, torture, mutilation, and
various capital punishments predominate, ranging from
beheading to burning at the stake. Alongside this, the
lawyers and clerks on the left appear inhuman in aspect.

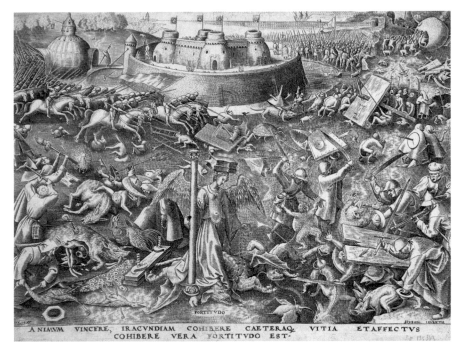

45 *The Seven Virtues, Fortitudo*, 1559
Copper engraving, 32.4 x 42.9 cm
Cabinet des Estampes, Bibliothèque Royale
Albert I, Brussels

Fortitude stands on a monster that she is subduing with a
chain. The symbol of her strength is the stone on her head,
while the column besides her is an image of her rectitude.
Here, the military as opposed to the spiritual aspects are
divided up, not in halves of the picture, but far and near, so
that in the foreground both soldiers and peasants are
fighting against animals and monsters.

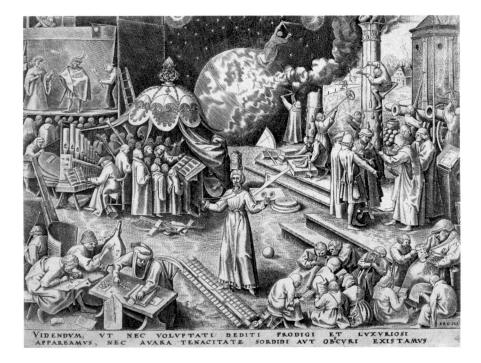

46 *The Seven Virtues, Temperantia*, 1559
Copper engraving, 32.3 x 42.9 cm
Cabinet des Estampes, Bibliothèque Royale
Albert I, Brussels

Temperance in Bruegel's view is clearly a question of
education: reading and writing, arithmetic and geometry,
singing and public speaking, astronomy and geography are
at home in her environment. She holds the reins of her
own bridle in one hand, in the other her glasses; she is
crowned by a clock.

corresponding item in Bosch's *Death of a Miser* in Washington. In the engraving of *Ira* (ill. 48), the personification of Anger bursts from her war tent with sword drawn and torch blazing. Accompanying her are homicidal warriors that are part human and part fabulous beasts. Two of them draw a grotesquely enlarged dagger across five figures that are lying naked and prostrate. Elsewhere, too, victims are laid bare, while on the tent of Commander Wrath two people are being boiled in oil, and in the tree house another is being roasted on a spit; in between all these stoops a figure whose floppy hat is equipped with a switch, which is a sign of jurisdiction, above a barrel in which, in the same way, murder is proceeding. The combination with the rod of justice may refer to miscarriages of justice and the particular harshness of vengeful punitive justice. The senselessness of wrath is abbreviated into a "picture within a picture" on the right, as a she-wolf and a frog engage in mutual destruction, which functions as an *aide-mémoire* alongside the other rather complex scenes. Nowhere is salvation in sight. Only the monk, ringing the tocsin in the tree house, and someone to the left of him bringing a ladder to the source of the fire provide a distant echo of more amicable relationships.

The compositions of the *Seven Vices* are more dense, compared with the *Seven Virtues*, and the number of figures and overlapping scenes is greater. The buildings often have human or plant shapes, their forms changing suddenly. The formal differences between the virtues and vices are so great that they should perhaps be considered not as a single series but as two separate series, conceived independently of each other, and also sold individually.

Up until thirty years ago, Bruegel's idiosyncratically realistic way of painting figures was explained by a collection of sketches whose figures were considered faithful studies of living persons. Significantly, this material became called *Naar het leven* studies, that is "life drawings" (ill. 56). For a long time, the drawings served both as a derivation and a transfiguration of Bruegel's genius, the artist who had studied his fellow men from life. In 16th century Netherlands it was by no means standard practice for artists to approach nature directly and in an unprejudiced manner. Neither Albrecht Dürer (1471–1528) in Germany nor Leonardo da Vinci (1452–1519) in Italy were benchmarks of their day – they were precursors. Painting would remain for some time an activity performed in closed rooms, and young artists were taught the rules of composition and imitation of earlier masters. Not until the 17th and 18th centuries did the ideal convergence of art and nature win through, a symbiosis effected in the actual artistic process. Today it is known that a later artist, for his own purposes, did the *Naar het leven* sketches from paintings by Bruegel, so that the sequence of events was quite the reverse of what had previously been assumed. Thus the color notes beside the figures refer not to the colors of the actual clothing but those Bruegel preferred as local colors for use as highlights in his pictures.

The re-attribution of the *Naar het leven* sketches not only created a lacuna in the Bruegel text, it also revealed a weakness of art-historical exposition. The search for similarities – and derivations based upon them – can be misleading if an artist such as Bruegel has his strengths in the transformation of subject matter and the combination of visionary pictorial settings. Isolated figures like those in *Naar het leven* show virtually nothing of this art. Yet in the *Virtues* and *Vices* Bruegel establishes his figures from their surroundings; he creates the landscapes that his scenes really need in order to look credible. This is also the main achievement of the multi-figured oil paintings executed in around 1560, often called "hustle and bustle" pictures by their devotees.

There are three oil paintings of approximately equal size that cram many of figures into a constricted area viewed from above. They are the Carnival picture, the *Children's Games*, and the *Proverbs* (ills. 57, 60, 63). The horizon lines are placed so near the top of the picture – against all probability of a real viewpoint – that only a few inches are left for the narrow strip of sky. By using a top view, Bruegel has more room for all his figures than he had available in his designs for the *Virtues* and *Vices*. Consequently, unlike in those, the scenes in the pictures hardly overlap at all; the size of the figures decreases towards the background slowly and steadily. This is reminiscent of older altarpieces where the painter virtually folds up the background in order to be able to paint ancillary scenes recognizably. The basic distinction remains that Bruegel treats the overall pictorial frame as earlier painters had used the view leading from the space that constituted the principal scene.

The format of these works, which are all about 120 x 160 cm, appears here in his oeuvre for the first time, but was to recur constantly in the following years. A noted Viennese Bruegel scholar of the first half of the 20th century, Gustav Glück, even claims that this size was known as the "Bruegel format" in the 17th century. He sought to explain it as a traditional cloth size, attributing it specifically to the artisan influence of the cloth painters of Mechelen, Bruegel's mother-in-law having been one such. The cloths used were thin fabric that was painted with watercolors, as a result of which reliable examples for comparison hardly exist. But the multi-figure paintings are all painted on wood. Canvases – and especially cloths – are very rare in Bruegel's work.

The multi-figure paintings have been described as "encyclopedic" because there is so much to see in them that is thematically related. They appear to wish to treat a topic exhaustively. Yet, unlike in an encyclopedia, nothing is explained to the viewer and everywhere we detect the artist playing games of his own with the subject matter.

As no reference works existed for either children's games or the carnival, the term "encyclopedic" is misleading. In literature and rhetoric, in contrast, there were enumerations and exemplary collections which are comparable with Bruegel's paintings for

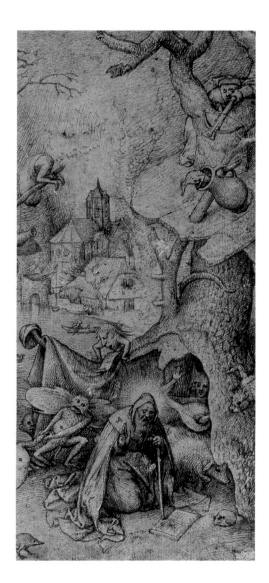

47 The Temptation of St. Antony (detail of ill. 5)

Virtues and vices lie close together and often pair off as opposing forces. Even in his drawing of the *Temptation of St. Antony* Bruegel had maximized the contrast using means drawn from Bosch's visual language. The saint prays outside his tree cell with book and skull, while a musician and a pig have made themselves comfortable inside. From the rear, cephalopods, fish people, and bird people threaten to interrupt the prayer, and the crossbowman in the tree has not only the featherless birds in his sights, but also St. Antony.

48 *The Seven Vices, Ira*, 1557
Copper engraving, 32.2 x 43 cm
Gabinetto dei Disegni e delle Stampe, Galleria degli
Uffizi, Florence

Wrath leads a pack of grotesque armed men from her
commander's tent towards an armed fish man. Naked
people have got in the way of the two fronts and have
been bitten or sliced in two with a knife. Many other
scenes in this engraving symbolize anger and hatred. Only
a monk in his tree house raises a feeble protest against the
frenzy with a bell.

49 *The Seven Vices, Avaritia*, 1557
Copper engraving, 32.2 x 42.9 cm
Cabinet des Estampes, Bibliothèque Royale
Albert I, Brussels

Avarice is personified by a well-dressed woman counting money from a chest in her lap. A beaked creature pours out more coins from a pitcher. Money is once again the subject in this picture, and all three buildings shown are the target of attacks by robbers.

50 *The Seven Vices, Desidia*, 1557
Copper engraving, 32.4 x 42.8 cm
Cabinet des Estampes, Bibliothèque Royale
Albert I, Brussels

Sloth is an elderly person dressed only in a cloth, who yawns and props herself upon a similarly prostrate donkey. They are surrounded by snails. Two large clocks, one in the tree house on the right, the other as a sundial in the left background, go unnoticed and without fulfilling their function recording working time.

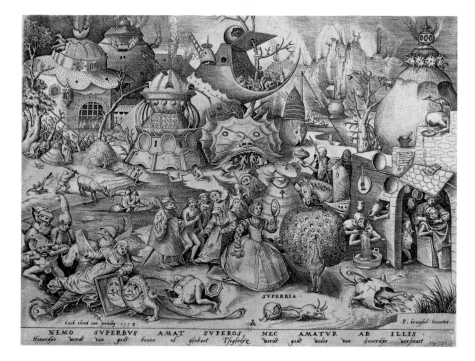

51 *The Seven Vices, Superbia*, 1557
Copper engraving, 32.3 x 42.8 cm
Cabinet des Estampes, Bibliothèque Royale
Albert I, Brussels

Like Prudence, regally clad Pride carries a mirror, but in this case for her vanity, not her self-awareness. Her farthingale has, quite deliberately, the same diameter as the fantail of the peacock. In the foreground, a cephalopod looks at itself in the mirror.

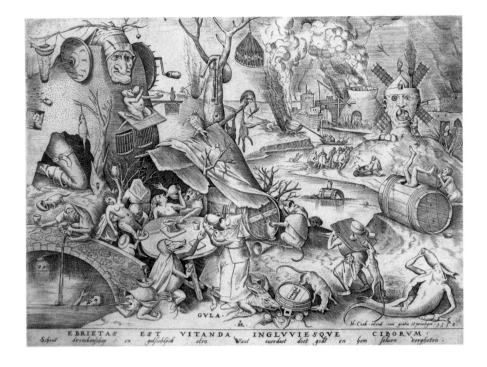

52 *The Seven Vices, Gula*, 1557
Copper engraving, 32.4 x 42.7 cm
Cabinet des Estampes, Bibliothèque Royale
Albert I, Brussels

Gluttony appears at first glance quite modest in wretched surroundings. A meal is being consumed at a round table. But the giant old man behind obviously possesses an eating mechanism activated with a crank. For it to work, he has been built into a mud hut. A similar idea underlies the head-shaped mill opposite, whose mouth is likewise being stuffed by the sackful.

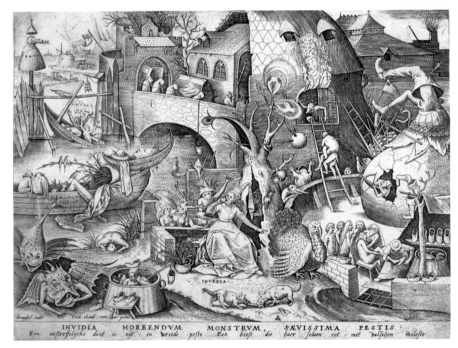

53 *The Seven Vices, Invidia*, 1557
Copper engraving, 32.3 x 42.8 cm
Cabinet des Estampes, Bibliothèque Royale
Albert I, Brussels

Envy will not even let the turkey enjoy its appearance, though it is her own symbol. She consumes her own heart out of envy. The dead tree she sits on bears peacock feathers. The meaning of the shoes prominent both left and right has so far not been explained: they could mean, in contrast to Envy, "to each his own."

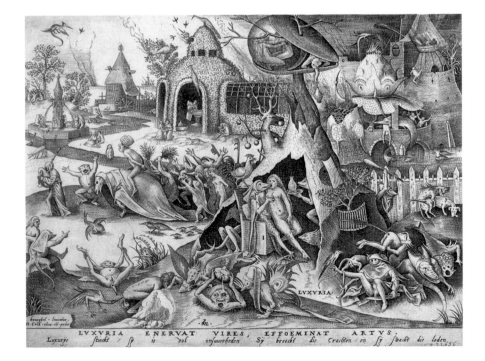

54 *The Seven Vices, Luxuria*, 1557
Copper engraving, 32.3 x 42.9 cm
Cabinet des Estampes, Bibliothèque Royale
Albert I, Brussels

Extravagance has less to do with material wastefulness than sexual extravagance. A naked woman in the tree house is French-kissing a fish man, who fondles her right breast. Further back there is a Garden of Delights, which is reminiscent of Bosch, with an arbor and fountain of youth.

43

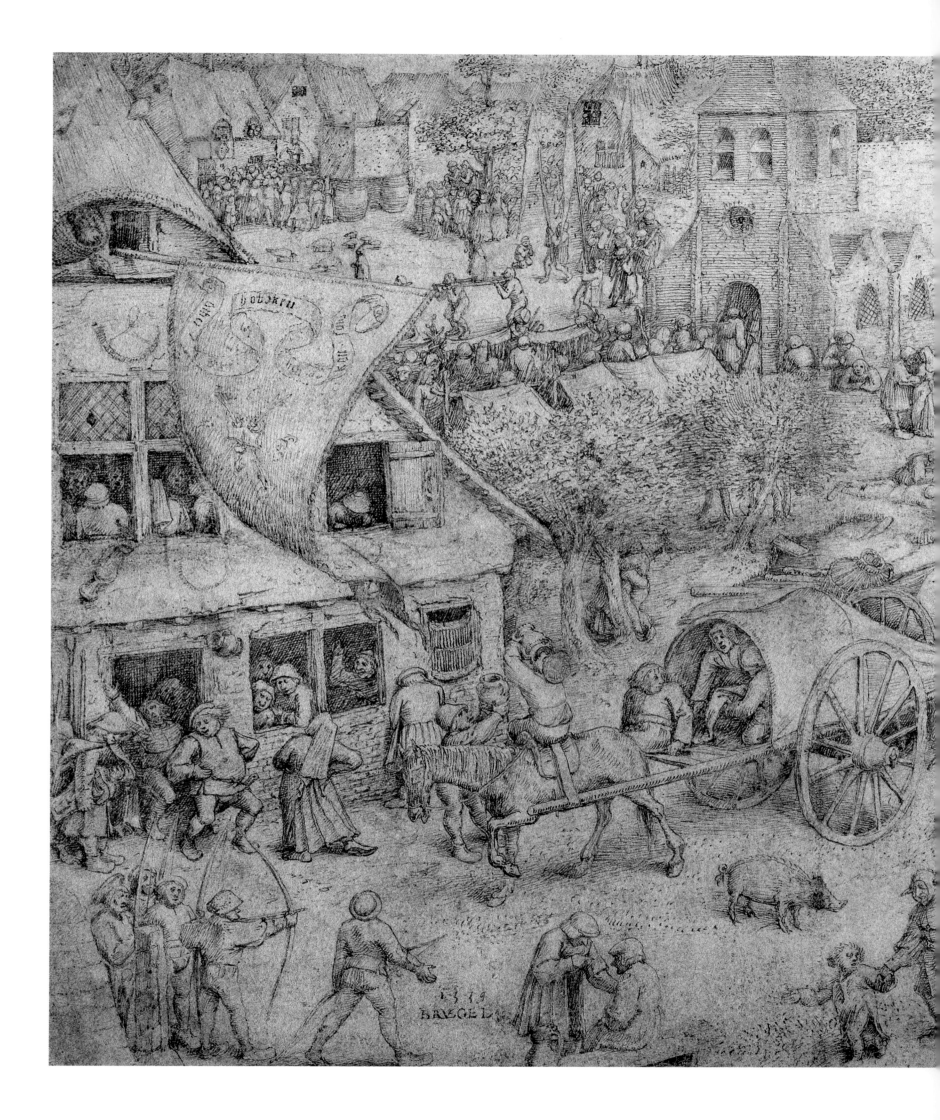

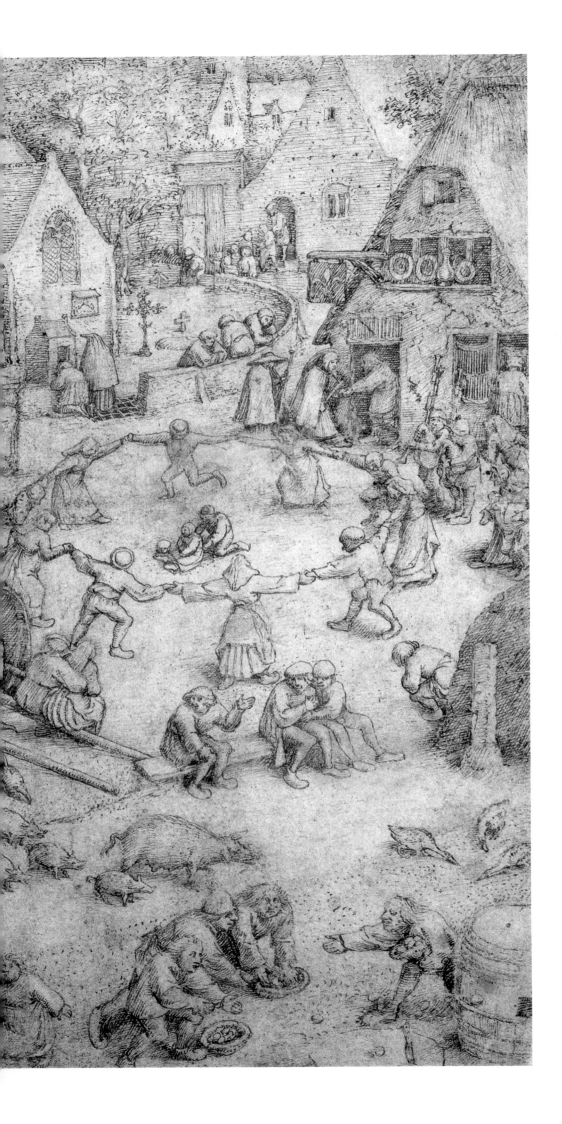

56 Unknown follower of Bruegel (Roeland Savery?)
Naar het leven studies (detail)
Pen over black chalk, 15.9 x 9.6 cm
Kupferstichkabinett, Staatliche Museen zu Berlin – Preußischer
Kulturbesitz, Berlin

The title describes a group of drawings – no longer ascribed to
Bruegel – which were assumed to have been done from life (*naar het
leven*). The idea was to explain Bruegel's originality as the result of
empirical studies from nature. It has been known for the last twenty
years that these drawings could only have been done using his works
as models.

55 *Kermes van Hoboken* (Hoboken Kermess), 1559
Pen and brown ink, 26.5 x 39.4 cm
Courtauld Gallery, London

This sheet shows a rural fair at which the kermess included not only
sports and merrymaking but also a market. Bruegel is supposed to
have visited such fairs often with his friend Hanns Franckert, as
Carel van Mander reported in 1604.

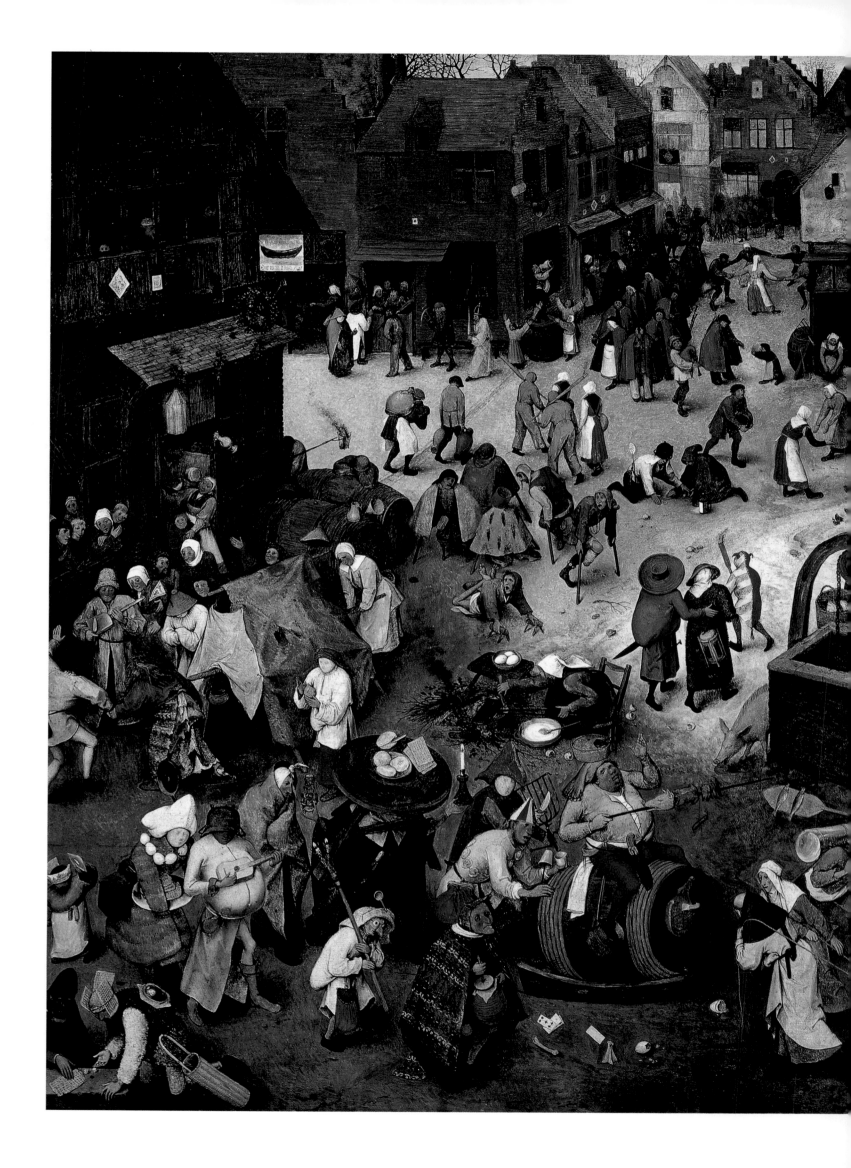

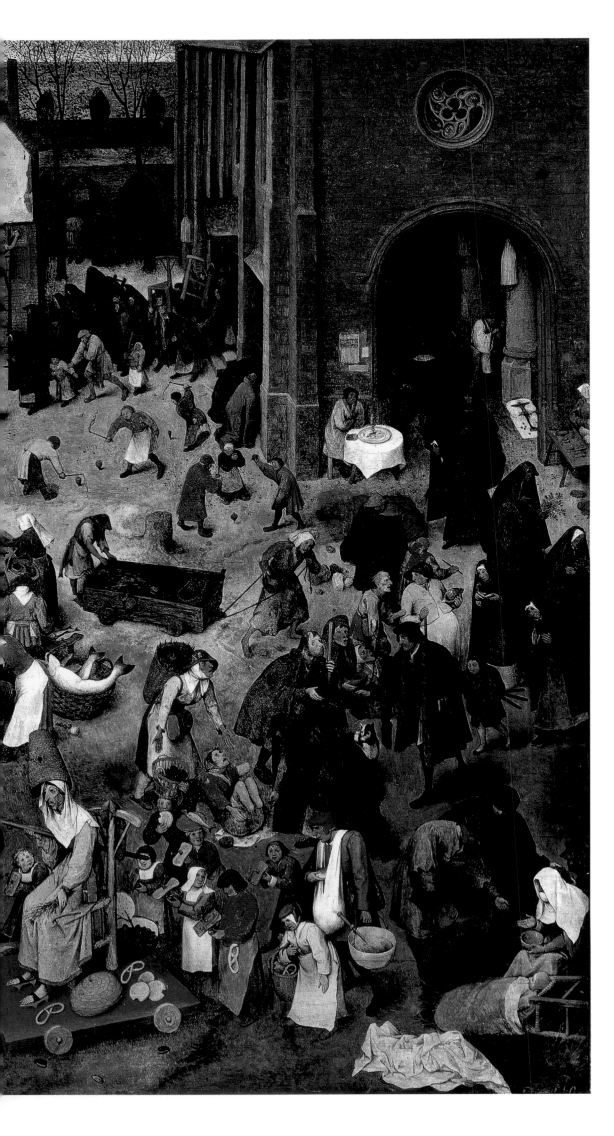

57 *Battle between Carnival and Lent*, 1559
Oil on panel, 118 x 164.5 cm
Kunsthistorisches Museum, Vienna

Carnival and Lent ride at each other like knights jousting. Gaunt
Lent sits on a processional trolley dressed in penitential garb and
armed with a bread shovel, while plump Carnival rides out with
sucking pig and spit and is seated on a wine or beer barrel.
Correspondingly fat or lean escorts shove and pull the combatants
toward each other. The whole picture begs for allocation into the two
camps, which here mistakenly share a single square, instead of
succeeding each other in time.

their variety and richness of expression. Catalogs of
ships and weapons have existed since Homer's time,
and Rabelais (1494–1553) has his giants Gargantua
and Pantagruel enumerating things in his eponymous
work of 1535, with humorous intent. Whether it is
the several dozen dishes that they eat or the several
hundred games they play, the exaggeration always
implies both the colossal arrogance that is intended to
characterize Pantagruel and the author's own crowing
that he knows so much. Rabelais is not concerned
with giving his reader factual information, but is
instead reveling in the wealth of games as well as the
euphony of the strange names. For his part, Bruegel
can take advantage of a feature that is not available
in a catalog enumeration: unlike the writer's succes-
sion of items, the artist can present many scenes
simultaneously, which he must, however, still arrange
credibly within the pictorial space. This allows for
numerous spontaneous cross-references and ambigu-
ities to be exploited.

The *Battle between Carnival and Lent* carries this title
because of the jousting parody in the foreground of the
village square: plump Carnival, mounted on a barrel,
rides out to meet scrawny Lent, shown as an old
woman (ill. 57). He is being pushed by his followers on
a goods sledge, while she sits in a cathedra perched on a
processional trolley pulled by a monk and a nun. In
place of lances, the weapons that they carry are food
and the utensils needed to make it. He holds a roasting
spit, while she has a bread shovel. In front, at least, the
temporal contrast can be counted as a battle between
the figures, with the pious on the right and the revelers
on the left. On Ash Wednesday, the fat days of
Carnival finish and the lean days of fasting begin for
everyone. But in the Bruegel picture, the church
calendar fails to gain acceptance. Further back, the
irreconcilable representatives of the temporal regula-
tions pass each by, taking no notice of the nonsense
made of the calendar by the events going on in the
foreground. The scene is an irregular village square that
opens wide into the foreground between the inn and
the church. It is unpaved, and its loamy surface,
modeled in various tones of brown, sets the overall
mood. The broad space is not constructed according to
the rules of central perspective. Clearly Bruegel has no
regard for paved squares such as those often painted by
Italian masters, and of which Bruegel had a good
knowledge from his travels. It is only at the edge of the
picture that architecture stabilizes the surface, which
seems to curve in the light-colored center. The center

of the square, and thus also of the picture, is a well,
around which the relationships begin to mix in a circle.

Besides the various, partly-ritual foods, it is games
and customs that Bruegel uses to characterize the
contrasts. Fish, mussels, pretzels, porridge, and flat
dough cakes are found on the side of fasting; eggs,
pancakes, waffles, and meat follow the carnival king.
Outside the church begging, charitable donations, and
all kinds of penitence are in train; oblations, also called
ex-votos, are on sale; some figures are praying, others
carry box foliage or heap ashes on their heads. Over the
square in front of the inn it is all waffles and games of
chance, masquerades and comic theatricals involving
dancing and musical parodies. In the picture there are
few onlookers merely watching what is going on – they
are leaning out of the inn windows. As the onlookers
are incidental, it is left open as to whether the disregard
for the time changeover from feasting to fasting is to be
taken as a didactic performance or whether a real
"catastrophe" of non-observance of temporal regula-
tions is taking place, with the hedonistic revelers
ignoring the beginning of Lent and thus church
requirements. In fact, such conflicts were quite
common in Bruegel's time and violent confrontations
during Carnival had long ceased to be a calculated
game or didactic performance.

Between the well and the waffle oven, a couple are
crossing the lightest part of the square, led through the
picture by a jester carrying a torch in broad daylight.
Wasted light (candlelight) is also shown in the carnival
train in the foreground; in one case candles are stuck in
a besom, in the other a candle-holder is being held up
high. In contrast, no light burns inside the gloomy
church, the sconces on the pillars being carefully
shrouded. Many interpretations see in the behavior of
the couple by the well, who are placed with their backs
to the events in the foreground a symbol or reflection
of the behavior of contemporary observers, who could
not decide between left and right and demanded a
sensible balance of fasting and feasting. The Fool with
the torch is no doubt heading for the carnival, as the
spiritualist theologian Sebastian Franck (1499–
1542/43) wrote in his *World Book* in around 1534:
"Shrove Tuesday with torches and lanterns, crying
pathetically: where is Shrove Tuesday gone?" And
indeed, the Fool has struck out towards the left and the
hostelry. Only the couple hold with downcast gaze to
the center course.

Games, pranks, and celebrations furnish a thematic
trail from the *Battle of Carnival and Lent* to the

Children's Games painting, which is now likewise in Vienna (ill. 60). Contrary to the suggestion of the title, the picture shows not only children, since adults are also enjoying the children's toys and children are not just playing games. The boundaries of games and fun are set wide, ranging from sport and competitions, through traditional toys such as dolls and hobby horses, to imitating the world of adults and malicious pranks. Although the top-view representation in *Children's Games* is similar to that of the *Carnival*, the construction is stricter and the distribution of figures over the square less busy, despite the depiction of all the games. Here too there is a mixture of individual figures and larger groups, but a common compositional movement, like the circling in the carnival picture, is absent. The sandy ground, which only gets darker where houses throw shadows, may account for the greater calmness. A striking feature is the extreme length of the broad street at the top running diagonally to the right, towards a tower or city gate, which is visible in the far distance. Scenes of play, roughly equally spaced out, extend far down the street. Bruegel seems to have a fear of empty spaces, a qualm that has become proverbial as *horror vacui*, expressing the medieval fear of the void.

Once the individual games are entered into, the calmness is soon over. It is not always apparent whether it is children or adults that are playing; the games themselves are nonetheless almost all children's games. This becomes clear in the parodies of the habits of adults, such as the children's marriage on the left by the red wooden fence, and also in the absence of card games or other games involving money. All the children's heads are round and they are all chubby-cheeked. Boys and girls are generally distinguishable only by the headcloths or short hair. However, their faces are not really young, they look more like diminutive adults. In his multi-figured paintings, Bruegel strongly schematizes the gestures his figures make; head shapes and facial features are repeated and only the variations of clothing and body posture convey an impression of individuality.

Attempts have been made to interpret *Children's Games* as a seasonal topic, like *Carnival*, and present them as a series of paintings. The notion was prompted by correspondences of age and month that are found in the calendars in books of hours. Books of this kind containing prayers and Biblical texts were owned only by the very well-to-do. The more expensive they were, the more richly illuminated was the perpetual calendar

prefacing the work. A few of the books do decorate each of the months with friezes of games in the margin, which indeed bear similarities to Bruegel's scenes (ills. 58, 59). In literature, too, childhood was considered the spring of human life, and games were its most palpable symbol. But as part of a putative series reproducing the seasons of the year, such as the later *Months* (ills. 96–104), the opportunities for sensible complementation are lacking. Even to the carnival picture, which does relate to a specific time of year, the games picture adds nothing. The idea of looking for an overall concept for these pictures has, therefore, long been abandoned. Instead, the two pictures are assumed to be what the inquisitive eye of the viewer enjoys in them: variety and richness by the depiction of almost inexhaustible details (ill. 61).

Bruegel's *Flemish Proverbs* picture (in Berlin) is just as rich in scenes as the carnival or games pictures, and here again the painter resorts to a high-placed horizon similar to those in older works of art (ill. 63). But in terms of architectural and landscape structure, the picture is more complex. The picture creates a sophisticated interlocking fantasy architecture beside the coast, half village, half town, and yet with room for fields, woods, and sea – it is to some extent a world of its own. The proverbial events define the spatial program. In the foreground are scenes that depend on small accessories or details, and therefore could be planned almost independently of the environment: "casting roses (or pearls) before swine," that is doing something pointless, "drape a blue coat on someone" (cheat on your spouse). But for the saying "go through the wall with your head" (be determined to get your own way), Bruegel sets up a separate, otherwise functionless, wall. The proverb is exaggerated, because the willful fellow of the saying is proposing to plow through the wall lengthwise. The knife in his right hand reinforces the impression of a blind effort of will in an enterprise that is in itself completely senseless. In such over-statement, which depicts the senseless in exaggerated pointlessness and the futile as already failed for other reasons, the didactic representation of proverbial wisdom merges into comedy – a proximity already latent in very many turns of speech, and not just proverbs, if taken literally. The epitome of such language-based humor at that time is the figure of Til Eulenspiegel, who by taking everything literally arouses the ire of his fellow men with their everyday understanding. The immediate environment of the "head through the wall" man sets up further cross-references in addition to this. The man is wearing

59 Gerard Horenbout
February (detail)
Breviarium Mayer van den Bergh, Cod. 946, fol. 2r
Tempera on parchment, 22.3 x 16 cm
Mayer van den Bergh Museum, Antwerp

The games are executed in a *camaieu* technique in which, as in *grisaille*, the color range is reduced to one basic color, mostly ocher, and other tones are obtained with white and black. Thus the impression is given of a painted frieze, which here fits into the upper margin of the architectural border. The scene shows children with hoops.

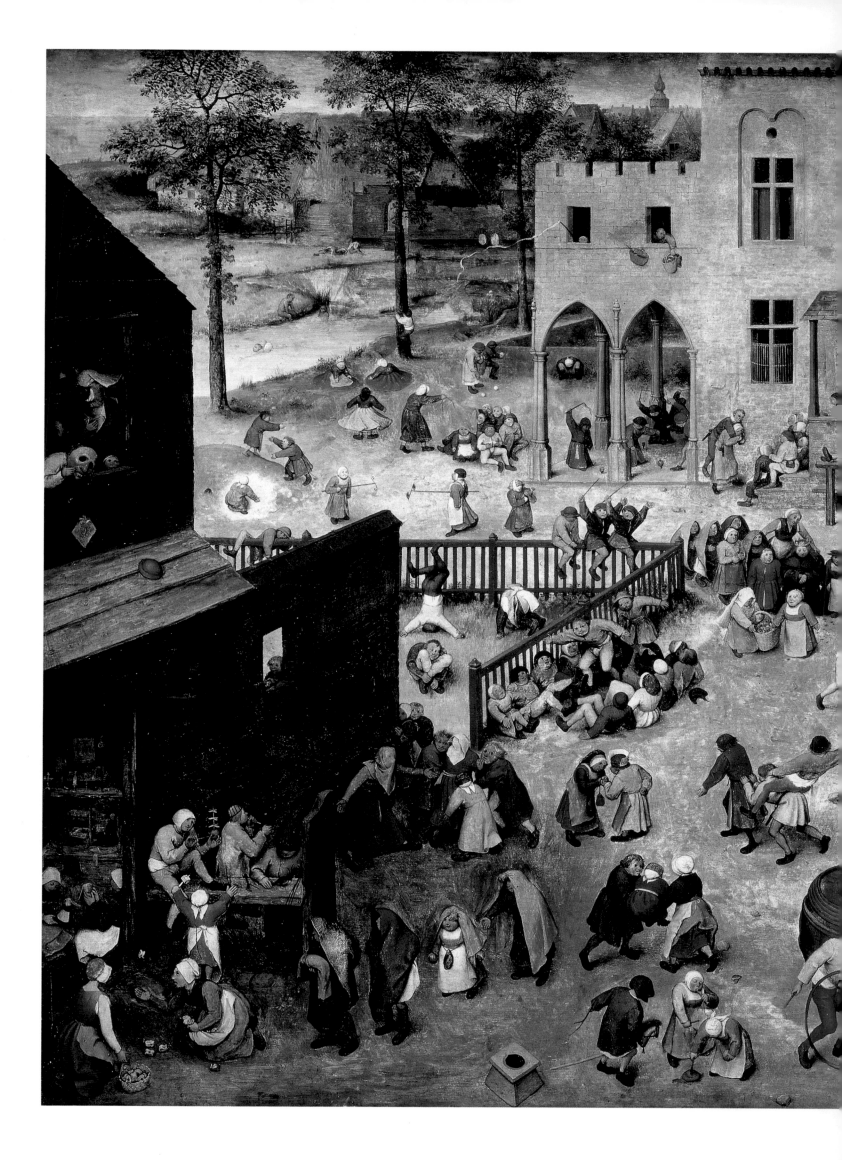

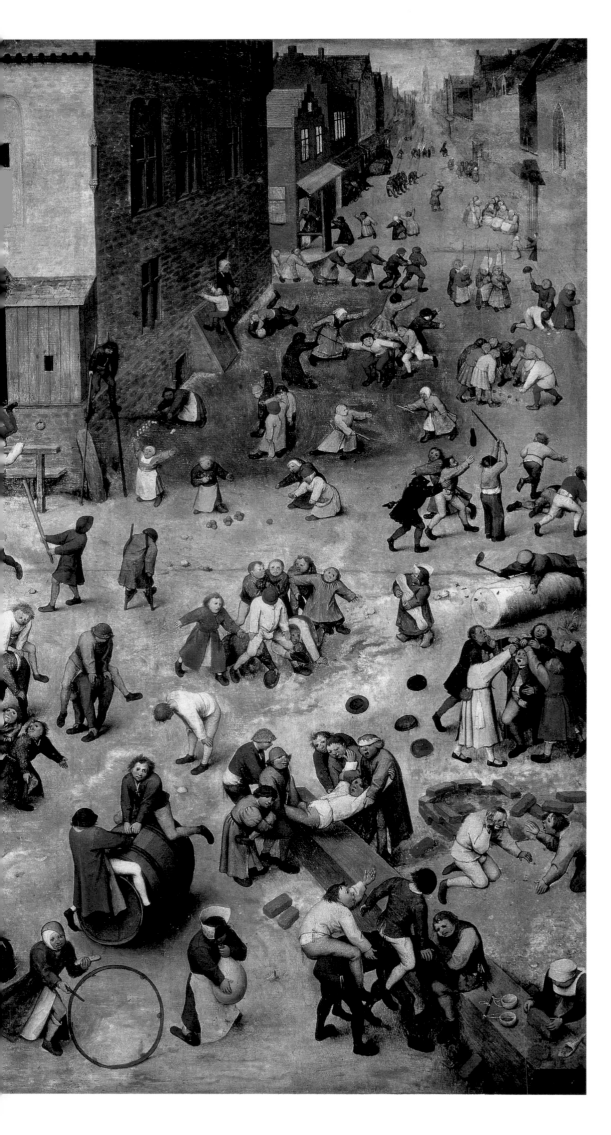

60 *Children's Games*, 1560
Oil on panel, 116 x 161 cm
Kunsthistorisches Museum, Vienna

Childhood is a modern invention, and it is therefore no surprise to find many children here running around like small adults, and that games are mixed across generations. A good part of the games shown constitute an imitation of the adult world; various scenes show toys, other scenes feature sports and games played in the street without any equipment. Here, too, it has been assumed that the painting belonged to a series arranged according to season. However, none of the compositionally related pictures fits into a series. The painting remains an astonishing one-off in the history of painting.

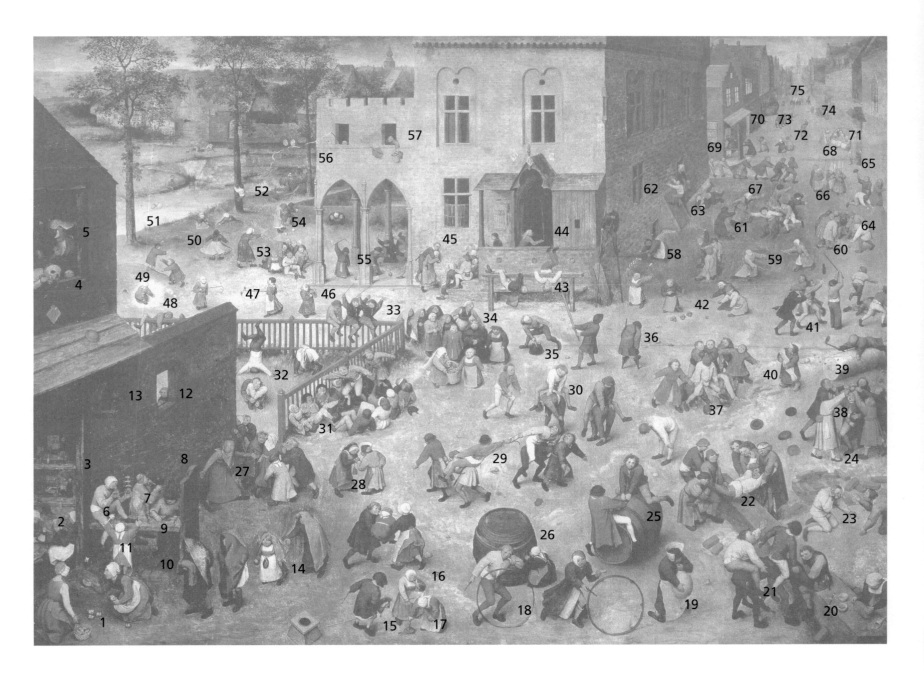

61 *Children's Games* (cf. ill. 60)

1. Fivestones
2. Rag dolls
3. Children's church, improvised altar
4. Masks (fancy dress)
5. Rocking
6. *Drillnoot*, spinning nut, on the principle of a yo-yo
7. Blowing bubbles
8. Rush hats
9. Taming birds
10. Brick dog
11. Top or gyroscope
12. Water pistol
13. Bird and bird house
14. Single file – baptismal procession
15. Hobby horse
16. Drum and horn
17. Stirring excrement (before threatening with the stick?)
18. Whipping hoops
19. Balloon (an inflatable pig's or cow's bladder)
20. Playing shops
21. Horsey horsey (one group makes the horse, the other jump on as riders)
22. Planing
23. Throwing knives
24. Building a well
25. Riding a barrel
26. Whooping into a barrel (echo)

27. Hoodman blind (medieval version of Blind Man's Bluff)
28. Guessing game: odds and evens
29. Tug-of-war (mounted)
30. Leapfrog
31. Running the gauntlet (similar to the punishment where switches were used)
32. Gymnastics, handstand, forward roll
33. Sitting/riding on the fence
34. Wedding procession (May Day bride)
35. Hunt the egg (similar to Hunt the Pot, where a blindfolded person hunts for a pot with a stick and beats it when it is found)
36. Walking on stilts
37. "Run Moon" (a variant of Plumpsack or clumsy fellow)
38. Pulling hair
39. Catching insects
40. Child with All Soul's loaf
41. Biting 'Plumpsack'
42. Shooting nuts
43. Gymnastics at the bar
44. Balancing
45. Tag
46. Rattle
47. Jousting with small windmills
48. Sandpit
49. Playing King of the Hill on the sandheap
50. Spinning skirts

51. Swimming
52. Climbing
53. "Mother mother where's your child?"
54. Bowls
55. Whipping tops
56. Flag game or imitation of fishing
57. Practical joke, hanging shoes and other possessions out of the window
58. Skittles (ninepins)
59. Variant of hockey?
60. Ball in the hole
61. Bear baiter
62. Wall running
63. Wrestling, or maybe a real fight
64. Throwing coins (against the wall so that it hits the one thrown earlier)
65. Cap game
66. Children's procession
67. Piggy back
68. Singing and clapping game
69. Single file
70. Pushing off the bench
71. Imitating artisans
72. Carrying on the shoulders
73. Fox in the Hole (or similar)
74. Broom game
75. Midsummer bonfire

an apron, for example, and to the left of the wall are sows ready for slaughter. Part of Bruegel's skill is to lead the viewer's eye adroitly and set up interconnections that cannot be resolved with a saying or turn of speech. Why does the butcher not stay with his sows? This chain of interconnections set up by the painter leads inevitably to the core of the proverb, "Cobbler, stick to your last."

A list of basic interpretations of scenes represented can thus only be viewed as a starting point for associations, which themselves could generate innumerable figures of speech. In this lies the basic difference between Bruegel and the almost contemporary engraving by Frans Hogenberg, which juxtaposes far fewer scenes in a more casual way, and gives each a written explanation. It has so far not been established whether the two works relate to a competition between rhetorical fraternities and if they do, to what extent. The *rederijkerskamer* was an institution that developed in the Netherlands post-1400 and, as did the archery fraternities, organized annual festivals. These were called the *landjuweel* festival, and were seen as an occasion for members to deliver their contribution on a predetermined subject. A jury decided which town had the best rhetoricians (*rederijkers*).

Death and hell were Bruegel's cardinal themes of 1562 and 1563. This was the period just before his move to Brussels, when he married and became a father for the first time. The ease of his former apparently objectively enumerative and additive style of representation vanished. The pictorial world of Bosch was no longer echoed in borrowings of related figures, such as individual monsters, but now affected the choice of subject and infernal compositions as a whole. Paintings were produced – in formats of equal size – where the dramatic movement and intense color created an impression of almost irresistible violence. The earlier paintings did not avoid disasters and mishaps but they incorporated them almost laconically into the course of things. If in the *Battle between Carnival and Lent* a corpse originally supported the begging in the right foreground, of which – following later overpainting – only the cloth over the rump and legs is now recognizable, this nonetheless expressed a balance between life and death that was probably generally valid for the older period. In the infernal pictures, in contrast, fear predominates, a fear felt by those who no longer glorify the world beyond or are only driven to believe by the fear of hell.

The *Triumph of Death*, now in Madrid, shows a desolate coastal landscape with burning and capsizing ships (ill. 65). The few extant trees have died and serve as either a death-knell or as instruments of torture. In the foreground death rules with its battalions of well-armed skeletons drawn up in military order. On the right, two similar armies, barricaded behind shields that are made of coffin lids, guard the entrance to hell, which is constructed from wood and at the same time resembles both a mine shaft and an outsized coffin. Anyone who cannot walk is carried in by skeletons or, like the king in the front on the left, informed with a

gesture to the hourglass to get up again and walk. At the same time, another skeleton clears away the royal treasure. Behind follows a horse and cart loaded with skulls. The cart initiates a sequence from left to right, a procession leading to the descent into the underworld, even if the table in the right foreground still provides a force of resistance to death: the round of cards is finished, but a fool is hiding under the table, two young knights are drawing their swords, and right at the front a nobleman sings a serenade, accompanying himself on the lute – either ignoring or not noticing his doppelgänger, a skeleton with a hurdy-gurdy.

It is not only symbolic deaths that are depicted here. For that, it would have sufficed to show scythes and hour-glasses, the widespread, traditional attributes of death. Bruegel clearly depicts some extremely violent forms of death. In the center ground, people are being drowned, in the foreground a throat is being cut, while on the hill to the right hanging and beheading are proceeding; spears and arrows strike again and again, while scythes are carried as real weapons. The only corpse to show an appearance of repose in death – because it is lying in a coffin and a candle is placed beside it – is being ruthlessly dragged over another corpse by three skeletons who are shrouded in monastic habits.

With its preponderance of both bird and fish-like creatures, the *Fall of the Rebel Angels* (1562), in the Musées Royaux des Beaux Arts de Belgique, Brussels, is closest to the pictorial creations of Bosch (ill. 66). Archangel Michael is shown putting an end to the rebellion of Lucifer and the "fallen" angels with him. As they plunge, the beings wheel about in disorientation, being sometimes upright and sometimes upside down. It is a form of representation familiar from depictions of hell, but one that rarely occupies so much space and attention. Only Bosch's triptych in the Academy of Arts in Vienna displays similar interconnections between countless fantastic creatures. That Bruegel was working directly contrary to the mainstream and ruling taste becomes apparent when this work is compared with the *Fall of the Rebel Angels* (ill. 62) by Frans Floris (1519/20–1570).

Bruegel mingles above and below even more artfully in the drawing of the magician *Hermogenes and St. James* (1564). The Apostle St. James the Great emerges from the door of a church or palace on the left, in front of him are all kinds of traveling entertainers and jesters. Many features suggest a school for jugglers and traveling artistes. On the right are tables, and over them chairs are stacked up into a climbing or balancing apparatus. Hermogenes, dressed in a mantle and fur-lined pointed cap, plunges headlong to the ground between his associates. Beside him, behind him, and above him epileptic demons are shown, who do not appear to be in thrall to his magical powers. The *Golden Legend*, the most important medieval book of the lives of the saints, reports that St. James had him bound and brought to him, and then converted him. To protect him against "the wrath of the demons," St. James handed him his staff.

62 Frans Floris
Fall of the Rebel Angels (detail), 1554
Oil on panel, 308 x 220 cm
Koninklijk Museum voor Schone Kunsten, Antwerp

In many respects, Frans Floris, who lived in Rome for a long time and after his return to Antwerp established an Italian-style workshop, was a counterpart of Bruegel. They lived in the same city and were esteemed by the same collectors. The subject of the *Fallen Angels* was especially valued in the Counter-Reformation: it celebrated the victory of the Catholic Church over heretics and all the Reformed churches.

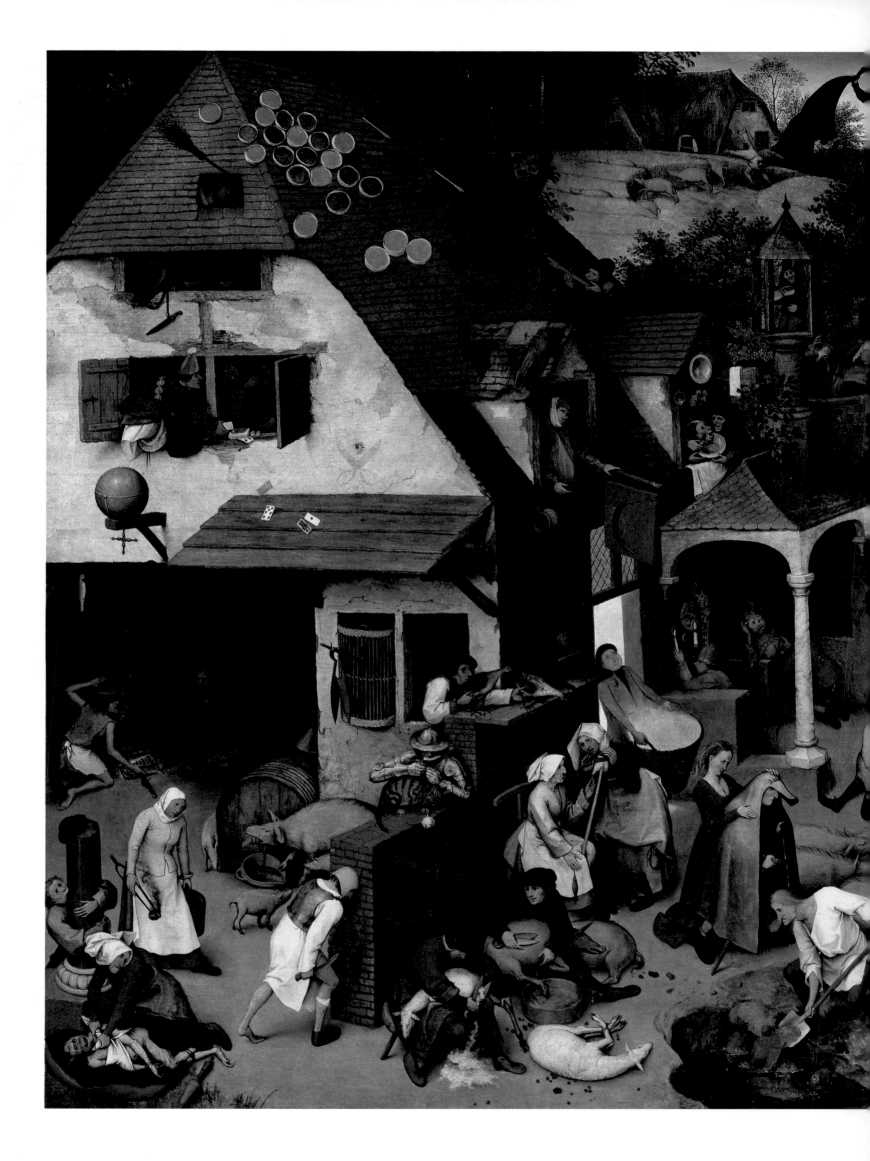

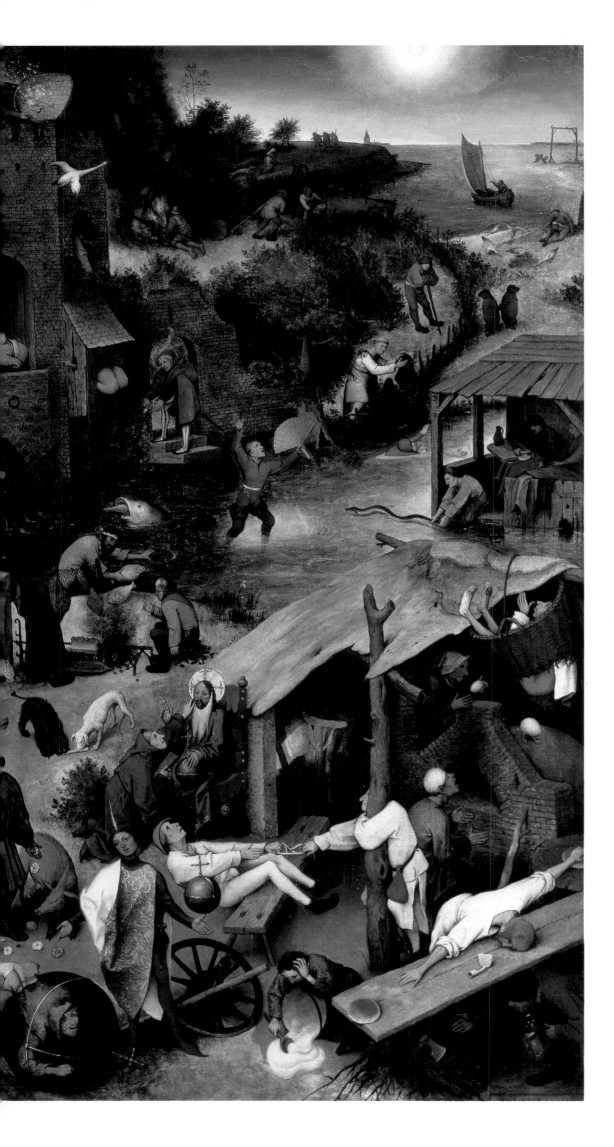

63 *Flemish Proverbs*, 1559
Oil on panel, 117.5 x 163.5 cm
Gemäldegalerie, Staatliche Museen zu Berlin – Preußischer
Kulturbesitz, Berlin

The depiction of proverbs was an innovation by Bruegel. Collections
of sayings were popular aides for preparing speeches, but early
examples of books with proverbs and turns of speech that were
illustrated show that pictorial language was also considered a genre of
its own. Over 100 proverbs were included by Bruegel, but the theme
of the 'topsy-turvy world' recurs again and again, and was therefore
adopted by many as the title of the picture. Outside the peasant's
house, front left, an inverted globe hangs like an inn sign.

64 *Proverbs* picture (cf. ill. 63)

1. The roof is covered with dough cakes (affluence, an image from the Land of Cockaigne)
2. Marry under a broomstick (without a church blessing)
3. The besom is out (the master's not at home, so they're doing whatever they want – when the cat's away, the mice will play)
4. He's looking through his fingers (be sure of something, and therefore not take it seriously)
5. There hangs the knife (challenge)
6. There stand the clogs (waiting in vain)
7. Be had by the nose (cheated)
8. The dice are thrown (it's all decided)
9. Fools get the best cards
10. It depends how the cards fall
11. Shit on the world (scorn)
12. The topsy-turvy world (nothing is what it seems)
13. Pull through the eye of the scissors (gain dishonestly)
14. Leave an egg in the nest (have something in reserve)
15. Have a tooth bound (appear harmless, but be fly)
16. Piss against the moon (to try or have already tried something impossible)
17. Old roofs often need patching
18. The roof has laths (eavesdroppers – walls have ears)
19. The pot hangs outside (use a chamber pot instead of a tankard as an inn sign)
20. Shave a fool without soap (mock somebody)
21. Grow out of the window (the truth seeks the light)
22. Two fools under a single cap (folly loves company)
23. Shoot off all your arrows (leave nothing in reserve)
24. Tie the devil to a cushion (everything is possible)
25. Bite the pillar (dissemble)
26. She carries fire in one hand, water in the other (insincerity)
27. Fry the herring for the roe (little benefit), or the herring is not frying (things are not going to plan)
28. Wear a lid on the head (?)
29. Have more in him than an empty herring (unexpected depths), or the herring hangs by the gills (mistakes have consequences)
30. Sit between two stools or in the ashes (be unable to decide, achieve nothing)
31. Smoke cannot hurt iron (better to abandon pointless ventures)
32. The spindles fall in the ashes (all is lost)
33. If you let the dog in, it creeps into the cupboard (be left standing, not get a look in)
34. The sow is pulling the bung out (maladministration)
35. Bang your head against a brick wall (waste of effort) or go through the wall with your head (stubbornness)
36. Be up in arms
37. Put a bell on the cat (do something all too publicly)
38. Armed to the teeth, or an iron-eater (somebody who acts big and strong)
39. Feel the hen (take trouble too soon)
40. Gnaw the bone (meager food or persistent action)
41. The scissors are hanging out (cutpurse, swindler)
42. Speak with two mouths (forked tongue)
43. One shears sheep, the other swine (identical work is not rewarded equally)
44. A lot of squealing, not much wool
45. Shear it but don't flay it (do not go for profit at any cost)
46. Patient as a lamb
47. Distaff that others spin (or pass on malicious gossip in parrot fashion)
48. Take care no black dogs get in the way (it could go wrong), or wherever two women are together, no baying hound is needed

49. Carry out the light in baskets (waste time)
50. Light candles for the Devil (flatter everyone)
51. Confess to the Devil (carry secrets to one's enemies)
52. An ear-blower (?) (schemer, plotter)
53. The crane invites the fox to supper (invite conmen in)
54. An empty plate may be very lovely … (bodily needs come before the senses)
55. A skimmer (?)
56. Be chalked up (that's a black mark against him)
57. Fill in the well after the calf has drowned in it (lock the stable door after the horse has bolted)
58. Make the world dance on his thumb (rule all-powerfully)
59. A spoke in his wheel
60. To make your way in the world, you must writhe (you will not get anywhere without trouble)
61. Put a false beard on Christ (God?) (a hypocritical swindler)
62. Throw roses (pearls) before swine (wasting treasures on savages)
63. She's draping a blue coat on her husband (cheating on him)
64. The pig has been stuck through the belly (the decision has been made and is irrevocable)
65. Two dogs seldom agree over one bone (greed and envy)
66. Sit on hot coals (a cat on hot bricks)
67. The meat on the spit must be basted, or pissing on the fire is healthy, or his fire is pissed out
68. No spit can turn with him
69. Catch fish by hand (be crafty, let others do the work, because he's robbing other people's nets)
70. Cast for a cod with a smelt (pointless and obviously lossmaking action)
71. Fall through the basket (fail)
72. Hang between heaven and earth (be in an awkward situation, where it is difficult to make a decision)
73. Take the chicken's egg and leave the goose's (make the wrong decision)
74. Yawn at the oven (futility)
75. Not reach from one loaf to the next (too little money)
76. Look for the hatchet (pick a quarrel)
77. Here he is with his lantern (he can shine)
78. If you spill the porridge, you won't save everything (sometimes it's too late)
79. They're drawing it out (each seeks his own advantage)
80. Love is on the side where the purse is.
81. Place oneself in the light, or no one looks for another person in the oven unless he's been in it himself (those who think evil attribute evil to others)
82. Play on the pillory (anyone who is already accused should not draw more attention to himself)
83. Fall from the ox on to the ass (do bad business)
84. The beggar is sorry if there's another beggar at the door
85. He can see through an oaken plank if there's a hole in it (he only seems to perform miracles)
86. Rub your backside on the door (overcome/disregard everything)
87. He carries his little pack (everyone has a burden to bear)
88. He kisses the ring (manifests false reverence)
89. Fish behind the net (miss a chance, be too late)
90. Big fish eat little fish
91. He's upset that the sun shines into the water (resentment)
92. Throw money in the water (waste)
93. They shit through the same hole (inseparable mates)
94. Hang like an outhouse over the ditch (it's obvious)
95. Catch two flies with one swat (or kill two birds with one stone)
96. Watch the stork (waste time)

97. You know a bird by his feathers
98. Hang your mantle according to the wind (trim your sails to the wind)
99. Shake feathers into the wind (work randomly)
100. Other people's skin makes good belts (easy to be generous with other people's possessions)
101. The pitcher will go into the water until it breaks (there's a limit to everything)
102. Catch an eel by the tail (something that is bound to fail)
103. He is hanging his habit over the fence (a new start with uncertain prospects)
104. It is difficult to swim against the stream (easier to be accommodating)
105. He can see bears dancing (hallucinating from starvation?); or bears like each other's company (unlike humans)
106. He is running as if his pants were on fire (panic); or eat fire and you'll shit sparks (sow the wind and reap the whirlwind)
107. If the door is open, the pigs run into the corn, or if the corn is decreasing, the pigs are increasing (advantage and disadvantage are often linked)
108. He doesn't care whose house is on fire as long as he can warm himself (take every profit with you)
109. Cracked walls are soon destroyed (a bad outcome is foreseeable)
110. It's easy to sail with a following wind (easy success)
111. Have an eye on the sail (keep a good watch)
112. Who knows why the geese go barefoot? (there's a reason for everything), or if I'm not made to be a gooseherd, I'll leave the geese to be geese
113. Horse droppings are not figs (don't be taken in)
114. He's sharpening a log (pointless dedicated effort)
115. Fear makes old women run (need makes the impossible possible)
116. Shit on (cheat) the gallows (fear nothing; a gallows bird who will come to a sticky end)
117. Where there's carrion, there are crows
118. When the blind lead the blind, they both stumble (one must know who he is trusting himself to)
119. The journey's not over when you descry church and tower (don't crow too soon)

65 (above) *Triumph of Death*
Oil on panel, 117 x 162 cm
Museo Nacional del Prado, Madrid

Bruegel's landscape of death shows the attributes of death:
hour glass, skeletons, coffins, crosses, and all kinds of deaths.
Deaths by drowning or torture are shown side by side with
murder and natural old age, and various capital
punishments also feature. Those who appear not to know
anything of death play foolish games.

66 (opposite, top) *Fall of the Rebel Angels*, 1562
Oil on panel, 117 x 162 cm
Musées Royaux des Beaux Arts de Belgique, Brussels

The fall of Lucifer, who set himself up in place of God,
became the epitome of the victory of the righteous in the
16th century. In most cases the victorious opponent of the
rebels is the Archangel Michael. But unlike Floris' warrior
(ill. 62), Bruegel's highest angel is a figure of light.

67 (opposite, bottom) *Hermogenes and St. James*, 1564
Pen and brown ink, 22.3 x 29.6 cm
Rijksmuseum, Amsterdam

Hermogenes was a magician. St. James the Great brought
him back to the right path of faith, to which Hermogenes
was able adhere to with the help of St. James's staff.

Dulle Griet, or Mad Meg (ill. 68), is the only
painting by Bruegel named after a character from folk-
lore. It was painted in 1562/63. The dating on the
picture is no longer completely recognizable; as so
often is the case, the decisive last two figures are
missing. However, the creation of the Mad Meg
painting is in all probability very close in time to that
of the *Fall of the Rebel Angels*. In her overall appear-
ance, the main figure resembles a market vendor, but
what she carries with her is in fact plunder. She is also
armed with a sword and breastplate. In her left hand
she holds two full baskets, and at the same time uses
her armored hand to hold up her laden apron. With
her upper arm, she clutches a small jewelry or treasure
chest. Her actions are the subject of a Flemish proverb:
"She plunders even at the mouth of hell." The name

Griet is short for Margaret, but could be used for any
peculiar or particularly quarrelsome woman. The jaws
of Hell are shown twice in the same picture, on the left
behind the main figure as the mouth of a giant fish-
like creature that could well be Satan, and on the right
behind a bridge occupied by a housewife highway-
women. The latter are achieving there just what Dulle
Griet has already done successfully – plundering at the
mouth of Hell, which must have been interpreted as
getting rich through the ruining of others. It is not
wrong, therefore, to consider the whole landscape
around Griet as an echo of this woman and an exten-
sion of her figure in visual terms. Unlike in the
Triumph of Death, in this picture courage and terror
are in balance, because the main figure of the title is
after all stealing away to the left with her booty.

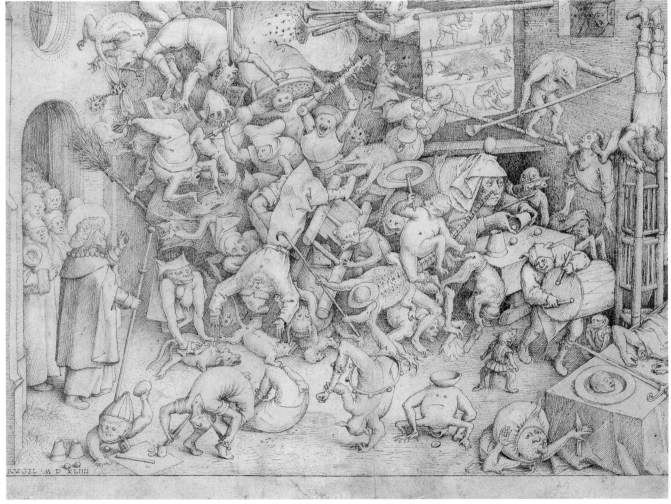

68 *Dulle Griet*, 1562
Oil on panel, 117.4 x 162 cm
Museum Mayer van den Bergh, Antwerp

The fantasy figure of Dulle Griet (Mad Meg) has stirred up wide-ranging interest in unearthing popular tales, legends, fairy tales, and even historical dreams, but she has so far eluded real explanation. A saying has her "plundering at the mouth of hell," that is profiting from the downfall of others. As she is clearly able to escape with the booty, she must be considered as an anti-heroine in confused times.

69 Hans Holbein the Younger
Philipp Melanchthon, ca. 1535
Oil on panel, diameter 9.5 cm
Landesgalerie, Niedersächsisches Landesmuseum,
Hanover

Philipp Melanchthon (a Greek translation of his real name
Schwartzerd) lived from 1497 to 1560 and was Professor
of Greek in Wittenberg from 1516. He advocated the
study of Hebrew, thus promoting a dialogue between
Christians and Jews. His training in rhetoric and dialectics
enabled him to be one of the first to systematize Luther's
Reformation (*Loci*, 1521). As with Erasmus and Luther,
philology and textual criticism formed the basis of his
scholarship. He translated many authors of antiquity and
published commentaries on them.

70 Hans Holbein the Younger
Erasmus of Rotterdam, 1523
Paper mounted on pine, 36.8 x 30.5 cm
Öffentliche Kunstsammlung, Kunstmuseum, Basle

Desiderius Erasmus, as he was called from 1496, lived
from 1466/69 to 1536, and became one of the leading
humanists of the north. He was an ordained priest, and
studied subsequently in Paris, London, and Italy, where he
became a doctor of theology in 1506. He became famous
around 1500, due to his collection of proverbs *Adagia* and
the satirical *Encomion moriæ*, which denounced an
antiquated and corrupt Church. He achieved scholarly
fame by the publication of the Greek New Testament in
1516, on which Luther's translation of the Bible is based.
From the 1520s, Erasmus endeavored to dissociate himself
from the Reformers, wanting to preserve a united
Christian Church.

In ancient times, rhetoric, with its rules for articulating
thought in public speech, was considered a basic science
that could also be applied to both the arts and precise
sciences. What it taught was which questions to ask, and
how to ask them. Sixteenth-century painting is nowadays
often interpreted in terms of rhetorical concepts and turns
of thought, which were taken over from classical antiquity.
Some painters adopted the explicitly rhetorical principles
of polemic art. So far, few comparable characteristics have
been observed in Bruegel, but even he uses allegorical
motifs, and symbolic subject matter not only features in his
work but pointedly so, whether he heaps up symbols in
the extreme manner of his *Vices* and *Virtues* (ills. 40–54)
series or introduces old rhetorical content in strongly
reduced form as in *The Fall of Icarus* (ill. 113) or the
Conversion of St. Paul (ill. 75). In cases where Bruegel
faithfully retains a motif such as the sorrowing Mary in the
Procession to Calvary (ill. 77), he nonetheless gives it a new
set of references.

A glance at the literature and rhetoric of his day can
forestall premature conclusions about the apparently inde-
pendent symbolism of individual motifs. Many details in
Bruegel's pictorial world do indeed appear old-fashioned,

and much seems to refer to medieval symbolism and its
rules of interpretation. Yet the transformed status occu-
pied by symbols and their interpretation in the 16th
century, in other words the modernity of his works, is just
as evident. The intellectual changes of the period affected
him as well.

Generating or understanding existing allegory as
symbolic representation in either text or pictures involves
exegesis. This is the process of interpreting the multiple
meaning of texts or pictures, and derives from ancient
Greece. In medieval theology, it became the predominant
typological approach to the interpretation of the Bible,
where the problem was to fit the Old Testament, the Bible
of the Jews, into the Christian framework of the New
Testament. This is where allegorical interpretation was very
useful, because everything that was written in the Old
Testament was deemed to be heralding a forthcoming
event to be fulfilled in the New Testament. The arch-
exponent of such interpretative practice was the Apostle
Paul, who in his letters to various Christian communities
supplied a figurative meaning for the literal, and, to some
extent, short-term proclamations of Jesus that had not
come to pass.

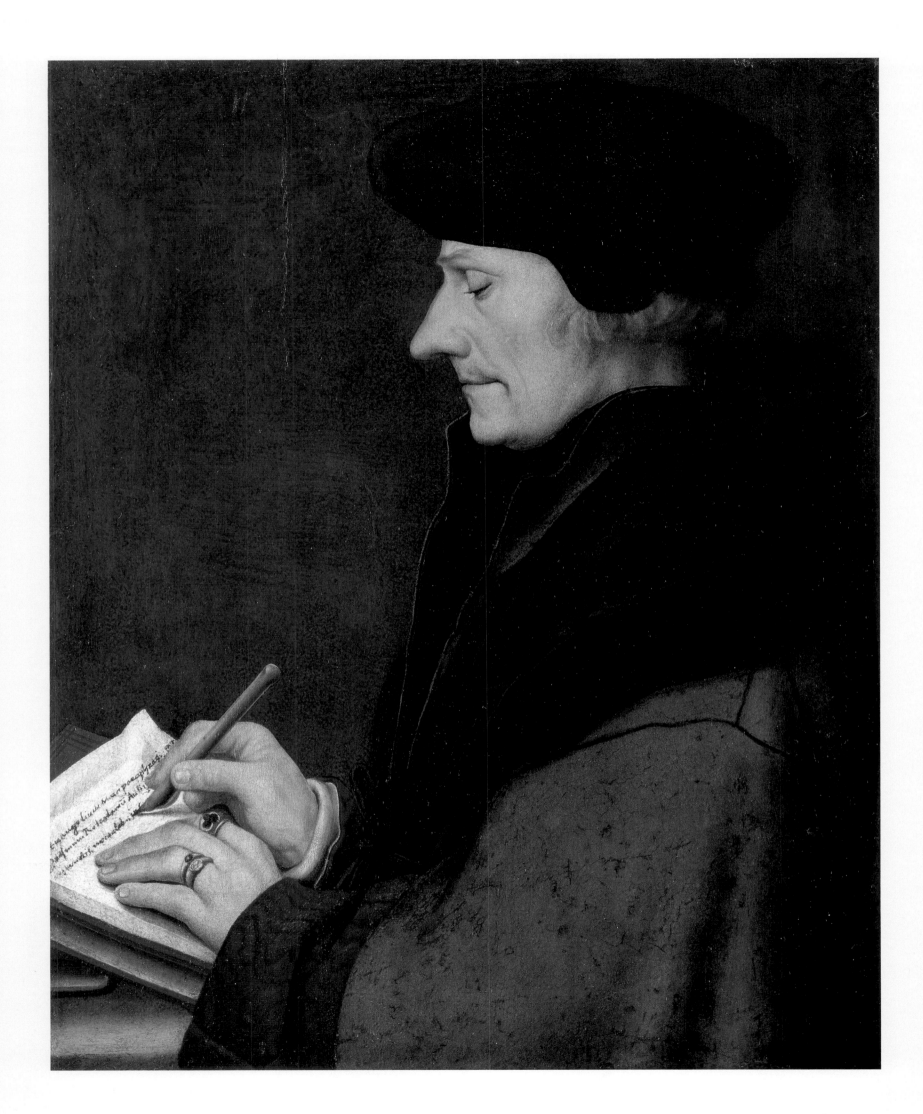

71 *The Alchemist* (detail), 1558
Pen in brown, 30.8 x 45.3 cm
Kupferstichkabinett, Staatliche Museen zu Berlin –
Preußischer Kulturbesitz, Berlin

The scholar's garb worn by the man at the desk was already
out of date in Bruegel's day. In his book it says *Alghe mist*
(it's all gone wrong). In the end, all that is left to his family
is the poorhouse shown in the background, with them
being taken in. Instead of increasing his gold, the
alchemist destroyed everything he possessed.

Yet the allegorical interpretations suffered from obsolescence, were downright fantastic, and over the centuries came to mutually contradict each other. Time and again it was demanded in the Middle Ages that the literal text be adhered to more strictly. But it was only with humanism and the new approach to textual criticism, based on printed editions and erudition founded on open debate, that historical interpretation regained precedence. Erasmus of Rotterdam (1466/69–1536), Martin Luther (1483–1546), and above all Philipp Melanchthon (1497–1560) demanded and promoted the teaching of Hebrew, consequently improving the knowledge of the Old Testament on its own terms. The fascination of an "original" language, as Hebrew was considered, worked in two ways. Scholars applied themselves to what were presumed to be the oldest written languages, hieroglyphics and Hebrew, and grammar and logic were pursued as precursors of a comprehensive theory of symbols. Speculation was thus set in train, the first cultural comparisons were undertaken, and their standards for comparison were refined against observation.

With classical Roman or Greek authors, exegesis featured most obviously as a strategy for Christian re-interpretation. In this way, in the Middle Ages Ovid's *Metamorphoses* could only be read and interpreted as a Christian text, every literal sense being forbidden as heathen. Dædalus was seen as God, for example, and Icarus as his self-sacrificing son. For humanists, the interpretation that was prescribed by the Church was not acceptable. Their historical and philological research yielded a verifiable historical meaning that had nothing to do with Christian allegorical equivalents. Connections that had been declared historically adequate did not need any allegorical interpretation to fit the straitjacket of the Christian belief in redemption. Allegorical exegesis appeared to be an arbitrary accretion.

Erasmus of Rotterdam's loyalties were split: although a Catholic, he was also an outstanding philologist with access to the sources of written knowledge that frequently contradicted Catholic doctrine. He made the Greek text of the New Testament generally available by printing *Novum instrumentum omne* in 1516, and published all the writings of Father of the Church of St. Jerome (1517). His collection of proverbs, *Adagia*, which was constantly reprinted from 1500, and his criticism of the Catholic Church in *Encomion Moriæ* of 1509 brought him fame. In 1521, Erasmus had to leave his home town, the university city of Leuven, because of suspicions of heresy, and he fled to Basle. However, the question of reform or scholarly opposition in the Reformation period cannot be oversimplified. Many scholars considered the Papacy capable of reform, and could not approve of Calvin or Luther's positions. After a dispute over communion, Luther and Erasmus fell out irreconcilably. Humanist Catholics continued to pursue the reform of their Church, which carried on into the period of the Counter-Reformation. The first multilingual Bible, which was an extremely time-consuming and costly Counter-Reformation enterprise, would appear in Bruegel's time, printed in Antwerp at the press of Christopher Plantin (1520–1589) with the support of Cardinal Granvella (1517–1586). In the Netherlands, the Catholics pursued important humanist projects with finance from the Spanish king Philip II (1527–1598), who was a loyal adherent of Rome.

Allegorical exegesis has been put forward as Bruegel's basic artistic approach. Allegorical interpretations of the paintings are still based on research by Carl Gustav Stridbeck in 1956. The principal theme is the depravity of the world. The blind in the *Parable of the Blind*, like the cripples, poor, and sick in other pictures by Bruegel, are not viewed as marginalized contemporaries but refer to unbelievers who do not find the way to the Lord because they trust in their own kind. The interpretations completely filter out creative aspects of Bruegel's art. They take medieval knowledge as their standard without noticing that this pictorial knowledge had been dismantled. Although Bruegel adopts the moralizing tone, he sets it in contexts that dispute its validity. Such games with the meanings of words and objects were very much in fashion in his day in the Netherlands. We cannot say for certain today whether painters such as Bruegel were in the vanguard of such experimentation or whether they were the expression of a broad oral culture of *rederijker*, which is no longer accessible to us. What is incontestable is that the 16th century was no longer under the sway the diktat of Christian morality.

The *rederijker* were organized, urban cultural guilds where burghers met each other. Such guilds were not restricted to the literati and artists, but also included merchants and artisans. An intellectually interested and thoroughly prosperous middle class had developed, which possessed a culture of its own, one not oriented to courtly ideals. It was among such people that Bruegel's printed graphics must have found customers. The main purpose of the guilds was participation in an annual *ommegang*, a street procession devoted to a particular theme that was presented by individual groups in learned and witty ways. Possibly Bruegel himself was illustrating an event of this sort when he has Rhetoric treading the boards in the background of *Temperantia* (ill. 46).

Looking beyond the narrower confines of Netherlands culture, we see what importance language and multilingualism had acquired, and was still acquiring, at the beginning of the modern era. Writers such as Rabelais (ca. 1494–1553) and Cervantes (1547–1616) reflected the coexistence of and conflict between various language levels and languages. It was the threshold of the era of modern literature, and *Don Quixote* was its first modern novel. Literature adopted the vernacular, and many books appeared in several languages at almost the same time, including Latin. The latter was still the language of learning, but in many places it had already declined into a vulgar form called *macaroni*. The great translation achievements of the time were renderings of the Bible in the vernacular, particularly that of Luther into German, and Tyndale and Coverdale into English, but also from Greek into Latin, such as that by Erasmus. Awareness grew of the manifold and necessary achievements of translation, which were inextricably bound up with writing and scholarship. It was a boom time for dictionaries, but also for games with words.

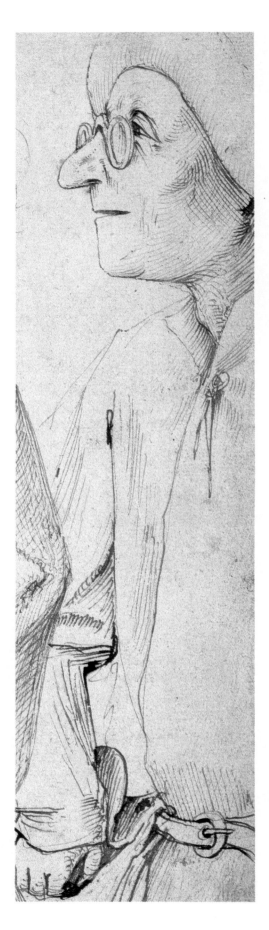

72 *Artist and Connoisseur* (detail, ill. 6)

With his glasses, the figure of the connoisseur is related to certain gaunt figures like the Magi's secretary in the London *Adoration* (ill. 81) and the assistant of the *Alchemist*. Whether the spectacles were, as has been supposed, an indication of intellectual incapacity cannot be proved.

FLEMISH BIBLICAL PICTURES

In the traditional classification of picture genres, depictions of Biblical scenes belong to history painting, that is to the highest category, if we follow the authoritative work on painting (*Della Pittura*) by the artist, architect, and architectural writer Alberti (1404–1472) published in 1436. History paintings were understood as any paintings with an event as the subject matter, whether the context was Biblical, historical or legend. In Bruegel's Biblical paintings, where the important event often recedes into the background, this genre classification is debatable in many respects. The 16th century, particularly the Mannerist period, was not a time when anyone in the Netherlands was noticeably interested in the hierarchy of art genres. On the contrary, sometimes deliberate disregard of the borders between genres was more highly regarded than observation of them. In Bruegel's case, the active figures are intentionally dominated by the landscapes in which they act. More important than the actions of the pictorial figures are the routes they can take and the positions they adopt vis-à-vis the landscape. In the modern titles, the fact is often taken into account with descriptions such as "Landscape with …," making the ostensible subject incidental in the title as well. *Landscape with the Parable of the Sower* (ill. 34) was the earliest example. But how could anyone consider, for example, such historical personalities as Saul and Paul as peripheral and see them treated incidentally? The problem is typical of Mannerism. Emphasizing what is important precisely by retracting it became a much-used artistic trick. That this contradictory form of emphasis could work at all was due to the fact that, unlike today, a purely landscape representation was still inconceivable. The painter could, therefore, rely on every viewer looking for the real subject. Establishing landscape's right to be considered a genre standing on its own, is due not least to Bruegel.

Although some of the pictorial subjects such as the *Suicide of Saul* (1562) or the *Conversion of St. Paul* of 1567 (ills. 74, 75) were not common subjects in the Middle Ages, attempts have been made to explain away Bruegel's concealment of the main subject on the basis of a medieval principle. It was surmised that in the theology of the past the view persisted that divine wisdom is hidden in the same way that God is hidden. In the Latin of scholasticism, the hidden God was called *Deus absconditus*, a model for the mysterious couching of insights – again a Latin word (*integumentum*). Yet there is a vast difference between Bruegel's incidental depiction and an intentionally mysterious reformulation that only becomes comprehensible after laboring at symbolic substitutions. In the *Suicide of Saul* and the *Conversion of St. Paul*, the main figures have to be sought, but there is no mystery about the way they are presented. They are almost completely deprived of anything that could make them mysterious: they are not placed in a symbolic array, but in a landscape with the utmost plausibility. Furthermore, Bruegel is sparing with spectacular light effects. The expansive landscape of the *Suicide of Saul* remains unaffected by the event, and for the time being no one notices the suicide.

As in the early paintings, diagonal lines dominate the compositions, shallower in the case of the *Suicide of Saul*, and very steep and rocky in the *Conversion of St. Paul*. Paul's train is proceeding from the bottom left into the mountains on the right, where dark clouds are gathering. On the coast from where they have come, sunny weather prevails, harmonizing with sea and ships. In the center zone, beams of sunlight highlight Paul. He has fallen from his horse and is lying on the ground encircled by his astonished retinue, who stand ready to help. Bruegel shows the moment when the fall and enlightenment jointly effect the conversion. Dark fir trees reinforce the light effects of the colors, the ground beneath Paul gleams bright, the apparel bright red, and some of the armor has white highlights. Almost all of the people are in the right half of the picture. Paul himself is very simply dressed, without a hat which he may have lost in falling, and in monochrome gray-green cloth, without armor. The severity of his clothing is an expression of modesty, which according to the Christian ideal of faith must precede a conversion. The back view of two riders, a dog-minder, and also the standard bearer, lead the eye towards the circle where the conversion is taking place. A fifth person on horseback has his arm flung out and is reporting what is going on in the middle. As both the riders and the viewer are witnesses to the occurence, the

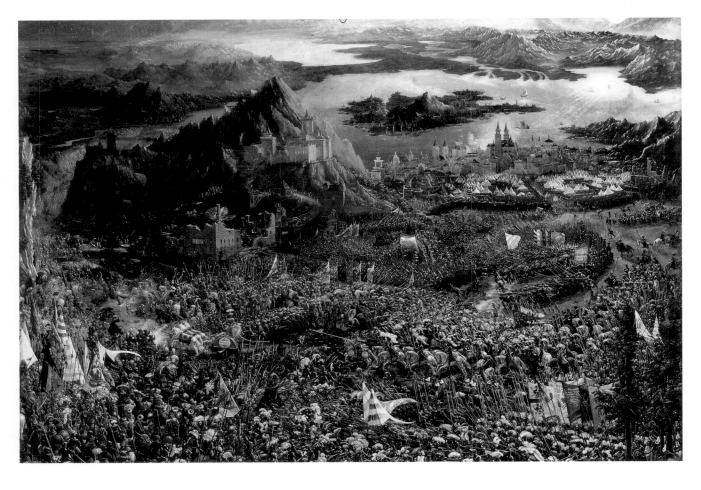

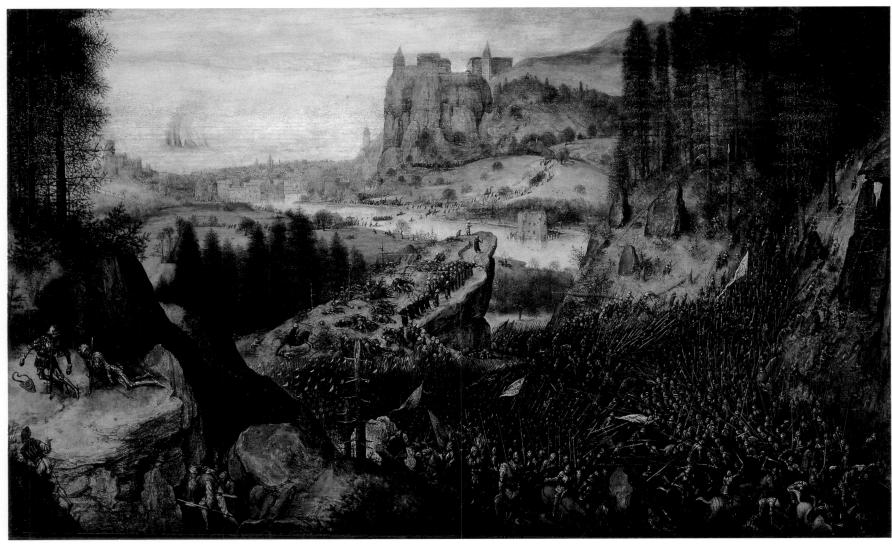

75 *The Conversion of St. Paul*
Oil on panel, 108 x 156 cm
Kunsthistorisches Museum, Vienna

St. Paul is the most important apostle after St. Peter. His conversion
to the Christian faith has always been a key Christian legend.
In comparison with the mountain landscape in the painting *Suicide
of Saul* (ill. 74), the formation shown here is unconventional: the
mountains are extremely steep, and the path reveals extreme
differences of height as it winds sharply upwards. This has been
attributed to Bruegel's direct experience of the Alps.

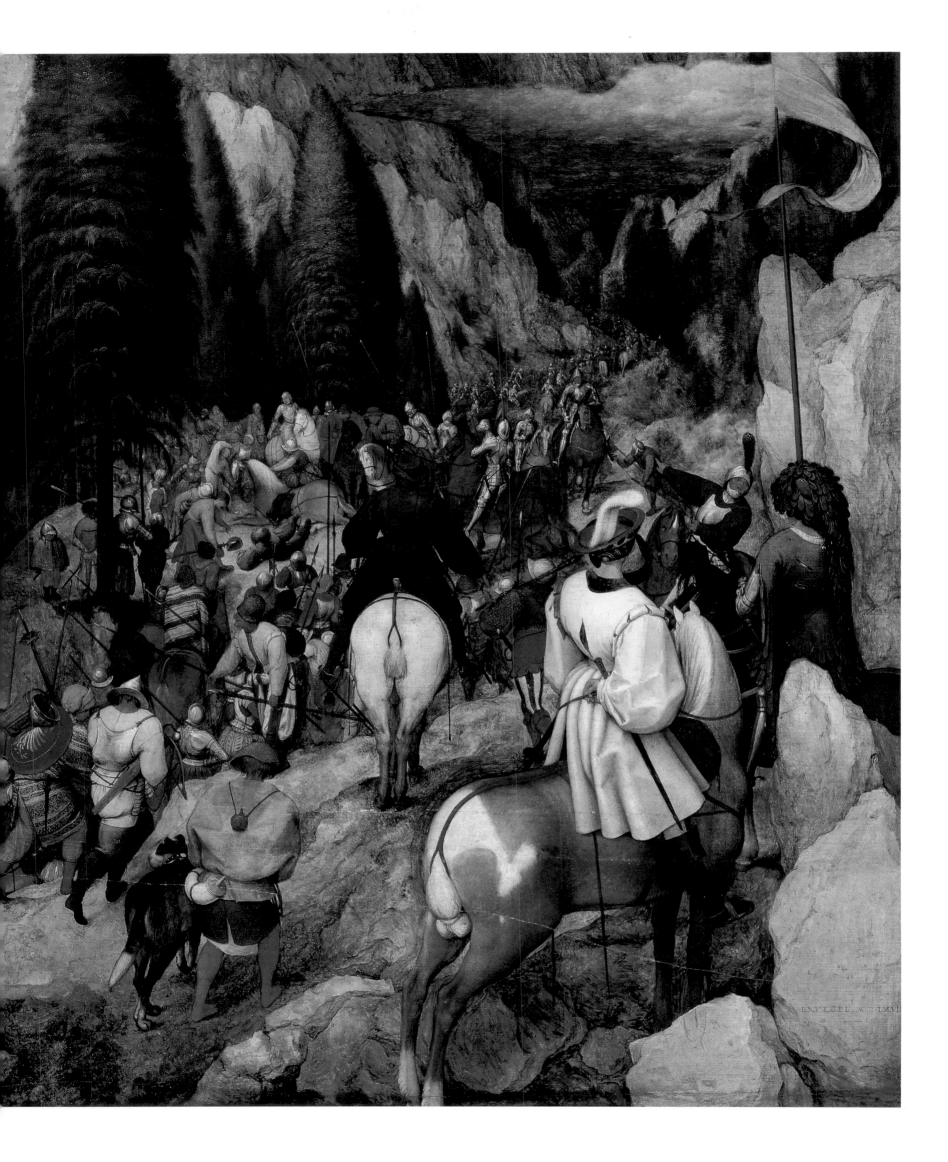

device is only a rhetorical reinforcement in the sense that he confirms the interesting nature of the event.

In the *Procession to Calvary* of 1564 (ill. 76), the eye has the same difficulty in finding the protagonist among the crowds. Dressed in a simple robe and with a crown of thorns on his head, Jesus collapses under the cross at the same moment as the soldiers tell Simon of Cyrene to carry the cross for him. Simon protests (ills. 77, 78). By being placed spatially at such a distance, the two groups of figures create a relationship of tension. People step back, and a rider clears a path so that the resisting Simon, whose wife energetically demonstrates her support, can be dragged to Jesus. As other painters had done before him, Bruegel uses a broad expanse of ground for the overall picture, extending in a curve from the town in the left background, around the windmill on a crag to the place of justice in the distance. Golgotha, the place of execution, is shown here not as a hill, but as open ground beside the next town, which is itself visible on the horizon in the right background. However, wheel

gallows on the right edge of the picture, beneath which is the skull of a horse, bring the subject of execution much closer. The circular shape of the wagon wheel noticeably echos the circle of spectators that has formed around Golgotha to watch the forthcoming executions. Bruegel uses such correspondences of form and content many times. However, this second "place of skulls" has another iconographical purpose, in that Bruegel presents within a single picture two Crucifixion subjects that usually require separate pictures. In addition to the story of Christ carrying the Cross, there is the anticipation of the Lamentation of the dead Christ at evening vespers. Mary sits surrounded by Mary Magdalene and others on an open plateau overlooking the broad arena of the procession. St. John, the beloved apostle of Christ, supports her carefully by the arm. Her eyes are closed, her cheeks wan and hollow. Her attitude is that of a woman exhausted: her arms are draped feebly over her left thigh, hands folded. The scene is Bruegel's anticipation of the theme of redemption by Christ's death, and it lends the painting a new

76 *Procession to Calvary*, 1564
Oil on panel, 124 x 170 cm
Kunsthistorisches Museum, Vienna

The painting links two very popular subjects – the carrying of the Cross, which had already offered Jan van Eyck an excuse for broad landscape depictions more than a century earlier, and an anticipatory Lamentation, which is shown close-up and is therefore more intimate. Both scenes are embedded in an enormous crowd of background figures, which were given as much creative attention as the Christian scenes. Probably even in his day, this elaboration of subject matter was a form of competition with the "old masters." Imitation of this sort was known in rhetoric and art as *æmulatio* (emulation).

77 *Procession to Calvary* (detail of ill. 76)

Jesus collapses beneath the Cross. To mock him and his almighty God, he was the only one of the condemned who had to carry the cross himself – God was expected to reveal himself and help him.

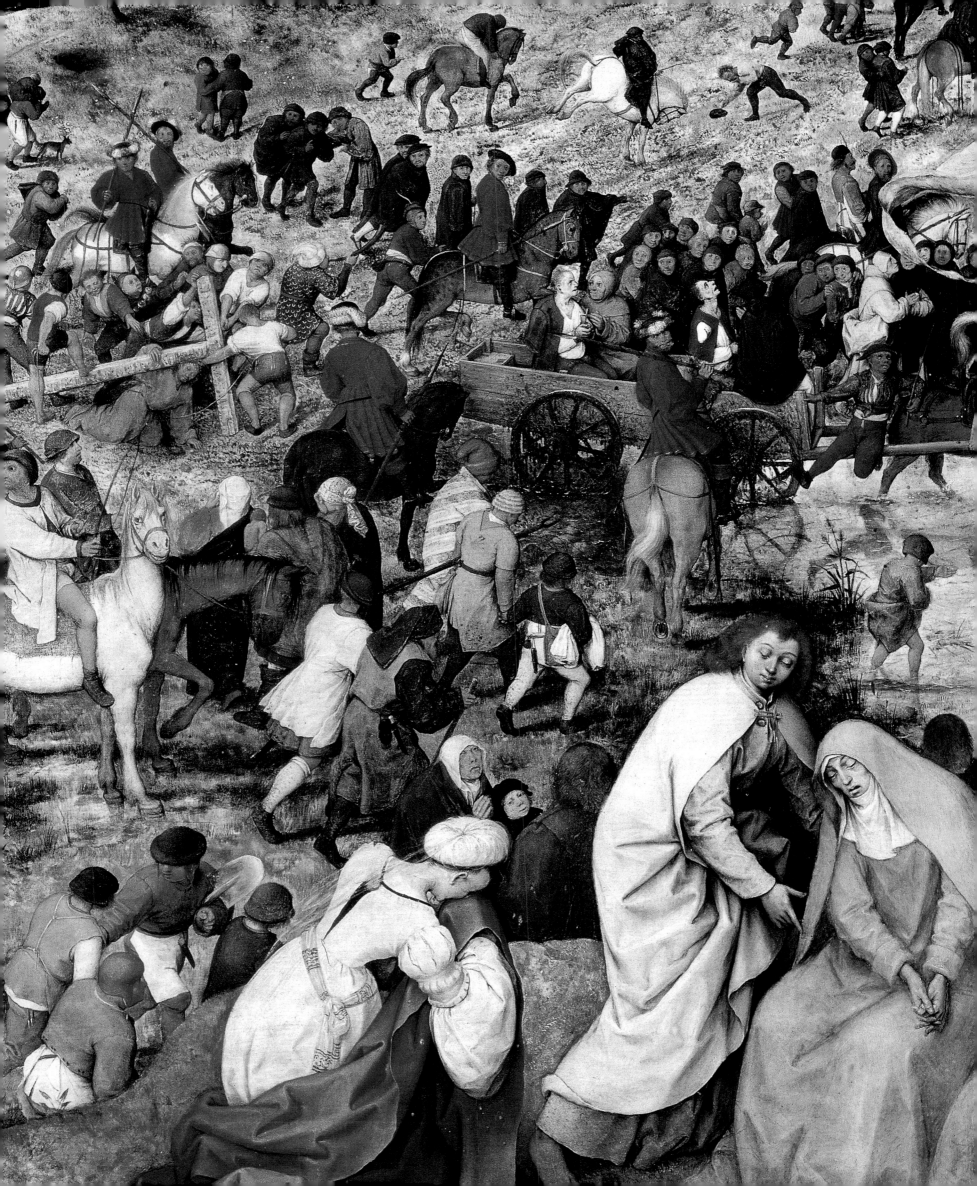

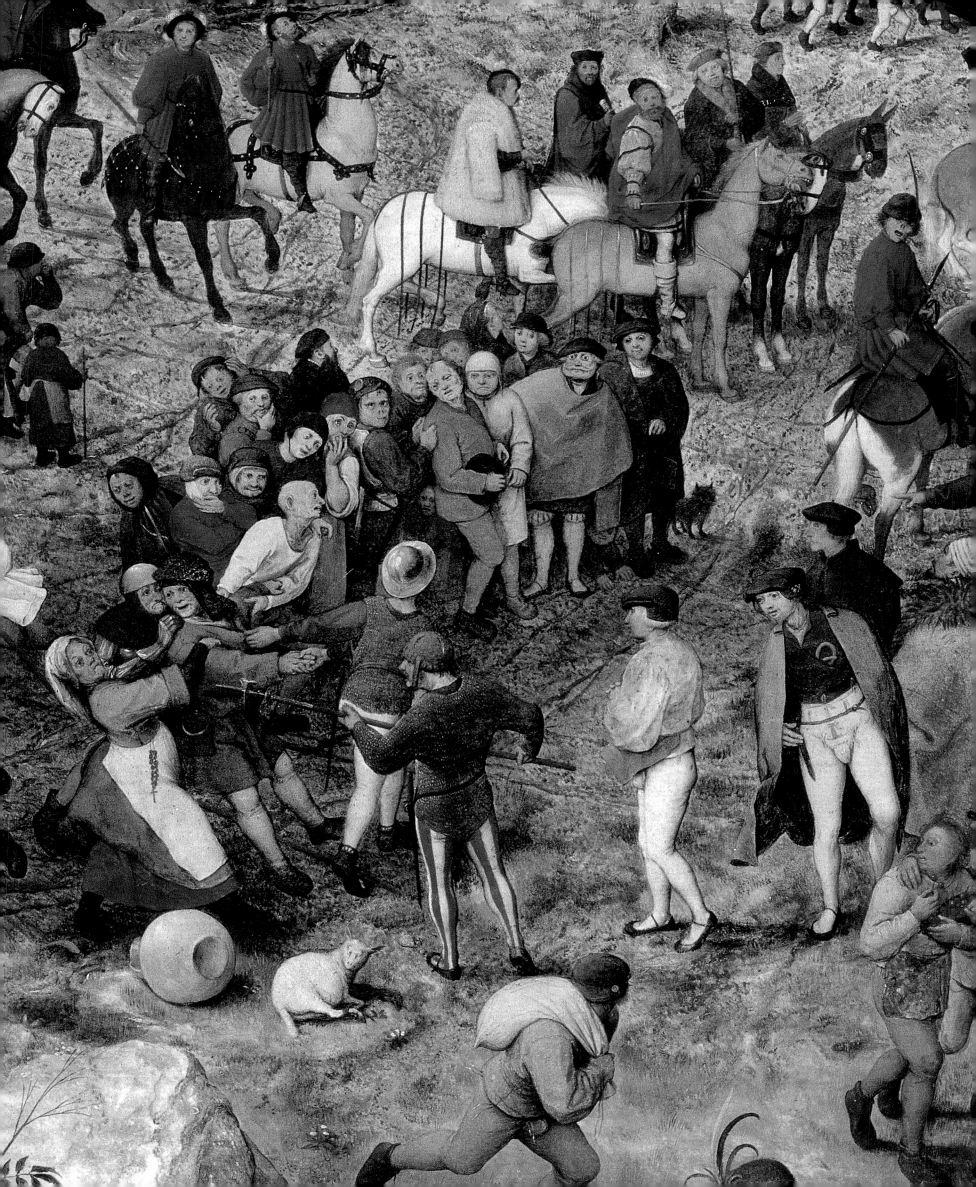

religious profundity. Nowhere else in the picture are Christian sympathy or the awareness of the historical importance of the event expressed in this way. On the contrary, Bruegel emphasizes the worldly character of the procession as that of a rare spectacle that no one should miss. Traders, idlers, cheerful shepherds, children, and dogs all trail along for the show. They set up a number of secondary scenes that divert attention from Jesus, and all kinds of mishaps take place.

The two criminals condemned with Jesus ride in front of him in a cart. They attract curious, sometimes alarmed gazes. One of the criminals is accompanied by a monk, and prays with a cross in both hands. By this scene at the latest, which includes Christian prayer and forgiveness of sins even before the Church was established, it becomes clear that Bruegel is posing a question of faith that was pressing in his day – how would Christ be accepted among us today? How much does the Church of our day have to do with Christ's self-sacrifice? Such reform-oriented thoughts bring Bruegel very close to the *devotio moderna*, the late-medieval devotional movement strongly influenced by the medieval preacher of repentance, Gert Groote (1340–1384). In the Netherlands of the 16th century, the basic tenets of its religious philosophy were widely understood, and due to the movement's charitable work, so widely admired that it gives no clue as to the artist's confessional attachment. Indeed, the juxtaposition of a very profane depiction of Calvary and a scene from the Passion, which is more appropriate to private devotion, constitutes a contradiction. After all, Mary's mourning is to be looked on as exemplary, and nothing ought to distract from the intense relationship. In Bruegel's painting, however, everything seems to distract, so that the group in the foreground provides both compositionally (that is as a *repoussoir* motif) and religiously a calmer, even meditative antithesis to the worldly bustle occurring elsewhere.

The depiction of the *Tower of Babel* from 1563, now in Vienna (ill. 79), must be reckoned to be among Bruegel's outstanding achievements. The tower, which was intended to take mankind into Heaven, was a blasphemous undertaking. What humans were doing was claiming a position that was the exclusive right of their God. As a punishment, God stirred up strife among mankind and finally imposed a babel of languages. In this picture, the great work is being constructed in a polder landscape, whose only rock is being used as the base of the tower. A harbor serves to bring in building materials. The hill from which the works can be viewed also allows King Nimrod, who has ordered the building, a chance to survey it and, as the kneeling stonemasons indicate, monitor progress on the work. With seven extremely tall stories already erected, each of them formed of rows of windows and arches, the tower has already reached the first clouds. The base is so broadly laid out that half the city lies in the shadow of the tower, and its supporting walls are as wide as a peasant's house. The building technique is reminiscent of Roman arenas such as the Colosseum in Rome, although that is open inside. It is not out of the question that

Bruegel used his own, now lost, sketches of Rome from his Italian visit, but in any case he had access to the *vedute*, printed by his publisher Hieronymus Cock before 1550, as an *aide-mémoire*. Bruegel reproduces the building site and its workers in the distance in fascinating detail without losing the atmospheric perspective. Man-powered treadwheel winches for lifting heavy weights can be discerned (ill. 1), as can the vaulting technology for the many arches and buttresses that make up the tower. Once the keystone is in place in the center of the arch, the wooden scaffolding beneath the arch can be removed. Service buildings litter the terraces of the structure. Dressed sandstone blocks appear to be used only for the exterior; in the interior, reddish brick is used. In many places on the Tower, it is evident that drawing the design of the building was not so simple. Corrections were necessary (as can be seen in the top left of the picture), which can be recognized with the naked eye. The reduction of the upper arches had to maintain a balance between the aim of appearing higher and more distant, and the actual reduced dimensions of the arches. As was so often the case, it is the people working and their tools that provide a reliable scale and make the perspective reduction of the Tower credible. This can be seen, for example, at the right-hand side of the Tower, where Bruegel neatly places workers atop a wall against the sky and likewise positions the very smallest figures high in the sky, to create silhouettes that furnish reliable points of comparison to estimate distances in the painting.

A second *Tower of Babel* (ill. 80) is smaller in format and lacks the foreground vantage point. Building work is further advanced, with five tall stories now completed. Bruegel also dispenses with the complications of incorporating an outcrop of rock into the construction. Again, the incalculable size of the Tower is reinforced by atmospheric coloration. Dark clouds draw in round the building. A third, still smaller version is mentioned in the inventory of Giulio Clovio's possessions, but has vanished without trace.

There are several diverse representations of the *Adoration of the Magi*. Two paintings, now in Brussels and London, show the three wise men close by the stall where Mary and the baby Jesus lie (ills. 81 and 83). Bosch did a similar rendering of the scene, especially notable for its comparable backdrop of comic, nosy bystanders, which today look like caricatures. More astonishing and novel than these is Bruegel's *Adoration of the Magi in the Snow*, now in the Oskar Reinhart Collection in Winterthur near Zurich (ill. 82). The setting is a snowbound Flemish village dominated by a ruined castle. Opposite, on the left, is a small hut outside which a crowd has gathered. Unlike in the traditional depictions, there are no costly fabrics, gifts, or regal insignia on display. The unspoken message used to be that the representation of the visit of the three Kings was always linked with the alliance of the soon-to-be-established Church with secular power, understandably an iconography with which later rulers could identify.

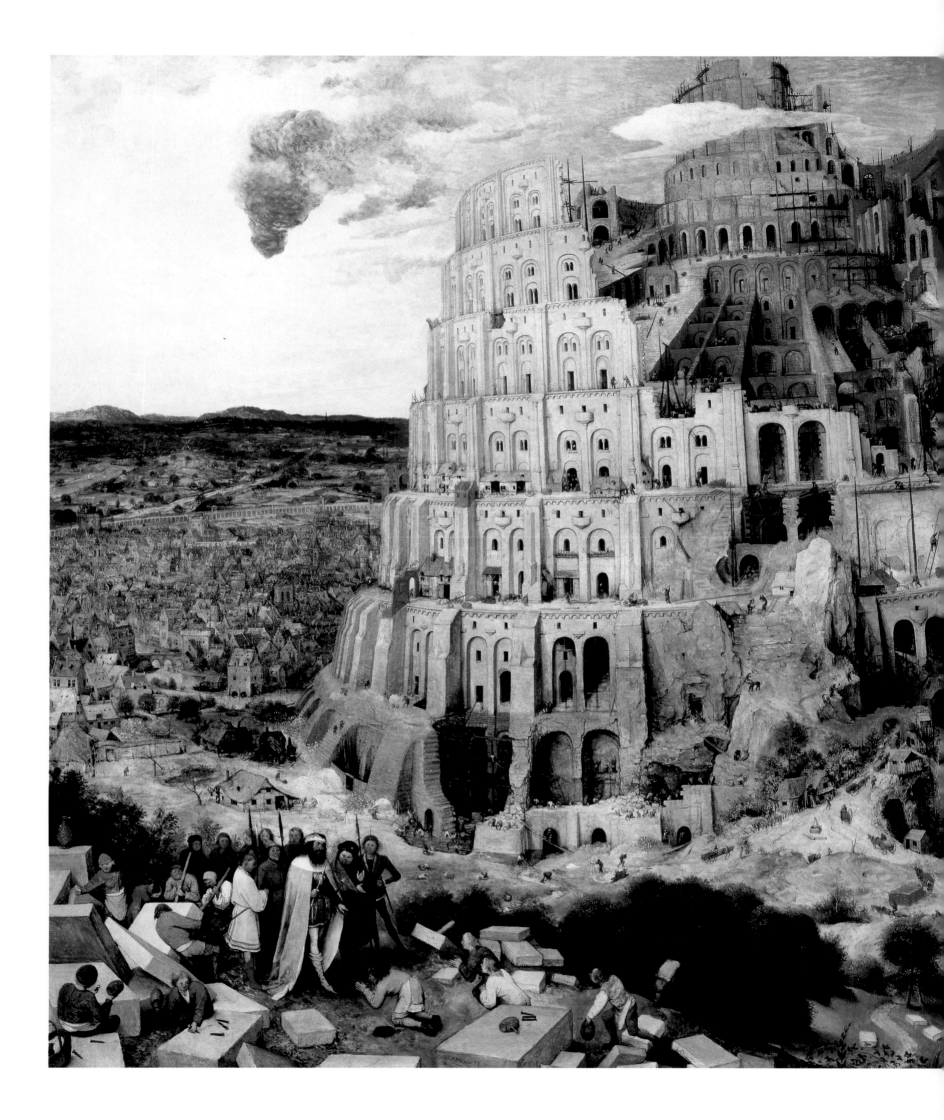

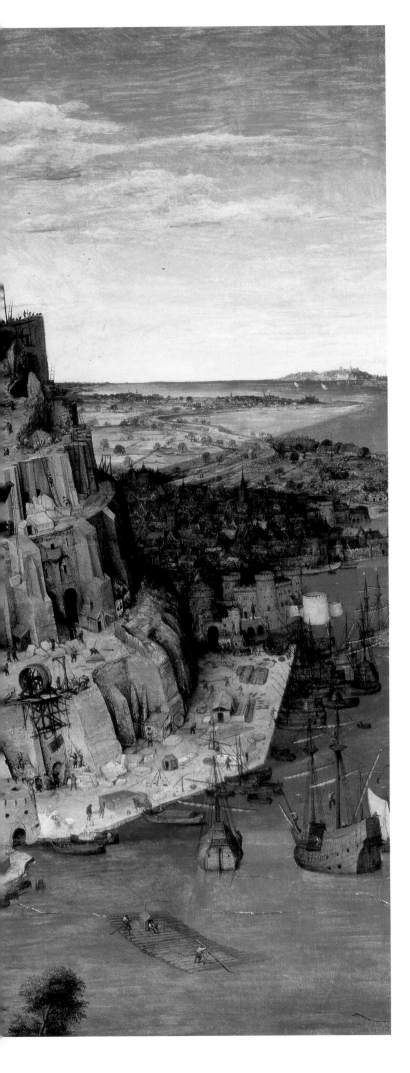

80 (below) *Tower of Babel*, ca. 1563
Oil on panel, 60 x 74.5 cm
Boijmans van Beuningen Museum, Rotterdam

In the smaller Babel picture, construction appears almost complete. Lacking the foreground scene with King Nimrod, who ordered the building, and his artisans, the tower seems more distant than in the larger version (ill. 79). The subject was already featured in book illustration as a welcome opportunity to paint construction scenes. Bruegel focuses less on the failure of the enterprise than on the fascination of such a gigantic and curious structure. The criticism of the pagan Romans, whose Colosseum ruin Bruegel knew personally and used here as a model, also remains a very limited aspect. Only rarely did Bruegel himself repeat a subject as he does here.

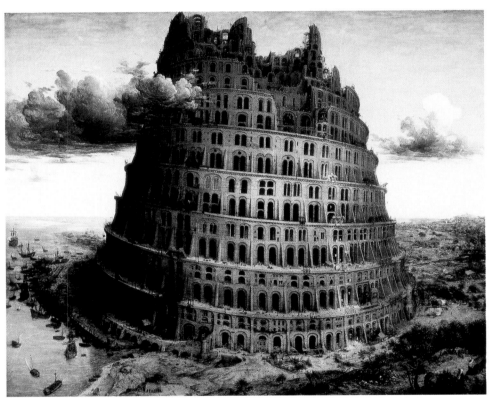

79 (left) *Tower of Babel*, 1563
Oil on panel, 114 x 155 cm
Kunsthistorisches Museum, Vienna

The story of the erection of the Tower of Babel is found in Genesis 11,1–9. God prevents the completion of the tower by sowing linguistic confusion among the builders and scattering them abroad. The "Babylonian babel" had its New Testament response at Whitsuntide, when the unifying presence of God is celebrated in the Holy Ghost as a "linguistic miracle." While Bruegel was painting, the language dispute was given new relevance by the split in the Church.

In Bruegel it is quite different. He opts decisively for the interpretation of Epiphany (January 6) as the celebration of the appearance of God on earth for all people. If it were not for the various armed – and even they are not mounted – soldiers on guard, all and sundry could visit the Holy Family. Bruegel's modernization of the material is not limited to amending ornate pictorial decoration into plain. He translates the whole picture into terms of everyday experience. The snowflakes are an optical innovation that virtually proclaim the art of accurate observation. This is not snow that has already fallen or is falling in the pictorial distance a long way from the viewer. The flakes are so large that our eye is bound to encounter them; as we look through the "frame" of the picture, our gaze has to pass through falling snow. Such an observation might be considered over-subtle, yet it draws attention to a pioneering artistic interest that expects its own art to process real visual experiences and reproduce them in pictures. The group with Mary, the Child, and the worshippers is pushed to the extreme left margin, while fetching water from the frozen pond, drawing water with a bucket through a hole in the ice, is deemed by Bruegel at least as worthy of attention as the scene in the stable. Moreover, greater tension is created by the child on the sledge, who seems unconscious of the imminent danger he faces of falling into the ice hole, than by the nativity scene. In direct contrast to the Biblical text, tension is created for its own sake. It is diffused over the whole scene, thus also conferring a dramatic impulse on the Adoration as well, which the otherwise customary extravagant vestments would have diminished.

Snowbound settings of New Testament events occur a number of times in Bruegel. As well as the Winterthur *Adoration*, there are the *Massacre of the Innocents* and the *Numbering at Bethlehem* (ills. 84 and 86); for the sake of completeness, mention should also be made of *The Hunters in the Snow* (ill. 96) from the *Months* series, which is not Bible-based. However, in none of these other scenes is it actually snowing. The reason could have been that reproducing a snowstorm artistically over a large painting area might be difficult – the *Adoration* is among the smaller oil paintings. From time to time, book illuminators also undertook representations of snowy scenes, these included the Frenchman Jean Bourdichon (1457–1521) and Simon Bening, who was closer to Bruegel.

The *Numbering at Bethlehem* shows a village familiar from other paintings by Bruegel. Thus the basic layout can be compared with the *Battle between Carnival and Lent* or the *Proverbs* and *Children's Games*. The perspective over a broadly laid-out village square opens from a corner house, once again an inn. The square extends diagonally upwards to the right, but also opens up to the left, beyond the inn. For the numbering, the inn becomes a temporary official census station. Inn names were often recognizable from symbols, which might be painted on signs or boards or hung as objects on the building. This hostelry could have been called "The Laurel Wreath," since that is what is hanging on a pole

from the upper floor. Beneath this an official badge appears to be fixed, showing a black and gold eagle on a red background – this may be an indication of Habsburg power in the Netherlands in Bruegel's day. The census seems to be linked with collecting taxes, because the official who is writing appears to be receiving payment at his window as well. The crowd clusters around his "counter," but they have come not only because of their obligations as subjects. Some are warming themselves inside, while outside the inn pigs are being slaughtered, as was customary at this season. A man kneels on the neck of the pig while a woman with a pan collects the pig's blood. This was the traditional calendar iconography for the month of December. The straw is all ready for the bristles to be singed off. Amid a multitude of anecdotal winter scenes, ranging from dice through skating, throwing snowballs, sweeping away the snow, and tapping wine to the often depicted whipping of tops, Joseph and Mary approach. Joseph is leading an ox and an ass to the inn, while Mary sits on a donkey wrapped in an ample cloak and holding a basket. A counterpart of the Holy Family is another group, a couple with an infant, coming over the ice. None of the gospels say whether the census recorded Mary and Joseph before the birth, or whether the Child had already been included.

In the *Massacre of the Innocents* (ill. 84), the sky is much darker than in the *Numbering* scene. Again, a village with similar houses and a comparably broad street is shown, but it is more densely built up. This street is the setting for the massacre, which was actually aimed at the young Jesus. Many innocent victims died, but Jesus was not found as his parents had already emigrated to Egypt with him. Once again Bruegel's mastery of pictorial organization is unexcelled, including several dozen figures distributed over sundry plausible centers of action, each with their own distinct character. Overarching activity ensures the unity of the action: in the background is the commander with further troops, while riders pursue escaping mothers right and left. The lamenting for dead children runs like a trail across the snowbound square, in the same way as the pleading for mercy by parents whose children are being snatched from them. Historically it is probably not accurate that Bruegel also painted older children as victims of persecution.

Bruegel's views of snow-clad towns and landscapes and his few "monochrome" works, *grisailles* painted only in tones of gray, return to the same skill of using only a few color tones for modeling. In the *Death of the Virgin*, the result is an extraordinary light that spreads between Mary and St. John, dreaming by the fireplace. The legend is that St. John experienced the death with her and wrote an apocryphal text. It is somewhat surprising that this picture should have been owned by the humanist and friend of Bruegel, Abraham Ortelius (1527–1598). Virgin subjects had after all been popular religious topics since the Middle Ages and did not exactly furnish occasion for erudite discussion. And yet in 1574 Ortelius even had an engraving made of the picture.

81 *Adoration of the Magi*, 1564
Oil on panel, 111 x 83.5 cm
National Gallery, London

In this, his only portrait-format work, Bruegel shows the Three Wise Men and the Holy Family in close up. The soft outlines of Jesus and the soft facial features of Mary have been compared with works by Raphael. They are in gross contrast to the coarse features of Joseph and other onlookers, who were clearly shaped contrary to the usual precious decorum. Whether kings or shepherds were visiting is virtually irrelevant for Bruegel.

82 *Adoration of the Magi in the Snow*, 1567
Oil on panel, 35 x 55 cm
Oskar Reinhart Collection, Winterthur

This *Adoration* is Bruegel's most modern version of the event. The
focus of the representation is on the everyday, indeed poverty-based
part of the picture, not on the depiction of costly ornaments and the
wealth of the kings.

83 (below) *Adoration of the Magi*, ca. 1564
Tempera on cloth, 121.5 x 168 cm
Musées Royaux des Beaux Arts de Belgique, Brussels

In 1564 two *Adoration* paintings were done in response to
Hieronymus Bosch. Bruegel's version of the visit of the wise men from
the east stresses the historical importance of the feast of Epiphany by
the presence of "normal" people. There is whispering and smirking; it
is not just pious faces that are seen. The work is among the few
surviving works on cloth, carried out in watercolors (tempera) and,
therefore, particularly delicate in the face of destruction.

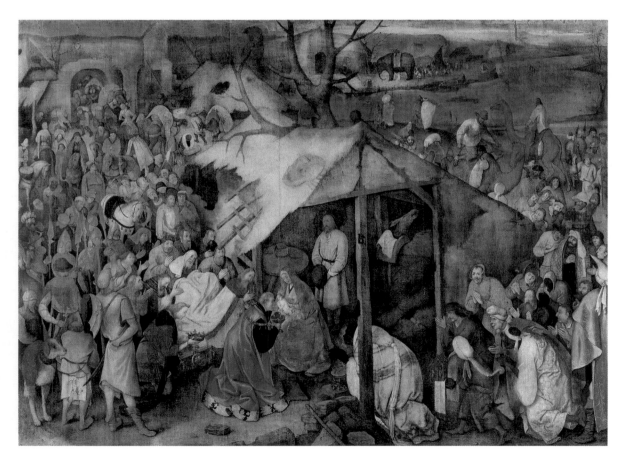

84 *Massacre of the Innocents*, ca. 1565
Oil on panel, 109.2 x 154.9 cm
Royal Collections, Windsor Castle

When King Herod heard that a new king had been born in
Bethlehem, he feared for his throne. A powerful man's fear and a
misinterpretation are consequently the trigger for the persecution of
infants, although Jesus later proclaims that his kingdom is not of this
world. Bethlehem is snowed under, the houses lie far apart. Doors are
broken down, people are driven out. Suckling babes and toddlers lie
dead in the snow, while others are still being protected by their
parents. But the superior force of the soldiers makes the futility of
their actions clear.

85 Cornelis Massys
Arrival of the Holy Family in Bethlehem, 1543
Oil on panel, 27 x 38 cm
Gemäldegalerie, Staatliche Museen zu Berlin – Preußischer Kulturbesitz, Berlin

The Holy Family is looking for accommodation and inquires at an inn. The village is brought to life and, as in Bruegel, the main personae fit in with the overall genre-painting nature of the event.

86 *The Numbering at Bethlehem*, 1566
Oil on panel, 115.5 cm and 164.5 cm
Musées Royaux des Beaux Arts de Belgique, Brussels

The census carries features of a fairground dampened by cold weather. Carts with barrels, a pig-killing, skating, and many other things are easier to grasp from the picture than the circumstance that the tavern on the left edge of the picture is being used for a census. But beside the carts with wine barrels, a carpenter is leading a donkey on which a woman sits in a blue cloak; this richly-clad figure of Mary in traditional pose represents the clearest reference to the Christmas story.

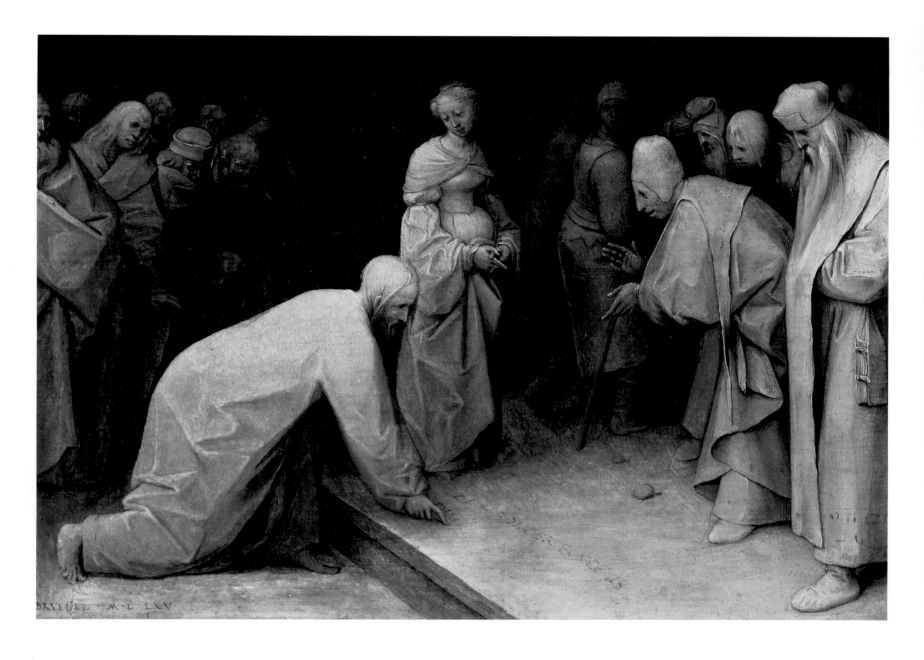

87 *Christ and the Woman Taken in Adultery*, 1565
Grisaille, oil on panel, 24.1 x 34.3 cm
Courtauld Gallery, London

Jesus has scratched in the dust at the feet of the elegant adulteress the Dutch sentence: "Let him that is among you without sin cast the first stone" (John 8, 3–9). The mantles of the Jewish scribes are inscribed with pseudo-Hebraic script. Bruegel thus keeps to the historic situation in which Jesus turns against old Jewish law. At the same time he also sets downs the famous words of mercy, comprehensible to all, in the local language.

Bruegel devoted another grisaille to the gospel story of *Christ and the Woman Taken in Adultery* (ill. 87). The composition consists entirely of numerous figures plus the stepped floor on which they stand, which is rare in Bruegel. Jesus and the woman he is protecting stand in the center, while to the right of them are the accusers, Jewish priests in prayer gowns the borders of which are trimmed with mock-Hebrew characters. Jesus bends over the step and writes in the sand: "Let him that is among you without sin cast the first stone" (John 8, 3–9).

The contrast of languages – a translation of the core Bible location into the vernacular on the one hand and the reference to the Hebrew culture of the priests on the other – is characteristic of Bruegel. He is not interested in a maximally correct reconstruction of the situation but in comprehensibility, taking the historical circumstances into account. Jesus, the young woman, and the priests stand out from the surrounding people and are brought by the act of writing into a psychologically intricate situation that is pregnant with waiting and silence – the decisive word is written. Only in the London version of the

Adoration of the Magi does Bruegel fill the frame with his figures to a similar extent.

The *Sermon of John the Baptist* of 1566 (ill. 89) has given rise to most speculation about Bruegel's confessional loyalties. Both the painter and onlookers stand, to some extent, in the back row and can see only the audience. A clearing or the end of a forest path forms the open-air meeting place. Indeed, forbidden meetings did take place outside the towns in Bruegel's day, where Anabaptists persecuted by the Inquisition preached and held services. Such preachings were called "hedge sermons." Compared with other pictures by Bruegel, the participants are dressed historically, and nothing refers to the impoverished classes amongst whom the Anabaptists found the most numerous following. The audience is attentive, but does not show either any reverence or particular devoutness. Two members on the right are discussing the contents of the sermon, and in the middle at the front someone is palm-reading. All this is much more the pictorial expression of the search for faith than part of a Christian catechesis that regarded John the Baptist as a teacher of Jesus. In the time of Christ, John the Baptist

was an independent religious leader who appeared in the desert and baptized in the lower reaches of the Jordan. His origin is unknown. The gospels depict him as a forerunner of Jesus and interpret his baptism as Christian. In the meantime, the rivalry that arose between the two sets of followers became obvious in the discrepancies between the gospels, which of course appeared only decades after Christ's death. The Johannine baptism was dismissed as unspiritual in contrast with Christian baptism.

Bruegel shows not a desert but one of his forest views, with a distant prospect over a river landscape.

Here too, the overall composition is adapted to his own day and the familiar landscape. After all the sophisticated layers of meaning Bruegel had already introduced in his earlier works, he must have expected a subsidiary association with hedge sermonizing. In the end, it is in any case not so far removed from the historical subject of John the Baptist's preaching. The visualization of the situation with John preaching tries to be historically fair to the modesty of appearance and the discipleship of Jesus of Nazareth. Both use everyday situations and occasions to portray their message, which links them with the hedge preachers.

88 *The Vices of Apelles*, 1565
Pencil and brown ink, 20.4 x 30.7 cm
British Museum, London

The Greek writer Lucian reported that the painter Apelles (second half of the 4th century BC) painted thoroughly lifelike representations of the vices to work off his rage after he had been slandered. This text gave rise to Bruegel's composition following the antique ideal. As the vices all serve calumny, those of Apelles could also be represented. The subject is, with the *Fall of Icarus*, one of the few topics from classical antiquity in Bruegel, but the artist's touch is surprisingly sure.

89 *The Sermon of John the Baptist*, 1566
Oil on panel, 95 x 160.5 cm
Szépmüvészeti Múzeum, Budapest

The Baptist was increasingly shown as a preacher during
the 16th century. He stands right at the back but is
emphasized by the attentiveness of his audience and the
outdoor arena in which he is speaking. With his left hand
he appears at that moment to be proclaiming the
importance of Jesus, who stands not far away. John is thus
shown as an itinerant preacher and teacher of Jesus on the
one hand and a messenger proclaiming the coming of the
Messiah on the other.

90 *Massacre of the Innocents* (detail of ill. 84)
Duke of Alba

The leader of the soldiers dispatched by Herod to hunt down the newborn King of the Jews has been identified with the Spanish Duke of Alba. This would equate the Biblical massacre of the children with the Bloody Councils that took place in Brussels and Antwerp in 1568 to bolster the Spanish Catholic rule. The subsequent punishments cost thousands of Flemish lives. With a portrait of Alba as Herod's military leader, religion and politics were inextricably linked in Bruegel's pictorial world as well.

In the 16th century, the Netherlands were under Habsburg rule but, initially, not under military occupation. Through Charles V (1500–1558), Austria gained the Spanish crown and reached its greatest power. Only England and France resisted his imperial claim to be the first among the kings and to express it, additionally in terms of ecclesiastical polity. The lesser duchies in the area of the present-day Benelux countries initially had no reason to question his rule, much less rise against him. Charles often resided in Brussels and spoke their language, being master of both French and Flemish. The local princes took part in the exercise of power via a state council; the economic strength of the Netherlands trade centers, principally Antwerp, which at the time was larger than Paris, constituted a mutual interest. After all, in earlier days constantly increasing tax revenues had been expected from the Netherlands only when prosperity was increasing, and the Habsburgs needed this money for their wars against the North African Muslims and Ottoman Turks. The former threatened Spain, the latter Austria.

When Charles abdicated in 1555 and passed power to his son Philip II, already existing tensions were reinforced. After Luther published his Theses in 1517, Charles had adopted a strictly Roman Catholic line against all Protestant forces or even those just critical of the Church. Yet, without lessening the importance of the burning of heretics, it must be said that he was largely successful in asserting doctrine by political means. Unfortunately, his son Philip lacked any diplomatic insight into the Netherlands and its political culture; he had grown up in Spain and spoke no Dutch. Government business would have required his presence in both Spain and the Netherlands, but in 1559 he withdrew permanently to Spain and in consequence was poorly informed about the situation in the small Lowlands states. He thus failed to notice that the religious dispute had turned into a social and economic debacle that only strengthened the reformers.

Processing English wool into cloth had, since the 15th century, been a highly profitable business for Bruges and Ghent, and later also for Antwerp, that involved trade all the way across Europe. Long-distance trade and traffic of goods likewise flourished. But increasingly England was making the cloth itself, and ports such as Lisbon were better-placed for world trade than Antwerp, which thus terminated the dependence on Netherlands trading centers. Both turnover and profits fell in the Netherlands. Added to this catastrophe came a disastrous drought in around 1560, which usually could have been offset by buying in Eastern European grain. Unfortunately, transport routes via the Baltic had been blocked in that and subsequent years by the war between Denmark and Sweden. Famine was the result. In this situation, Philip introduced several new taxes, because revenue from existing taxes was down due to the country's poverty. The council of state was deprived of power, and Philip's sister

Margaret of Parma (1522–1586) ruled as Regent, surrounding herself with three staunchly Roman advisers. One of these was the Bruegel collector Perrenot de Granvelle, Cardinal Granvella.

Desire for reform in the Netherlands did not date back only to the appearance of Luther or Calvin. The popular preacher Gert Groote had founded communities of lay brothers back in the 14th century who preached a new piety. Their message was all the more convincing in that, unlike the clergy, their lives reflected it. They preached and prayed in the everyday vernacular. They set up important institutions for looking after the poor and the sick, and these worked together with the *béguinage* charitable houses. However, in Bruegel's day, the most rapid increase was in the number of Baptists, also known as Anabaptists. They came out against the connection between Church and State, against any higher authority, and even Luther's reforms. Their creed was the declaration by adults of adherence to a community whose followers of Christ stood in the service not of the State or the Church but only under the obligation of faith. They conducted well-attended religious services outside the towns beyond state control, the sermons being nicknamed "hedge sermons." It is easily conceivable that Bruegel was alluding to such "hedge sermons" in his painting *The Sermon of John the Baptist* (ill. 89), now in Budapest.

In the 1560s, mutual incomprehension among those in power sharpened the conflict between Spaniards and Netherlanders, the latter meanwhile being represented by Counts Egmont (1522–1568) and Hoorne (1524–1568) together with William of Orange (1533–1584). These three demanded the resignation of Cardinal Granvella and threatened to quit the council of state, which would effectively have crippled the work of government. In 1564 Granvella did indeed leave the Netherlands after his opponents had increased the pressure for him to resign. This success might have defused the tension had not the following winter proved exceptionally hard, and the Inquisition acted so mercilessly to suppress the rapidly increasing number of Baptists and Calvinists produced by the new situation.

In fact the local princes had in the meantime quashed all heresy laws, and in 1565 Count Egmont journeyed to Madrid to gain retrospective approval for this decision. The negotiator was astonished to find on his return to the Netherlands, against all his expectations, several warrants ready for the execution of heretics. Philip had decided to persecute people of other faiths more severely than ever. This bloody policy gave rise to wide-ranging resistance among the Netherlands nobility. They turned as a whole to Margaret in protest, and she promised a more lenient approach. It was on this occasion that the nobility were abusively dismissed as *un tas de gueux* (a heap of beggars), from which the anti-Spanish opponents became known as *Gueux*.

Untouched and unmoved by the negotiations of the elite, outbreaks of iconoclasm spread sporadically, but with extreme violence, in the Netherlands. Political agreements were wrecked, and both camps prepared for either occupation or war. Unfortunately the *Gueux* could not put up a united front. Allies were found in Reformed states, but internally there were too many who stood loyally by the Regent and did not want a religious war. Thus, in the autumn of 1567 the Spanish army, which was led by the Duke of Alba, who was renowned for his harshness, occupied the Netherlands almost without losses. Terrible punishments were levied on the rebels, and approximately 1,000 of the

12,000 who were accused at the "Bloody Councils" were executed. Counts Egmont and Hoorne were publicly beheaded in Brussels in June 1568, and nobles who did not consent to this judgment were themselves dispossessed. Dispossession befell William of Orange, who henceforth became the leading figure of the Dutch emancipation movement. Despite countless military operations, the movement only attained its goal – independence – with the Treaty of Westphalia in 1648. Alba's actual reign of terror began in the last months of Bruegel's life, when new taxes were imposed against considerable resistance – money without which Alba could not have maintained his army.

91 Abraham Ortelius,
Theatre, oft tooneel des aertbodems, 1571
Letterpress on paper, hand-colored, folio
Stedelijk Prentenkabinet, Plantin-Moretus
Museum, Antwerp

The map is taken from the second Flemish edition of Ortelius's *Theatrum orbis terrarum*. The Spanish Empire reached its greatest extent after 1580 under Philip II, following wars of conquest and as a result of several marriages. Possession of Naples had already established supremacy in the Mediterranean (victory of the Armada at Lepanto in 1572). Annexing Portugal in 1580 brought numerous overseas colonies with it, and Spain came into conflict with England, which defended its supremacy.

92 Jacob Jonghelinck (?)
Portrait medallion of Alexander Farnese
Silver, 4.63 cm in diameter
Museum Mayer van den Bergh, Antwerp

Antwerp was not militarily occupied until after Bruegel's
death. Alessandro Farnese was the successful general in the
battle that is recalled here (April 4, 1585), taking the city
with his troops the following August. Under his control
the situation calmed down, and Antwerp regained a
modest degree of prosperity.

93 Titian
Charles V with dog, 1533
Oil on canvas, 192 x 111 cm
Museo Nacional del Prado, Madrid

Charles V systematically built up the might of Spain by his
administrative as well as his military ability. In 1555, he
abdicated in favor of his son Philip II.

PHILIPPVS · D · G · PEX · HIPAN · DVX · BVRG · E℣

94 Abraham de Bruyn
Philip II, 1560
Etching, 30.2 x 19.9 cm
Stedelijk Prentenkabinett, Plantin-Moretus
Museum, Antwerp

Philip, the son of Charles V, was deeply religious and
devoted himself wholly to the Catholic cause. The
Counter-Reformation led to the modernization of the
Roman Catholic Church, which also produced
humanistically minded scholars and reforms.

The Months and Peasant Festivities

In the period between 1565 and Bruegel's death in 1569, the artist created the works that established his name and reputation – the peasant pictures that later almost became clichés. In fact there are only two paintings that depict peasant life as simply and effectively as if they were fulfilling a pack of preconceptions: the *Peasant Wedding* of 1568, set in a barn, and the *Peasant Dance* (or kermess) of the same year, set in a village street (ills. 119, 121). The figures here are larger than elsewhere in Bruegel's work and their appearance is graphic. This has inspired interpretations assuming moral criticism of the "primitive" peasants in the pictures, on the grounds that in Bruegel's time all art still had a didactic character. However, as soon as we generalize about all peasant pictures by Bruegel, the moral interpretation becomes dubious, because in the sequence of the *Months*, painted a year or two earlier, all the work dominated by landscape and the seasons is treated very seriously. The rural population is depicted in epic breadth, such as to bring out – even today – their work ethos of fulfilling the given tasks of the day. This is all the more successful in that Bruegel offsets this by showing the compensatory pleasures of village life.

In terms of format, subject matter, and dating from 1565, five landscapes form part of the series of *Months* pictures: *The Hunters in the Snow, A Gloomy Day*, and *The Return of the Herd*, now in Vienna, *The Corn Harvest* in New York, and *Haymaking* in Prague (ills. 96–104). They all show seasonally appropriate weather, the starkest contrast between them being the snow-bound landscape of the returning hunters with its greenish overcast sky and the shimmering heat over the cornfields in high summer. The atmospheric intensity of the depictions of the sky is unparalleled in the history of art, not only in earlier works but also for a long time afterwards. The range of subject matter, of course, has its counterpart in fresco painting, the *Labors of the Months* being one of the most common secular subjects of the Middle Ages. Frescos of the months are found in North Italy, and the seasons of the year were depicted in both cathedral sculpture and the calendars prefacing books of hours (ills. 105, 107–112).

It was not until the advent of oil painting that convincing pictures of weather were made possible.

Unlike in the medieval tradition of the labors, Bruegel consistently dispenses with the otherwise customary symbolical and allegorical trappings, such as the signs of the Zodiac, as being incompatible with his realism.

For a long time it was debated how many paintings were missing in this series of five pictures. Had there originally been six or twelve paintings? The possibility that one of the paintings listed did not belong to the series and the cycle formerly consisted of four paintings of the seasons can be excluded on iconographical grounds. The more Flemish calendars from the work-shop of Simon Bening (1483–1561) were drawn into the comparison, the more apparent became the concept of presentation two months at a time. In the calendar miniatures of the books of hours, the months are indicated (or a reminder of them is given) by activities that in part look forward, in part look back. To a book illuminator such as Bening, it was not a matter of the defined function of his pictures of the months. Books of hours had admittedly been hit by competition for buyers from printed books, but they stood out by virtue of a kind of intrinsic poetry. Representations of agricultural labors within a calendar framework proved very flexible, both temporally and in terms of content, and Bruegel took advantage of this.

The question as to which painting opened the series depends on the number and the concept addressed. Despite the Easter year end, which was still usual in Bruegel's time, iconographically the Latin calendar was followed, which begins on January 1st. This would suit Bruegel's winter picture with the return in *Hunters in the Snow* (ill. 96). But this landscape is also conceivable in December, because the fire being assembled on the left in front of the house can be interpreted as preparation for the pig-killing in December – although no animal is visible, unlike in the *Numbering at Bethlehem*. The low diagonal line of the hill brow in the foreground seems to take the eye on to further landscapes on the right. The path of the hunters into the picture also creates a calm starting point for the viewer, who can scan the distant prospect to see where Bruegel's main figures are going. Equally important as a guide for the eye are the bare trees that loom over the picture, because they create a transition from the close-up – the

101 *The Corn Harvest* (detail of ill. 102)

From the extreme foreground right to the farther reaches of the landscape, Bruegel characterizes high summer with secondary scenes: the pitcher placed in the shade in the corn; the reapers, the noise of whose scything has alarmed two partridges; three girls carrying sheaves of corn to the hay wagon; people bathing in the pond; beyond that, an orchard; to the right of that a village green on which people play.

102 *The Corn Harvest*, 1565
Oil on panel, 117 x 160 cm
Metropolitan Museum of Art, New York

The grain harvest is firmly set in August in all Flemish calendars. As there is a striking amount of ripe fruit shown in this picture as well, the scene presumably represents the months of both August and September. The latter was generally recognized as the month for the ripening of fruit and depicted as such.

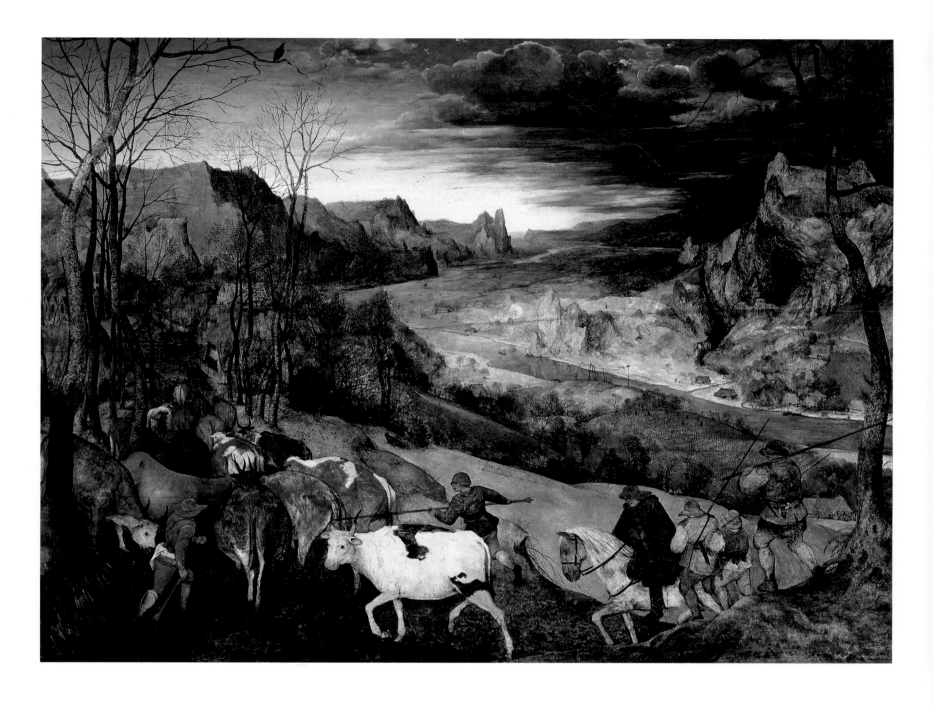

103 *The Return of the Herd*, 1565
Oil on panel, 117 x 159 cm
Kunsthistorisches Museum, Vienna

The *Return of the Herd* is not a subject derived from
Flemish calendars or Flemish custom. Perhaps Bruegel is
combining here his knowledge of Alpine cattle husbandry
with the compositionally convincing desire to paint an
autumn mountain landscape. The traditional motif of the
vine harvest is moved to the center ground and left little
room. The herd of cows returning to the village is among
Bruegel's freest creations. The backs of the animals are
correctly proportioned to the woodland path, and the
rendering of their skins, with the underpaint showing
through, is very tactile. If one were to decide which picture
was the last in the *Months* series, or was painted with the
most experienced and rapid hand, it would probably be
this picture of late autumn.

104 *The Return of the Herd* (detail of ill. 103)

The approaching storm draws a large part of its effect
from the mountain ridge opposite.

with the outline of the sleeper and how to position his
arm beneath his head. Also the perspective of the path
through the corn, which draws the eye away, and the
size of the water carrier just arriving, were problematic
areas of the picture (ill. 101). However, there are other
details on which the theme of summer was treated
realistically. On the left, partridges are escaping out of
the corn, while in the fruit tree on the extreme right a
boy has climbed into the tree and is shaking the crown
to get some of the fruit down. Not least, the dry heat is
depicted in the pale, bright sky, which is suffused pink-
ishly nearer the horizon. Following the latest cleaning of
the picture, the moon can be seen high up on the left.

Only the hilly river landscape in the *Return of the
Herd* cannot be traced back with certainty to the
Flemish calendar picture tradition (ill. 103). There,
cattle herding was usually placed in the spring, among
various labors around the farmhouse; these might
include breeding small animals, dairy matters, spin-
ning, and winding flax. Also frequently shown were

herds of sheep being driven out. In the case of this
particular painting, this means the return could be
taken as an autumn picture, as a contrary pair for this
subject. In fact the time of year is established by secon-
dary scenes, because in the center ground and on the
far bank Bruegel paints a harvested vineyard or second
harvest. Thus, this is a depiction of October and
November. The composition is familiar – the viewer
looks out from a raised point over the river and the
other side of the valley opposite. The broadening
expense of fluvial plain leading to the horizon is
repeated from earlier pictures. More exciting is the
rendering of the village on the left; it is placed in a
wood, but painted so transparently that the distant
landscape shows through it (ill. 104). Bruegel's bolder
touch is also recognizable in the spontaneity of the
painting. Less was drawn in and carefully tried out in
advance before being fully worked out. The branches
were painted straight onto the panel without any fears
about distinguishing those in front and behind.

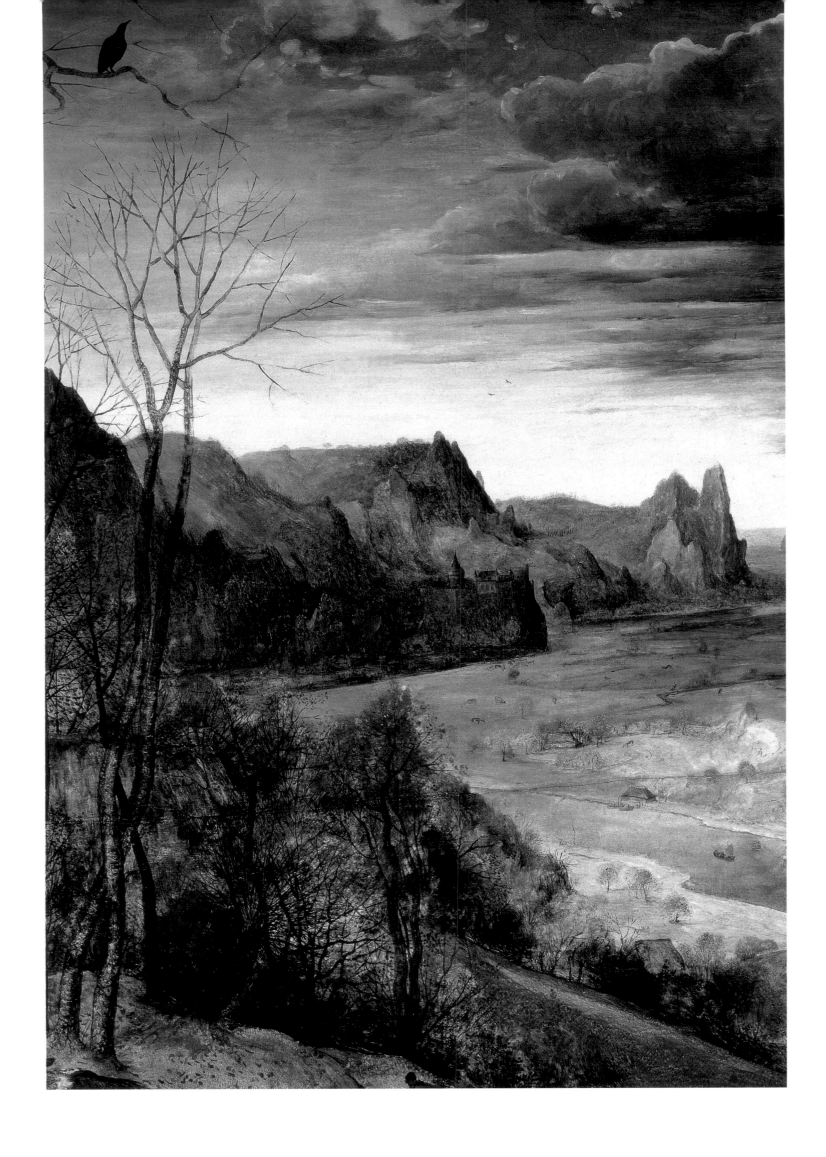

105 Simon Bening
Hennessy Book of Hours, October
calendar miniature, MSII, 158, fol. 10v.
Cabinet des Manuscrits, Bibliothèque Royale
Albert I, Brussels

The autumn vintage was one of the usual Labors of the
Months in the calendars of books of hours, even though
wine-growing was hardly widespread in the north. Thus,
the status of viticulture was greater than its real
importance, and the seemingly realistic scenes of the wine
trade (ill. 110) and planting vine stocks (ill. 117) are
misleading in this respect.

A similarly fleeting – which for the viewer also means more vivid – representational style is applied to the beasts of the herd and their drovers. Bruegel manages to paint a herd of independently-minded cows who really do require drovers with long poles. On the left one animal has wandered into the undergrowth, while the white cow with black splodges looking towards us serves as a *repoussoir* motif. Once again Bruegel brings together the mood of the weather and the coloration of landscape features into convincing harmony. Stormy blue-black clouds are approaching from the right. They contrast with the brownish-black of the ground in the foreground and the diagonal line towards the village. The river, which is bathed in sunshine, separates the two dark zones.

The cycle of seasons is completed with the *Hunters in the Snow* (ill. 96). In a villa, the sequence of this series would correspond to its hanging on the four walls of a room. Does this painting therefore close the year or does it begin it? The downward diagonal to the right has been taken as an indicator of the sequence in the sense of a beginning; yet the central figures are not setting off on a hunt but returning home with meager booty.

The question of the spatial arrangement of the sequence thus remains undecided, particularly as similar difficulties also occur in the other panels. The cows are indeed returning to the byres, but they are being driven up the slope not down into the pasture. To take a further example, thematically, haymaking and corn harvest would fit together best, but Bruegel has explicitly avoided this: on the left in the center ground of *Haymaking* the corn is growing, which could have been reaped both spatially and temporally afterwards on the right. Common to these observations is an enhancement of the special status of the individual picture, which is not determined by its contiguity with the one before or the one after.

The ensemble was not a continuous frieze. The landscape regions were not linked in a panorama but are independent. In terms of subject matter, the perpetual calendar from books of hours is the richest and most widespread source on which Bruegel could draw. Yet the actual calendar, which gave the days of Christian saints and Church festivals, is not indicated anywhere. The result is that the program has a universally secular character. The nickname "The Flemish Georgics" seems apt, even though the classic didactic poem by Virgil, which deals with agriculture, cattle breeding, and beekeeping, was not the basis for the pictures. Neither the four-part form of the *Georgics* nor their content are reproduced. And yet the stress on cyclical aspects of seasonally changing nature and the emphasis on the necessity for man to work, is reminiscent of a similar ideal of humanity – agricultural society as a better age.

The paintings were already the property of the Antwerp financier and tax official Niclaes Jonghelinck shortly after 1565, and probably he should be looked upon as the client. Bruegel was neither so independent nor financially so secure that he could afford to paint five paintings of this size in the confidence of finding a speculative buyer. A surety of 1566 indicates that Jonghelinck was the most important contemporary Bruegel collector known of today. According to the security document, he had sixteen paintings by Bruegel, including the large *Tower of Babel* (ill. 79) and the *Procession to Calvary* (ill. 76). He also possessed works by Bosch and some by Bruegel's Italian rival, Floris. *De tweelf maanden* (the Twelve Months) are mentioned as part of the security, but not all the other paintings. As explained above, the number twelve is taken nowadays as a figurative expression for what was really only six paintings.

The likely place where they were hung could conceivably have been the country house of T'Goet ter Beken outside the gates of Antwerp, but this is by no means certain, as the financier and tax official owned numerous properties in the city. There are grounds for describing this country house as part of an Antwerp villa development, in which the landscapes constituted a specific Flemish counterpart to north Italian landscape frescos. Vitruvius had demanded these in his book of architecture, which had been translated into Dutch a few years earlier by Pieter Coecke. In this case it was not a villa at the heart of an extensive agricultural estate. It was, in fact, one property among others developed and marketed by the well-known urban developer van Schoonbeke – even at that time it was already a suburban villa for the nouveaux riches, who acquired landowner ideology along with an estate but themselves remained town-dwellers. This is also evident in the fact that a few years later Jonghelinck became insolvent and the city of Antwerp called in the guarantee.

As with virtually no other work, the *Landscape with Plowing Peasant and the Fall of Icarus* (ill. 113) shows that Bruegel consciously worked as a translator of language into picture. The painting, more commonly called *The Fall of Icarus*, is the only one of his to have a mythological subject. It concerns the Greek artist and inventor Dædalus and his son Icarus, who tried to fly with homemade wings of wax and feathers. Icarus plunged to earth because, against paternal advice to steer a middle course, he came too close to the sun and his wings melted. The arrangement of the figures, that is plowman, shepherd, angler, and the falling Icarus only in the center ground on the right, leaves no doubt that Bruegel followed the text from Book 8 of Ovid's *Metamorphoses* more closely than any artist before him.

106 *Spring, "Mert, April, Meij,"* 1565
Pen drawing, 22.3 x 28.9 cm
Graphische Sammlung Albertina, Vienna

Spring, from Bruegel's incomplete series of the seasons, follows strict representations of gardens with country houses. In the background, there are scenes with motifs from different months.

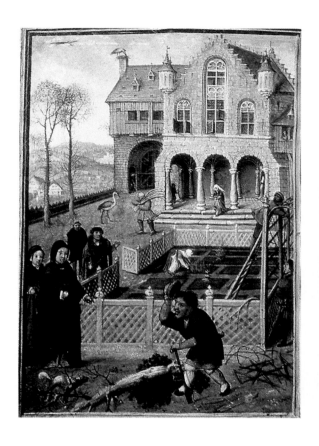

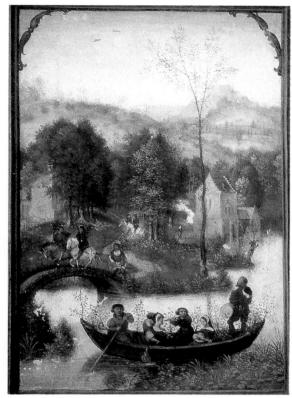

107 (far left) Simon Bening
March, ca. 1545
Flemish calendar, fol. 4v.
Tempera on parchment
Bayerische Staatsbibliothek, Munich

The March picture shows gardening and the supervision of it. The landowner and his wife are giving instructions for digging out a dead tree and tending an arbor.

108 (left) Simon Bening
May, ca. 1545
Flemish calendar, fol. 6v.
Tempera on parchment
Bayerische Staatsbibliothek, Munich

May pictures traditionally showed not peasants at work but princely lovemaking. This scene juxtaposes a boat outing with music and a May ride. The whole scene is set in a delightful waterscape and is presented with a variety of green and blue tones.

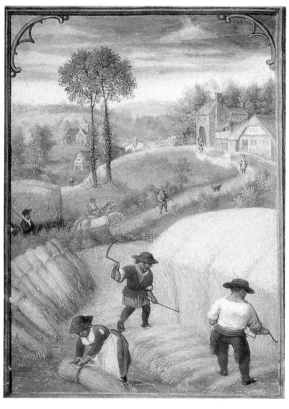

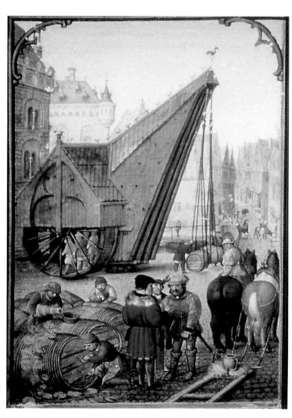

109 (far left) Simon Bening
August, ca. 1545
Flemish calendar, fol. 9v.
Tempera on parchment
Bayerische Staatsbibliothek, Munich

Like Bruegel's painting of the same name (ill. 102), Bening's corn harvest shows a variety of activities such as reaping, binding, and carrying away. The *bas de page* (lower margin) of the opposite page complements the subject with a fruit picking scene.

110 (left) Simon Bening
October, ca. 1545
Flemish calendar, fol. 11v.
Tempera on parchment
Bayerische Staatsbibliothek, Munich

Urban scenes are an exception in Flemish calendars. This one shows wine-dealing in the Place de la Grue in Bruges; in the front, tasting is proceeding, while at the back the boats are being loaded with the assistance of a wooden treadwheel winch.

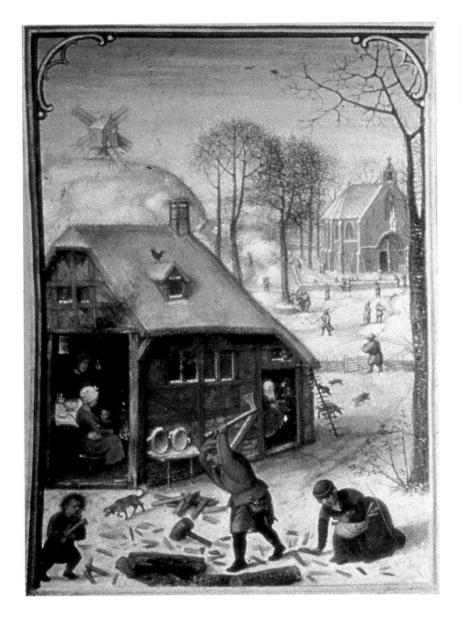

111 Simon Bening
January, ca. 1545
Flemish calendar, fol. 2v.
Tempera on parchment
Bayerische Staatsbibliothek, Munich

Calendar pictures of winter by Flemish masters were
influenced by the most famous book of hours of all, the
Très riches heures by the Limbourg brothers, created after
1413. The view into the hut with a warming fire, the
chopping of firewood, and snow scenes first occur there.

112 Simon Bening
January, ca. 1545
Flemish calendar, fol. 3
Tempera on parchment
Bayerische Staatsbibliothek, Munich

The snowball fight is one of Bening's innovations, and can
be compared with the games frieze in the margins of the
Mayer van den Bergh Breviarium (ills. 58, 59).

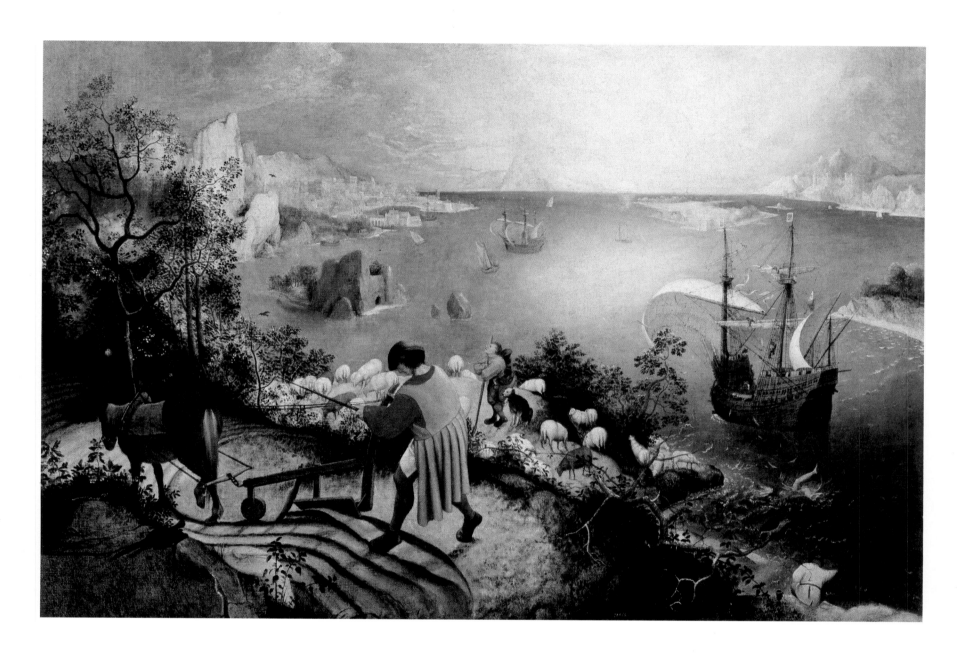

113 *Fall of Icarus*, ca. 1565
Oil on canvas, 73.5 x 112 cm
Musées Royaux des Beaux Arts de Belgique, Brussels

The island landscape with plowman, angler, shepherd, and the
falling Icarus is Bruegel's only mythological painting. It follows
Ovid's account of the story of Dædalus and Icarus from Book 8 of
the *Metamorphoses* literally, with the eyewitnesses of the flight
mentioned there in passing being here shown in the foreground.
The painter paints their "views," in that the dramatic events merit
hardly any attention, even if Ovid wrote that the fall did not happen
until Icarus was some islands farther on from the eye-witnesses. It
has always been considered surprising that Dædalus is not visible,
but according to Ovid he had lost sight of his son and had to search
for his body.

In the Penguin translation:

"Some fisher, perhaps, plying his quivering rod, some shepherd leaning on his staff, or a peasant bent over his plow handle caught sight of them as they flew past and stood stock still in astonishment, believing that these creatures who could fly through the air must be gods.

"Now Juno's sacred isle of Samos lay on the left, Delos and Paros were already behind them, and Lebinthus was on their right hand, … when the boy Icarus began to enjoy the thrill of swooping boldly through the air. Drawn on by his eagerness for the open sky, he left his guide and soared upwards, till he came too close to the blazing sun …"

Bruegel thus shows Ovid's eyewitnesses, who fulfill a double rhetorical function in his text. They stress both the special character of the flight and the speed with which father and son flash past the eyewitnesses and many islands. Ovid narrates the context of the flight in detail. The inventor Dædalus has to leave Athens and go into exile to escape retribution for murder. In Crete he works for many years as an inventor in the service of King Minos, where Ovid supplies various episodes about inventions and counter-inventions. However, in the end, after a quarrel, Minos incarcerates both father and son. Flight – literally – is the only escape route that is available to them, and their destination is Athens, their homeland. It appears – implicitly – that the problem of the murder charge has lapsed. Dædalus imagines that he is flying back for a reconciliation, when Icarus plunges headlong and abruptly reminds him of the beginning of his odyssey and his guilt – consumed with envy of his inventions, Dædalus had pushed his most gifted pupil Perdix, who was also his nephew, off the Acropolis. Minerva, the goddess of the arts, intervened and changed the falling man into a partridge (*perdix* in Latin).

The transformation into a species of bird that resorts particularly to boggy ditches, embodies the moral that those who do not fly high cannot fall far. However, in Bruegel's painting, unlike in this zoological definition, Perdix sits on a branch over the water. The bottom right corner turns out to be a picture within a picture and follows a staging of its own – the coast with the angler, Perdix, and the passing ship, besides which Icarus plunges into the breakers. Only the angler connects these with the island where the eye-witnesses, mentioned by Ovid, are located.

One of the most popular earlier representations of the *Fall of Icarus* shows the flight and the subsequent burial by Dædalus at the same time (ill. 115). Here too Perdix sits contrary to habit usual of partridges on a branch. In Ovid, the story of the escape and the tragic flight reaches its high point in the encounter at the grave: the transformed dead Perdix laughingly mocks the burial of Icarus, thus aggravating Dædalus' grief. In the painting, Dædalus will be sought in vain, and his absence is all the more surprising in that the eye-witnesses of the flight, who in the original story are only secondary figures, are taken literally by the painter. It was long thought that the high aerial figure had been overpainted, and a copy of the picture does

show Dædalus in the top left corner. On the other hand, the landscape with Icarus falling in the distance assumes that the story is known, so that it is logical to simply omit the father – an element of the story of which everyone is aware. After all, this also follows Ovid literally: Dædalus flies ahead and only notices later that Icarus has fallen. He therefore has to search for him, and only discovers him when the corpse is washed ashore. The painter of the above-mentioned copy thus completed the story but diminished Bruegel's more profound understanding of Ovid's poetry. One can conjecture that it is remorse that drives Dædalus to fly not to Athens but to Sicily after the burial.

As well as the complete familiarity with the *Metamorphoses* and the charming treatment of familiar Ovid illustrations, there is a third aspect that demonstrates Bruegel's extraordinary preoccupation with the myth of Icarus. This is a detail to be found in the left half of the picture (ill. 118). On the left, by the trunk of a fruit tree towards which the plowman's furrows run, lies a dead man, who is recognizable only by his skull. For a long time, it was associated with the proverb: "A farmer does not leave his plow for the sake of a dying man" – an enigmatic proverb which appears to have no mythological reference. Yet there is an explanation for the visual symmetry of Icarus and the dead man, midway between whom stands the plowing farmer.

Greek mythology admits to an Athenian farmer called Icarios, who housed Dionysus the god of wine and received vines by way of thanks. When, as instructed, he gave them to other farmers to taste so that wine-growing should become popular, he was struck dead by them. As they did not yet know the effect of alcohol, the farmers thought he was poisoning them. The story was known through astrological commentaries, such as that by Hyginus. He had occasion to tell the story when in the course of the stellar year the constellation of Arcturus, to which Icarios belonged, or of Erigone, the daughter of Icarios, had to be explained. Mourning the death of her father, Erigone had killed herself, and the gods turned her into a star. A further star, Sirius (the dog star), is linked with the tragic tale, because it is supposed to recall the family dog that helped Erigone to find her dead father.

Two features permit the reference to the plowman. All these stars are visible in the spring sky, and the iconography of the labors of the months shows not only the plowman, but also the shepherd and the angler, almost exclusively in the spring (ill. 117). Moreover, in Hebrew (which in the 16th century was considered a "primeval" language) the word root *ikar* means "husbandman." Underlying Bruegel's painting, therefore, is a pictorial cultural comparison, which comprises of Flemish calendar motifs, Roman literature, and Greek mythology, to create a pictorial and semantic connection. Surprisingly, the plowman is a young man, whose step seems light-footed and whose apparel, with its long waistcoat and red shirt sleeves, is

114 Unknown artist
Icarus falls into the Aegean near the island of Samos, ca. 1560
Woodcut
Archiv für Kunst und Geschichte, Berlin

The meaning ascribed to the ambitious youth and victim of his passion for flight changed in the 16th century. Whereas earlier he had been held up as a negative example of arrogance and presumptuousness towards God, he now became a seeker after knowledge, whose courage was admired and whose death was transfigured in melancholy. Ovid's *Metamorphoses* and translations of this were always the most important source: "Here Icarus plunges into the ocean because the sun, which he approached too closely, caused his wings of feathers and wax to melt."

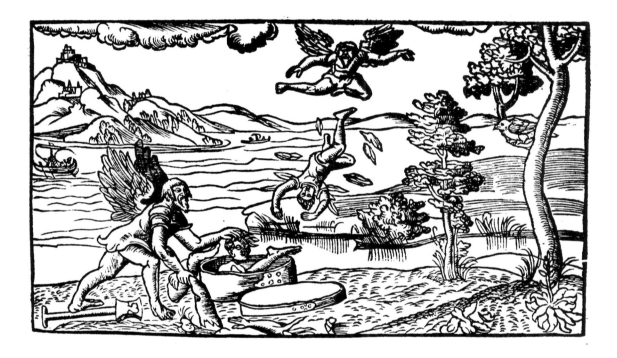

115 Ovid
Illustration of the Fall of Icarus
From: *Metamorphoses*, Venice 1522

This popular illustration from Book 8 of the *Metamorphoses* shows
two successive episodes simultaneously. In the sky are Dædalus and
Icarus with their homemade pinions of wax and feathers; on the
shore, the father digs a grave for his fallen son, who has been
shattered to pieces by the impact.

116 *Fall of Icarus* (detail of ill. 113)

The figure of the fallen Icarus is only very small, sinking into the
billows in front of the ship. The partridge on the bough is
intentionally paired with him: according to the mythological story,
this is his cousin Perdix, transformed into a partridge, who will mock
Dædalus during the burial of Icarus. "Perdix" is Latin for partridge.

117 Simon Bening
February, ca. 1545
Flemish calendar, fol. 3v/4
Tempera on parchment
Bayerische Staatsbibliothek, Munich

Bening's famous miniature of February shows laborers in the vineyard on a headland above stormy seas, and further back a plowman. At the bottom right of the picture is an inlet and fishermen's huts. Due to the fishermen on the shore and their colleagues in the storm, the landscape has a dramatic character.

almost inappropriately festive. His enigmatic figure pulls the puzzle picture together, and gives him a context as a motif in the subsequent peasant pictures as well. Without the plowman and his calendar significance, the only mythological painting by Bruegel would be too alien.

The *Peasant Wedding* in Vienna takes place in a barn with few decorations (ill. 119). It is the people and their characterization that lend the picture a festive air. The long table follows an old tradition of similar corner motifs in Last Supper paintings; the board runs towards the corner of the barn in the left background. The room offers enough space to show how the guests are fed and entertained. A barn door has been taken down and used as a tray, on which two different kinds of pottage are being served. Pitchers of beer stand in the bottom left corner, and a waiter is in the process of filling smaller jugs from them. Above the bowls that are already being handed round by someone sitting at the

table, the eye is directed over the table, almost accidentally, towards the bride. She sits with a simple-minded expression on her face, eyes half-closed, and hands clasped together, with a green wall-hanging and paper crown behind her to mark her special place. In accordance with the custom of the day, the groom is not present. The fact that she has not been given anything to eat also follows the established wedding custom. Above the group of figures sitting on the right, diagonally behind the bride's father, hang crossed sheaves of corn, which are to be taken as a blessing. They also indicate the favorite time of the year for weddings of that age, namely the weeks that followed the harvest. The eating and drinking is, therefore, certainly not intended as a criticism of over-indulgent peasants. Everyone seems to be enjoying the food, particularly the child who is sitting on the floor in front, and the guests are depicted as both drinking from the jug or taking food to their mouths.

118 *The Fall of Icarus* (detail of ill. 113)

The plowman is heading straight for the skull in the undergrowth
but has not noticed it. The skull could be taken as a reference to the
Athenian farmer Icarios, who was slain by fellow farmers. After the
gods had turned them into stars, he and his daughter Erigone gained
great significance for the prosperity of the spring sowing.

119 *The Peasant Wedding*, ca. 1568
Oil on panel, 114 x 163 cm
Kunsthistorisches Museum, Vienna

Plying the guests with food and drink is at the forefront of the wedding hospitality. This is the only scene in large format by Bruegel, showing an extensive interior scene. That the setting is a barn is only evident from the back walls. The decoration of the walls gives discreet emphasis to the bride in the middle of the festive company: she sits in front of a green wall-hanging beside her parents, above whom hangs a crossed pair of corn sheaves, which are a sign of fertility.

Anti-Epicurean criticism of peasants came into fashion only later, and in the 17th century gaming and alcoholism are indeed represented as vices in a developed "genre." In this case, the picture is a pioneering representation that is motivated by artistic curiosity and executed with great human sensitivity. Only someone who uses a criterion of ideal beauty, such as is found virtually nowhere in Bruegel's pictorial world could come to the conclusion that the portrayal of the guests at this wedding is satirical and grotesquely distorted. In his pictures of festivities, Bruegel may make use of opportunities for exaggeration, which he also uses to depict depravity, but the charm consists principally in showing a balanced juxtaposition.

With an artist such as Bruegel, questions of content are also problems of form at the same time. In the *Peasant Dance*, also in Vienna (ill. 121), the frequently rather ponderous bodies of Bruegel's figures are in motion. The man running into the picture from the

right towards the dance floor seems anatomically not properly in proportion, yet the right angle of his calves seems to reproduce visually something of the rapid rhythm between dancing, stamping, and running. The bagpiper, who has probably been induced to play again with the promise of a jug of wine, leans against a table that is not only occupied by cheerful revelers. Bruegel also shows wrangling, raucous singing, physical violence, a couple kissing, and a man leaning drunkenly with his head against the wall. The viewer's eye sweeps over another house from which a splendid flag hangs. Below it, a reluctant woman is being lured onto the dance floor. The eye passes onto the bystanders and the village green and church, where the crowd becomes thicker. In front of the church, traders' stalls can be discerned: the scene is a close-up and compositionally so cleverly put together, it is as if the painter were inviting the viewer to join in the dance. There is no landscape view beyond the village, but only the green between the peasant houses

that leaves room for dance and celebrating in the street. This intimacy of the village is elegantly linked with the proximity of the people represented.

On the peasant dance ground shown in the *Wedding Dance in the Open Air* (ill. 120), now in Detroit, it is precisely this proximity which is lacking, although the subject matter of the dancing peasants appears to be the same. On the right we have the bagpiper once more, there are dancers, drinkers, exchanges of kisses, and apparently uninvolved bystanders. The clasped, raised hands of the dancing couples in the middle of the picture take the viewer's gaze rhythmically into the picture. Bruegel varies stances easily, showing each of

the different types of person and stance in different garbs: sometimes with a white coif fluttering from the motion, sometimes with hair down and flying, sometimes a handsome young fellow with a flat cap, sometimes someone more wrinkled wearing a creased hat. There is a rhythm to the colors, too: red, blue, and white are distributed over the predominant brown with a sense of balance. In contrast with the genre-like secondary scenes of the beer pouring and bagpiping in the Vienna picture, in this dance picture Bruegel focuses especially on the people moving in time to the music. Music, rhythm, and motion push all recollections of crude peasant societies into the background.

120 *The Wedding Dance in the Open Air*, 1566
Oil on panel, 119 x 157 cm
Detroit Institute of Arts, Detroit

The festive location is half wood, half clearing and is taken up in front almost exclusively by dancing to the music of the bagpipes, while the bystanders at the edges amuse themselves, drink, or watch the dance. The bride sits at a table in the background, with a cloth hanging behind it. Bruegel has laid out the composition between two less populated alleys between the dancers and the onlookers, which lead diagonally from the outside towards the tree trunk in the middle. This creates a triangular dance floor where almost everyone is shaking a leg, flinging an arm upwards, or putting hands on hips. In this area Bruegel's careful preliminary drawings are still visible to the naked eye, lending the lively picture additional vivacity.

121 *The Peasant Dance* (kermess), ca. 1568
Oil on panel, 114 x 164 cm
Kunsthistorisches Museum, Vienna

Although the festivity is taking place in the street, the arrangement of
table and dance floor would be just as conceivable in an interior.
Movement enters the picture from the right, where an old peasant is
dragging on his dancing partner. His legs are anatomically
deliberately distorted, to create an impression of rapidity. Bruegel has
left his mark on our visual memory with these large-scale figures,
even though he rarely painted large figures and only then in his final
years, as here.

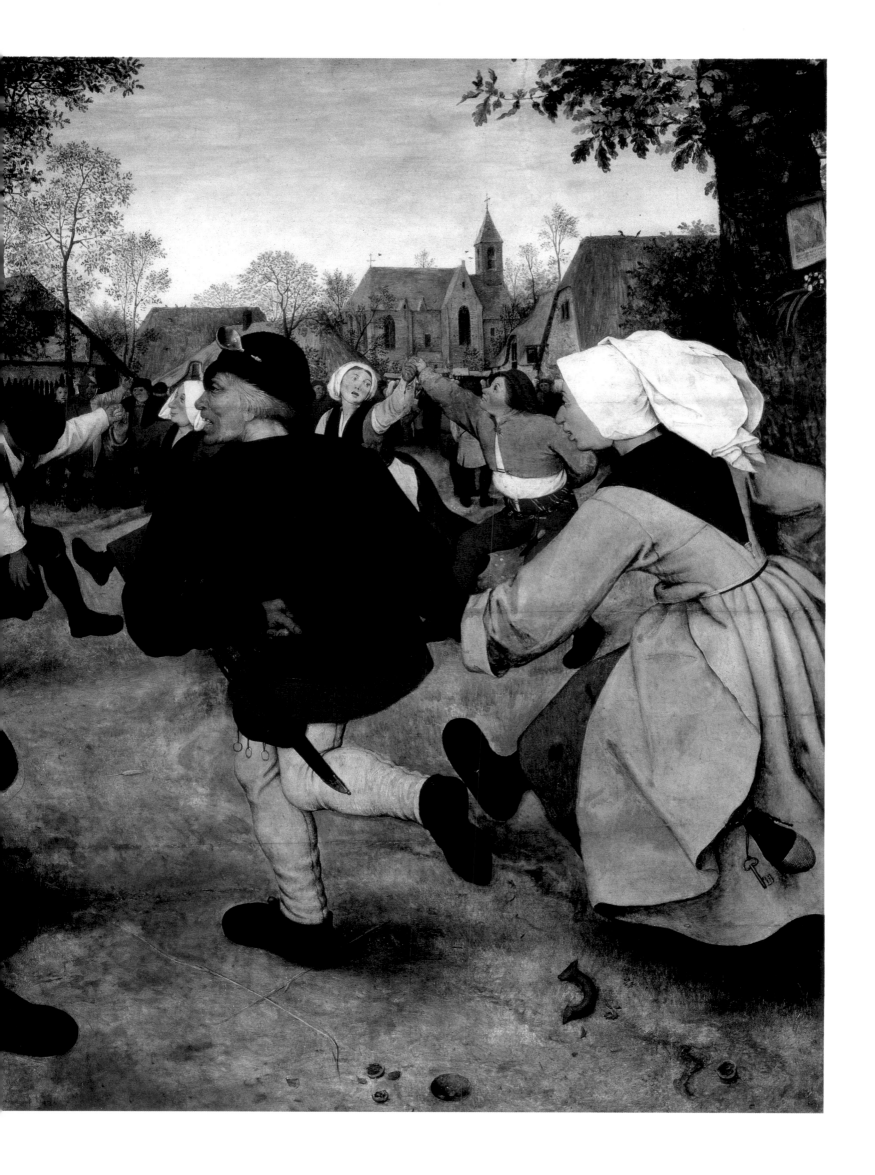

122 Philipp Galle
Abraham Ortelius, 1579
Copper engraving, frontispiece of *Theatrum orbis terrarum*, Antwerp 1579
Stedelijk Prentenkabinet, Plantin-Moretus Museum, Antwerp

The inscription says, in translation: Ortelius showed the world to people, let Galle show Ortelius to the world. This touches ironically on the rivalry between art and cartography. Both are convinced of the enlightening usefulness of their scholarship.

Ever since Carel van Mander wrote his short biography of the artist, the question of Bruegel's friends and acquaintances has been helpful in giving a more complete picture of his life. Adapting freely the motto "Tell me who your friends are and I'll tell you who you are," more can be discovered about Bruegel than originally suspected. With the assumption of a reasonable knowledge of his friends, the intellectual and social status of the artist can be reconstructed through them. Unfortunately, nothing further is known of Hanns Franckert the merchant, who as van Mander reports went to country fairs with Bruegel. There is better information about two outstanding contemporary collectors of his works, however. They worked in Antwerp and Brussels, where Bruegel himself also lived.

Art collectors such as Cardinal Granvella, who promoted the publication of the first multilingual Bible at Christopher Plantin's press, and the merchant and tax official Niclaes Jonghelinck (1517–1570), do not fit in with the image of Bruegel as a simple peasant painter. Both of them had close links with the Spanish regime and exerted extensive influence as patrons of art. However, it is not possible from the sources to decide whether Bruegel worked for these people more as a dependent artisan or treated them as like-minded equals, that is, he associated with them something in the manner of a humanist *accademia*. A few works by Bruegel give an impression of superior – that is to say, brilliantly articulated – knowledge of the stories of classical antiquity; however, most of Bruegel's works remain free of standard subject matter from classical culture, even where this would have suggested itself to contemporary viewers by comparison with the work of others. For an explanation of this, we have to return to the *rederijkers* mentioned earlier, members of the cultural guilds or rhetoricians' chambers found in many towns and open to all burghers. Their annual festivals dealt with literary themes. These were material in bringing about, in a way even now not properly understood, an astonishing democratization of higher education. Conversely, there was also a tendency among renowned collectors towards popularizing their interests. It was the accepted norm to listen to the person in the street, and this should not be dismissed too glibly as condescension or even mockery.

Granvella came from Besançon. His father had also been a cardinal, and had risen to become one of Charles V's advisers. During Bruegel's decisive creative period, he worked for Margaret of Parma, who resided in Mechelen as stadholder. Granvella himself possessed a moated castle in the direct vicinity of Brussels, in the garden of which he kept a small zoo. It has, therefore, been suggested that he was in some way responsible for Bruegel's move from Antwerp to Brussels in 1562. But in 1564 he himself moved to Naples, and it is not impossible that he took some of Bruegel's works with him. After all, that is where

two paintings – the *Misanthropist* and the *Parable of the Blind*, both on easily transportable, in other words easily rolled up, cloth – still are today. The tradition is also that, shortly after he had left Brussels almost as a fugitive, he had commissioned an intermediary, Morillon, to buy back the paintings left behind and plundered. He discovered that their price had risen enormously within just a few years of Bruegel's death.

However, the most eminent collector was the Antwerp merchant and tax official Niclaes Jonghelinck. In 1565, he is documented as having sixteen paintings by Bruegel. Whether he later had enough financial assurance to buy further paintings is not known, because the document that mentions his paintings is a security. Jonghelinck had his possessions listed there as collateral for 16,000 guilders that his friend de Bruyne owed to the city of Antwerp. He had misappropriated money as a tax collector.

The 1560s were generally a time of corruption and financial collapses in Antwerp. The first international exchange also produced the first exchange collapses. It is thus assumed that Jonghelinck lost a large part of his possessions, including his country house T'Goet ter Beken just outside the city, which is mentioned by name in a local map of the Antwerp area (ill. 125). Very probably Jonghelinck's collection of paintings was accommodated in this country house. We must imagine the house as probably one of the finest villas in Antwerp, as it was classed for tax purposes as top-category *huizing* (housing), carrying an annual rate of 200 florins.

Nearby lived the selfsame de Bruyne, in a new commercial development that had been opened up for the construction of villas a decade earlier. As the architectural treatises by Vitruvius and Serlio had been translated into Dutch in the middle of the century, these buildings presumably represented the ideal of the *villa suburbana*, although it is no longer possible to confirm this, as none of the buildings survived the siege of Antwerp in 1585 and there is no documentation available. However, it is clear that such a villa would have had a library and that it was a place for social festivities and diplomatic meetings. A passage in a letter indicates that the Spanish king, Philip II, must have visited the place. And Domenicus Lampsonius praises it in 1563 as liberal and recommends it to all "Italian students" – the reason for the latter being that important works by the Antwerp Romanist Frans Floris could be studied there, which Lampsonius ranked on a par with Italian art. It can be gathered from the inscriptions of these paintings, which nowadays are known only through engravings, that they were intended for the country house and were to be seen there "near Antwerp." Even then, collecting was not restricted to a single style. An old master, such as Bosch, still would fetch a high price, as did the contemporary artist Bruegel, even if the heroic figures of Floris were better suited to public display.

123, 124 Abraham Ortelius
Liber amicorum, 1574 –1596, fol. 12v/13
Pembroke College, Cambridge

Ortelius had his friends throughout Europe included in this book of friendship. He himself composed an obituary for his already deceased friend Bruegel, which puts the latter on a par with classical artists. The text was obviously written in several phases, the last lines occupying the margin and the next page, which actually belonged to another entry. On the left hand page, it states in the bottom margin that he painted many things that actually could not be painted (*multa pinxit, quid pingi non possunt*).

125 Christopher Plantin
Bescriivinge van paelen der vriiheit van Antwerp, 1582
Copper engraving, 26 x 45 cm
Stedelijk Prentenkabinet, Plantin-Moretus Museum, Antwerp

This map of the surroundings of Antwerp, showing Jonghelinck's country house, is one of the rare references to a villa culture outside the gates of Antwerp. The houses on the area of Terbeken, developed by an urban developer and speculator, are named. Thus, in the middle of Markgravelei street is the label "Jonghelinck." The country house was destroyed during the siege of Antwerp by Alessandro Farnese in 1585.

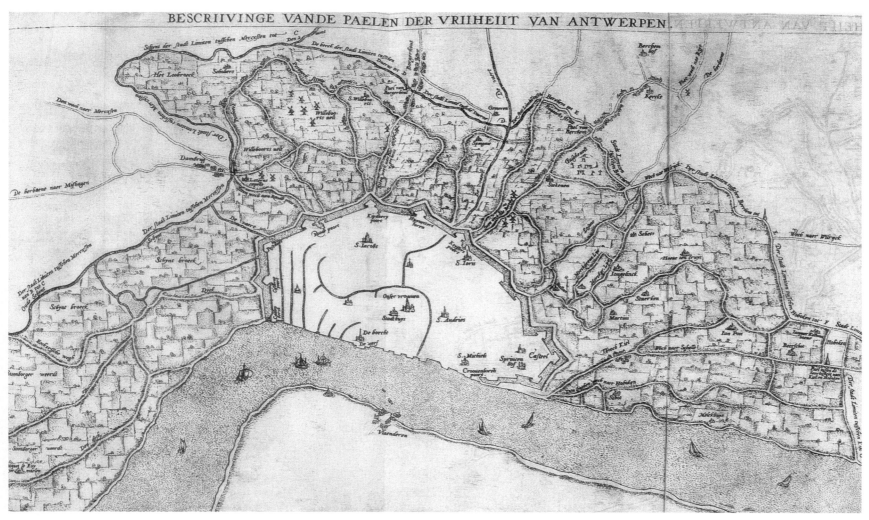

LAST WORKS –
RETROSPECTIVES AND CLOSE-UPS

The Old Peasant Woman is unique in Bruegel's work,
because no other portrait-style pictures have survived nor
are there any further studies. The old woman with the
white cap is shown in profile in front of a dark, spatially
unarticulated background. Her thin, feeble lips are open,
so that the white sheen of individual teeth reinforces the
effect of the gaps. A vacuous gaze upwards and slack lower
jaw indicate apathy, not speech. Thus the painter
mercilessly exposes not only great age but also the loss of
facial control, which surely no client would have
permitted. This is not, therefore, a portrait but a study of a
head, the purpose of which is so far unknown.

In the last years of his life, Bruegel concentrated on
individual figures and groups of figures. Instead of
linking many of them together in broad landscapes,
they are transposed into spartan surroundings and
stand so far forward in the pictorial plane that many of
them even seem to fall out of the picture. The figures
become larger in scale, and their bodies are given more
gravity. Suddenly, it appears that Bruegel's Italian trip
did absorb some influences of the art of Raphael
(1483–1520) and Michelangelo (1475–1564), or
even Netherlands Romanists such as Bruegel's fellow
citizen Frans Floris (1519/20–1570), who had built
up a large workshop business based wholly on his study
of Italian painting.

The subject matter of the late paintings will in many
respects already be familiar to Bruegel connoisseurs
and attentive readers of this book, because many of
them had already featured as individual secondary
scenes in the multi-figure works of around 1560. That
such details are worth portraying outside the "encyclo-
pedic" approach also says something about the early
panel paintings. Even there, the motifs presumably
carried a weight of their own. We must assume that
detaching subject matter from his own works corre-
sponded to a development in the pictorial sensibilities
of his clients and collectors, who presumably ordered
individual motifs detached from the more comprehen-
sive pictorial environments. If that is so, then contem-
poraries paid close attention to details in Bruegel's
works and their wit, which proves the popularity of
Bruegel's pictorial creations even during his lifetime.
The sum of all details cannot be squashed into a moral
such as that of the "topsy-turvy" world that Bruegel
was supposedly criticizing. It is rather that, even in his
early paintings, the figures constitute puzzle pictures in
a figurative sense, and each requires an individual
interpretation. To subordinate them to a moral
purpose becomes an inadmissible simplification as
soon as they contradict each other – even doing this
within themselves, thus becoming ambivalent.

Bruegel's treatment of his early works, his quoting
of his own motifs, was almost totally contrary to the
Bruegel tradition as continued in the painting of his
sons and others. Jan Brueghel the Elder (1568–1625)

and Pieter Brueghel the Younger (1564–1637/38)
attached themselves principally to the broad land-
scapes with numerous people, and copied many
compositions several times over, sometimes more than
a dozen times. They draw on the more monumental
later works of their father, but they lack the open-
mindedness with which Bruegel himself turned even
unconventional motifs into independent pictures. His
sons did not select sections of pictures or individual
scenes that could be detached as set pieces. The reason
may be that they worked for a restricted market or
thought that their success would come only from
copying the well-known works of their father. As well
as numerous woodland landscapes, Processions to
Calvary, and other subjects, Jan Brueghel the Elder
and Pieter Brueghel the Younger also painted char-
acter heads. We only know of one such painting of this
kind by Pieter Bruegel the Elder, but because of the
production of engravings, small portraits of peasants
were closely associated with his art both in the 16th
and 17th centuries.

Unlike the other paintings which quoted from his
existing works, the study of the head of an *Old Peasant
Woman* is not based on any design of visual language
(ill. 126). Both temporally and stylistically it is close to
the realistic peasant figures in the *Peasant Dance* and
Peasant Wedding, for example the bride and her parents
or the dancing peasant (ill. 128, 129). The small
painting is classified as a study that should have served
as a basis for a larger work which has been neither
preserved nor copied. The head cannot be reckoned a
real portrait, because who could have commissioned it?
Few portraits have come down to us from this time
that did not arise from a need to establish the sitter's
high status. An elderly peasant woman, unsparingly
rendered in profile, can certainly be excluded as a
client. And the Ferrara *Court Jester Gonella*, a picture of
an old, badly-shaven man that was earlier – not without
reason – also ascribed to Bruegel, but is now considered
the work of Jean Fouquet (1415/1420–1477/1481),
was executed for the court of Milan, where he was
employed (ill. 127). Only the drawing of the *Artist and
Connoisseur* could be accepted as a portrait by Bruegel,
but it too betrays idealizing intentions (ill. 6). The old

127 (opposite) Jean Fouquet
Gonella, Court Jester of Ferrara, ca. 1445
Oil on oak panel, 36 x 24 cm
Kunsthistorisches Museum, Vienna

The jester was identified as Gonella by a marked copy. He served Niccolo III d'Este in Ferrara. Gray beard stubble and shiny nose are painted in a naturalistic manner. Clothing and hands have been retouched by an alien hand, which for a long time made any attribution difficult.

128 (left) *The Peasant Dance* (detail of ill. 121)
Head of the dancer

The large figures of the late works are reproduced with increasing individuality. Compared with the character study evident in the face of the dancer, the round, almost swollen face of the young man in the *Birdnester* (ill. 138) is all the more noticeable. Spherical heads with no facial expression are characteristic of the children in Bruegel's *Children's Games* (ill. 60).

129 (below) *The Peasant Wedding* (detail of ill. 119)
The bride and her parents

The exact reproduction of physiognomies in Bruegel is always associated with size relationships within the pictorial space. More distant figures are never precisely characterized. Yet it would be inappropriate to equate the absence of individual features with caricature, because the whole picture design would then have to be subordinated to it.

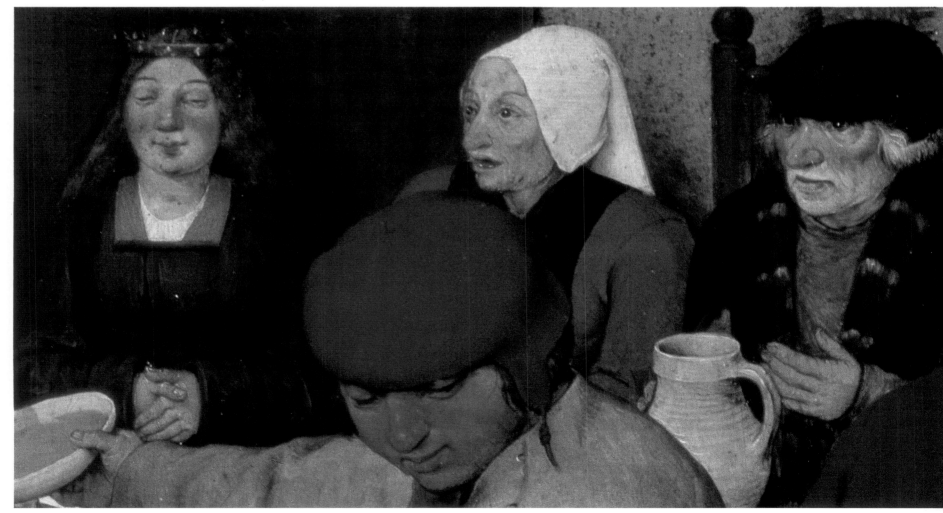

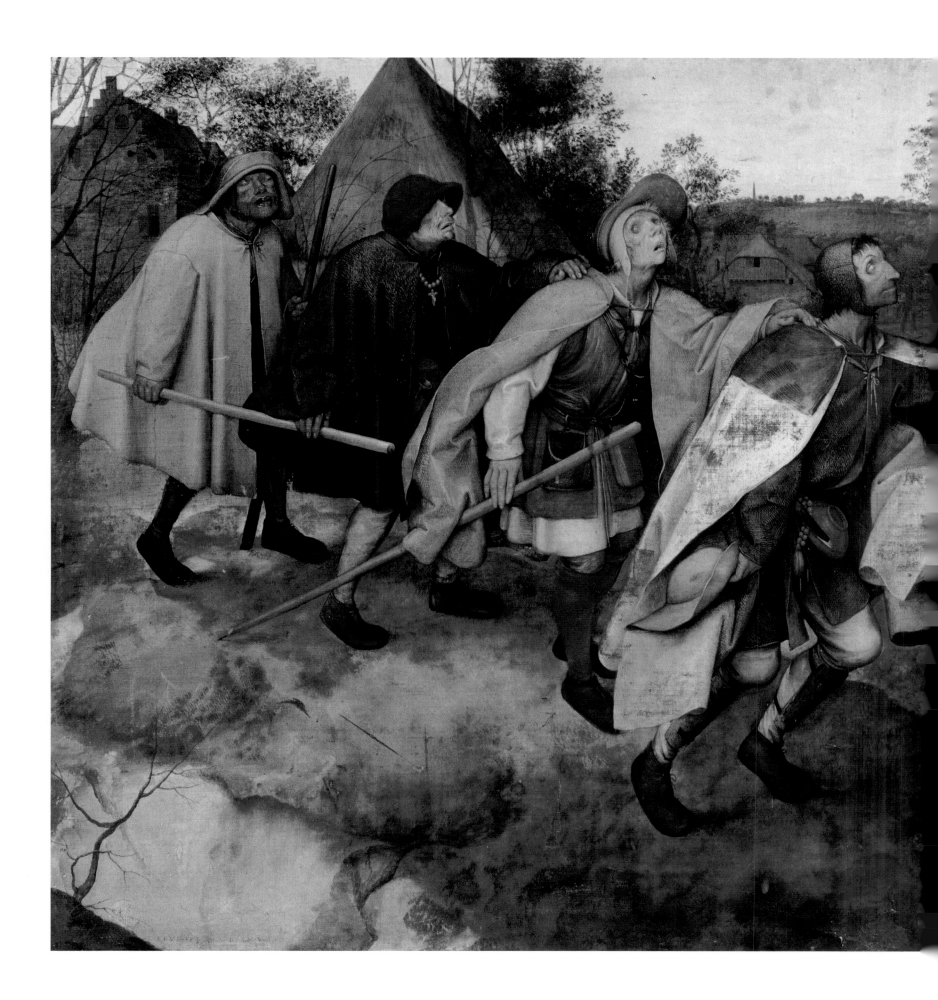

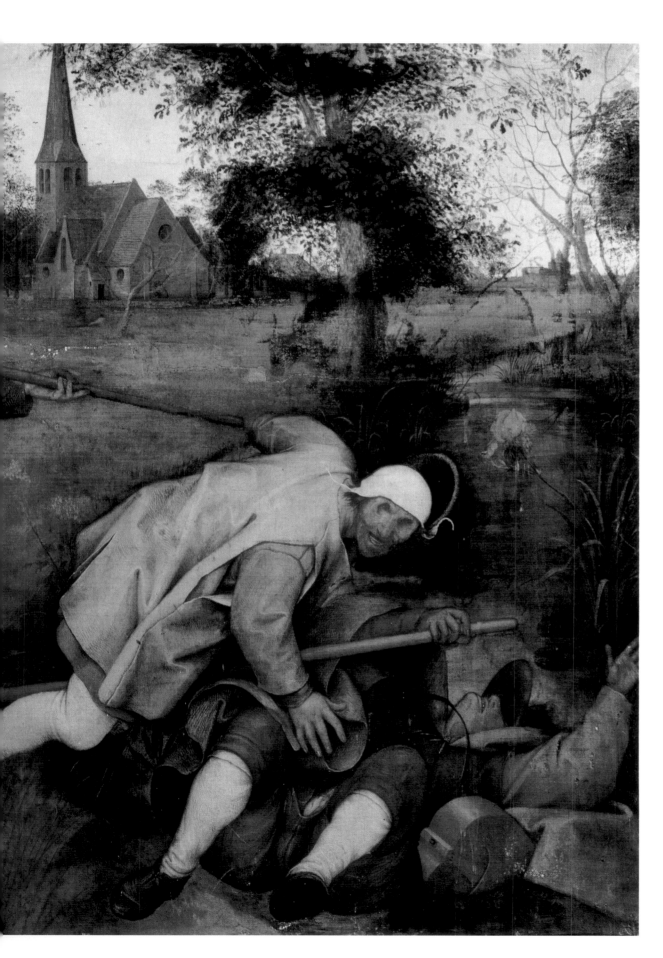

130 *The Parable of the Blind*, 1568
Tempera on canvas, 86 x 156 cm
Museo Nazionale di Capodimonte, Naples

"If the blind lead the blind, they all fall in the ditch," says
the best-known of the proverbs about the blind. Yet given
such a long procession of them, the level of comparison
for the saying (or Biblical quote) is not easy to find: is it
about human blindness in general, or the community
of non-believers?
The blind are Bruegel's most impressive proof of an
independent, monumental late style. The train of blind
men falling, pressing forward and holding back is held
together in a unique forward and backward motion; the
central three stay upright with arms extended onto the
shoulder in front. In each case, the opposite shoulder is
grasped, adding to the sense of unease.

peasant woman unmistakably shares certain features with *Dulle Griet* (ill. 68), even if the streak of frenzy is missing. Yet she cannot be a preliminary study for that work if the late dating is correct. The profile and upward gaze could, of course, be taken as a posture of prayer or devotion, but it is also conceivable that this head, like other "character" heads, was seen as a concentrated sample of Bruegel's art, indeed, to some extent as a trademark. In this sense, a commission is conceivable, because the output of a painter without a large workshop could not be expanded at will. His works were sought after, and more collectors could be reached and satisfied with smaller samples of work. In his *Liber amicorum*, the book of friendship begun only after Bruegel's death, the humanist Abraham Ortelius praised Bruegel for his frank depictions of people:

"For painters that paint people in the prime of their lives and try to add pleasing features of their own nature, thereby completely distort the picture of the sitter, and by straying from the model also stray from true beauty. Bruegel is free of this failing." (cf. ills. 123, 124)

Bruegel must have painted other heads in addition to this head of the *Old Peasant Woman*, to which the judgment by Ortelius would apply that true beauty resulted from fidelity to the real appearance. A yawning peasant, for example, is known in a copy and later engraving, and Bruegel is mentioned as the creator of this and comparable pictures. *Gonella the Fool* and the *Old Peasant Woman* are, in fact, traces of a secondary current in the development of portrait painting. They are, of course, distinct from the portraits of wealthy citizens and princes, which were intended to impress, but they should not be dismissed as more grotesques or caricatures.

The hierarchy of painting, in which peasant themes belonged to the lowest rank of subject matter, was imposed only following Bruegel's death. As this hierarchy acquired increasing status, so Bruegel himself fell into virtual oblivion throughout the course of the 17th century through until the 19th century. It was only at the end of the 19th century that interest in him re-awakened. Then, conversely, it was particularly the "primitive" and "archaic" features of his figures that were praised, and the fact that he was not just the "peasant painter" or "Droll Piet" was disregarded. Bruegel's portraits convey far too many vivid and realistic facial features to allow them to be criticized in accordance with academic rules. In contrast to the later genre painting, Bruegel was interested in the dignity of the person. As soon as his portraits, such as the *Old Peasant Woman* and some of the participants in the festive peasant pictures in Vienna (ill. 128, 129), have been accorded the value of a whole picture, they become quite distinctive.

One of the few canvas paintings by Bruegel, the *Parable of the Blind* in Naples, is dated from 1568 (ill. 130). Five blind men are holding each other by the shoulder and tapping their way forwards. Bruegel captures them in the moment when their guide – who is blind as well – is falling into a water-filled ditch. It appears that the disaster will overtake them all, even if at present most are still on their feet. Bruegel depicted a similar procession in the *Proverbs*, on the horizon. The supposed meaning there is, "When the blind lead the blind, they all fall." This is intended as a warning against false counselors and unreliable leaders. This basic interpretation certainly applies to the *Parable of the Blind* as well, but it has been doubted that this is decisive. It may be assumed that it required a more complex iconographical program for the blind to be accorded such pictorial status. *Schilderachtig* (picturesque) was a term used by van Mander thirty years after Bruegel's death in discussing artistic matters. In his view a painter should be aware of the story and how it previously had been depicted, in order to be able to decide whether a subject actually possessed this quality. Yet the theme of blindness has no history that can be uncovered by either literary or philological research. As a picture there are only simple precedents, for example a small printed illustration by Cornelis Massys (ca. 1510–post 1562). A painting with blind people by Bosch appears to have vanished. Modern scholarship, however, has put forward all kinds of thematically related matter, asserting that this is what underlies the picture. For example, the Church is not an accidental background motif, but represents the Biblical context of the blind: the internal blindness of the human soul is what is intended, that of non-believers, who are also addressed in Matthew 15, 14, where it says: "Let them alone, they be the blind leaders of the blind. If the blind lead the blind, both shall fall into the ditch."

Moving away from earlier depictions, Bruegel raised the number of blind people from two to the six depicted here. The longer chain has been taken to mean "an endless procession," as a warning reminder of the blindness of humanity. However, it has also been noted how graphically Bruegel characterizes the blindness of the figures. In the *Battle of Carnival and Lent* (ill. 57), the blind are likewise among the most expressive portrayals. Here, they are eyeless, the skin has sunk into the eye-sockets. In each of them, their attitude indicates a presentiment of a fall, yet, except for their leader, each one of them is firmly balanced on his own two feet. This could be, over and beyond any textual reference, how the picture was initially conceived, namely to capture the essence of blindness as depicted in a painting for the sighted. Not, moreover, just through empty eye-sockets, but in physical movement and even the landscape. The entry into the picture is itself old-fashioned. The ditch (at the front right of the pictures) continues as a dividing line. Behind the blind men, the land flattens out. There is no longer the fear of empty pictorial space such as was evident in the works of around 1560, nothing here is hidden. Presumably the bare landscape in itself cannot be conceived as an allegory. In its sparseness it matches the sad gray cloaks of the blind men. A subdued landscape without abrupt differences of height or dramatic contrasts – here, juxtaposed to the successive fall of each of the blind men – is a feature of all of Bruegel's late works.

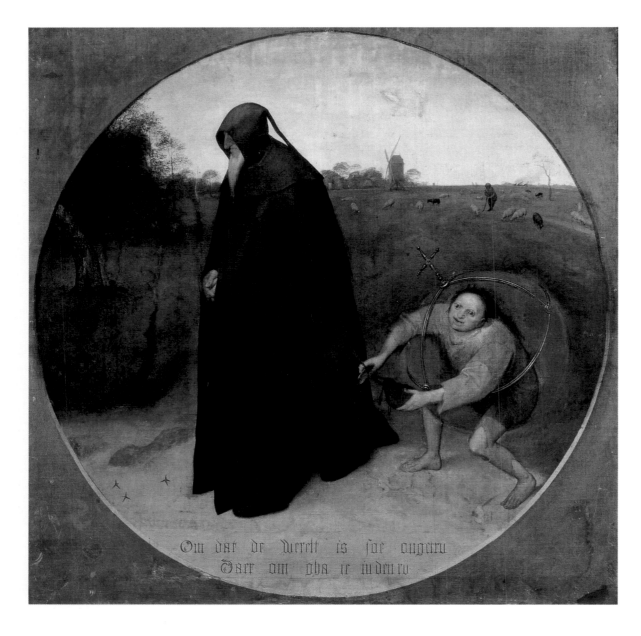

Oni dat de Werelt is foe ongero
Daer om gha ic indrivu

131 *The Misanthropist*, ca. 1568
Tempera on canvas, 86 x 85 cm
Museo Nazionale di Capodimonte, Naples

A misanthropist hates people, which makes his appearance here as a monk with a purse unexpected. The globetrotter trying to relieve him of his leather purse represents the vanity of the world. Bruegel plays with contradictions in the picture, relating them to each other as a complete paradox. What, after all, does the person in the globe want with the money if everything is vanity? The shepherd appears to relate to the metaphor of the misanthropist in a bad world in a similar way to the viewer: Bruegel has indicated no opportunity to intervene in the circular process, interrupt it or forestall it, whether it is the theft by the figure of vanity or the victim's treading on the tacks at his feet.

The pessimistic subject matter of the *Misanthropist* of 1568 (ill. 131) could have been the occasion for a dreary landscape allegory. The reclusive hermit is not exempt from the malice of the world that he seeks to escape. A cutpurse in the globe, a pictorial attribute that appeared in the *Proverbs* as an allegory of vanity, is robbing him of his purse. That he even has such a thing can be interpreted as hypocrisy. Because of the mill and village, but particularly due to the shepherd leaning on his stick, the landscape despite its bareness appears as a counter-image to the deceitful scene in the foreground, representing as it does the idyllic, rural ideal of the peaceful pastoral life.

The Land of Cockaigne dating from 1566 (ill. 132), which is the second Bruegel painting in the Alte Pinakothek in Munich, displays no subject matter that is borrowed directly from the *Proverbs*. However, the roof covered with dough cakes, and other motifs such as the pig ready for killing, return in similar form. The Cockaigne story was as popular in the 16th century as stories of Paradise and follies. The setting is a hill that looks like a loaf of bread and is as amorphous as the cloud of dough in the background. Three men lie with

full stomachs around a magical food-providing table placed on a tree. They represent different social classes. A clerk, who is recognizable from the book and paper as well as the expensive fur mantle, lies on his back with open eyes. He stares upwards, waiting for the last drop to fall from the upturned wine jug that is on the table above him. He has folded his arms under his head. To his left (as the viewer sees him) with his back to the viewer is a simple peasant lying on his threshing flail, with both arms extended. Dressed in a white, long-sleeved smock and brown trousers, which are both tight and creased at the same time, he lies like an ungainly sack.

The outlines are very soft and the body shapes extremely rounded. Depicted in a similarly unprepossessing way is the third man, an armed soldier in red trousers with black stripes. His legs are strongly foreshortened, while his upper body, which is dressed in chain mail, is twisted, but is at the same time very short and runs flat into the left arm.

According to the story, anyone who wanted to get to Cockaigne, where food is plentiful to excess, had to eat his way through a mountain of dough.

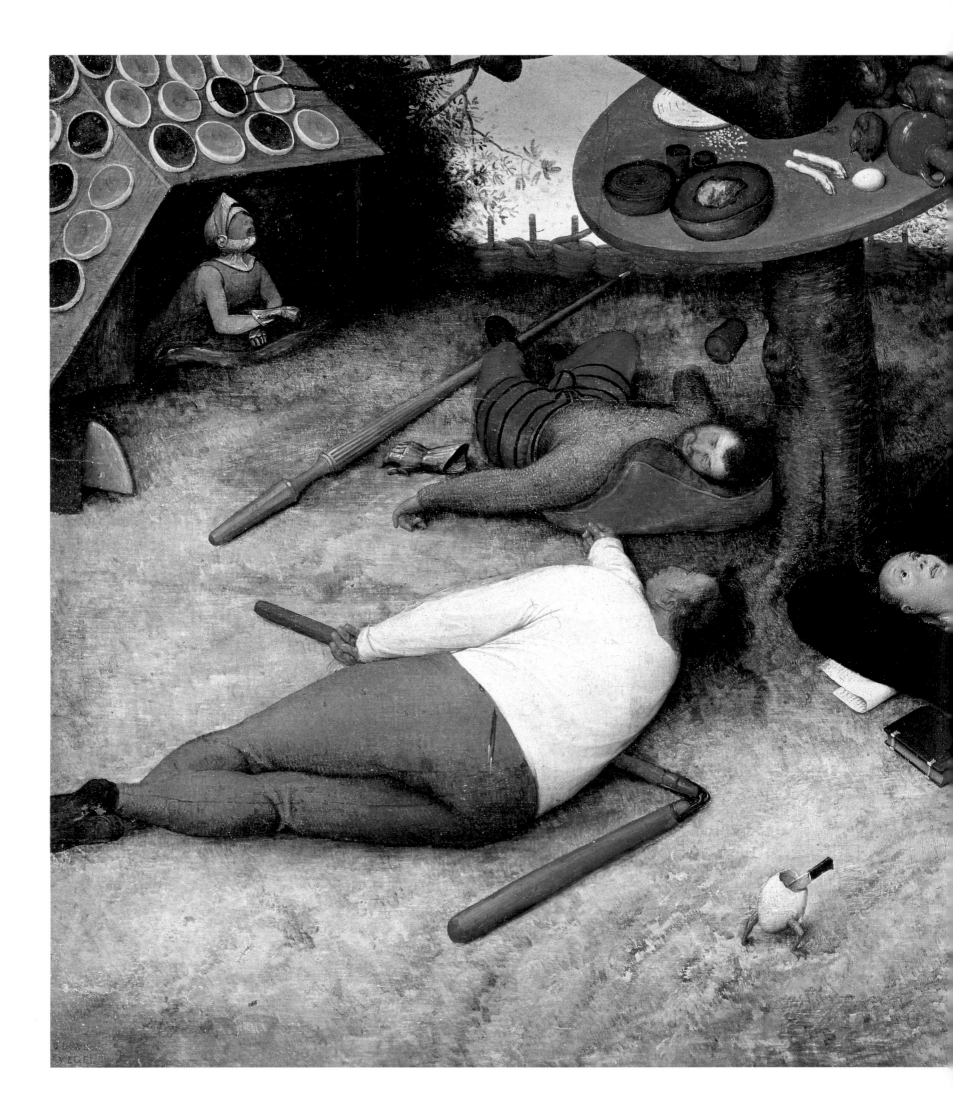

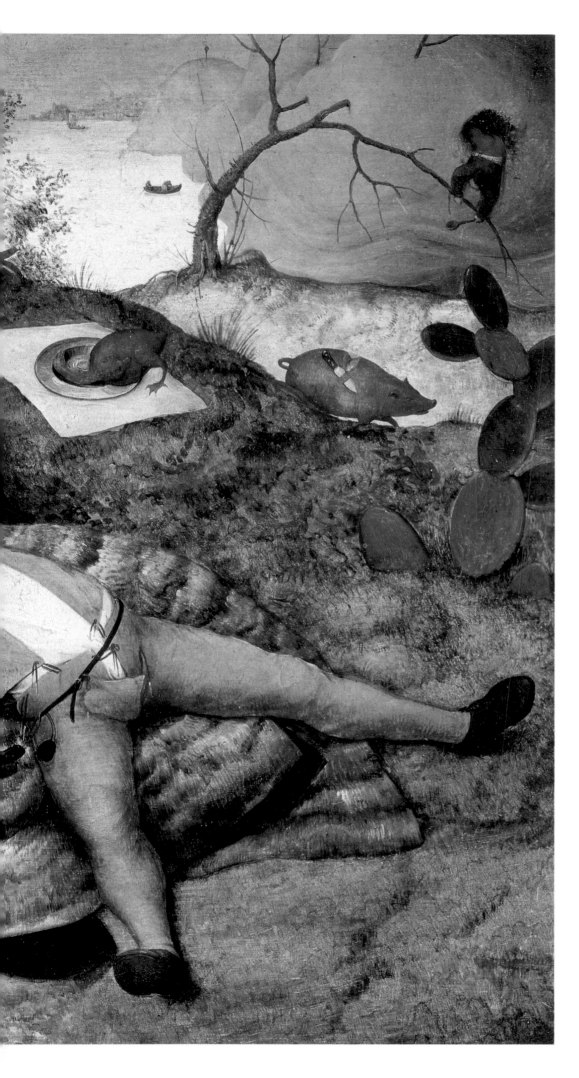

132 *The Land of Cockaigne*, ca. 1567
Oil on panel, 52 x 78 cm
Alte Pinakothek, Bayerische Staatsgemäldesammlungen, Munich

The land of Cockaigne and its population of idle Cockaigners, was a popular topic in the early modern period. The story mixes Utopian aspects with criticism of indolence and extravagance. Around the table-tree lie peasant, soldier, and clerk, like the spokes of a wheel around the hub. This community is a sign that all classes gladly linger in the land of Cockaigne.

133 *Summer*, 1568
Pen drawing, 22.0 x 28.6 cm
Kupferstichkabinett, Hamburger Kunsthalle, Hamburg

Summer, with its figure of the drinking reaper in the foreground, is a creation of Bruegel's late figure style. Unlike the sleeper in the *Corn Harvest* in New York, the figure almost approaches an allegory of summer. This composition, which was not duplicated as a print until 1570, attracted imitators among painters. It is not clear why Bruegel painted *Summer* three years after *Spring* (ill. 106). The other two seasons were completed by another painter after Bruegel's death.

In the drawing of *Summer* in Hamburg (ill. 133), a reaper's thirst becomes the epitome of the season. Without standing on ceremony, he drinks the pitcher dry. He is seated in a field of stubble situated between cornfields and a row of trees and bushes. The impression is almost given that he could actually step out over the edge of the picture and move about in front of it. Breaching the inscription area beneath the drawing plays with the three-dimensionality of the peasant: his outstretched leg and scythe throw shadows from the picture on to the paper itself. Such illusionism derives from the framing of Cock's engravings, where by convention there was room for inscriptions beneath the picture, but there is no precedent for it to be seen in Bruegel's earlier works. Next to the drinker, a woman enters the picture on her way to market, her head entirely covered by a large flat basket, which is filled with vegetables and fruit. Presumably the basket on her arm is full of cherries.

With regard to the field in the background, where large hay ricks have been erected, *Summer* is a blending of *Haymaking* and *The Corn Harvest* (ills. 99, 102). The perspective alignment between field and copse recalls the *Corn Harvest*, where the charm of a narrow path through the corn does not coincide with the centralized perspective (ill. 101). In *Summer*, in contrast, the edges of the field run towards the center of the picture and line of the horizon. Confusingly, the terrain rises again beyond that, and overlaps the horizon implied by the field.

In the drawing of the *Beekeepers* (ill. 134), three beekeepers are trying to round up a swarm of bees. One beehive is lying in the grass on the right, with another one standing further back under a shelter. The subject was thus defined beyond doubt, even though the cooperation of the three beekeepers looks rather complacent. The person in front on the left is carrying a hive as if it had to be kept secret. His head is turned

to the right, but he appears to be about to collide with the center figure with dangling arms, who is walking towards him. Behind him is another figure either closing or opening a hive. The great puzzle is the lad in the tree, to whom the handwritten inscription on the left applies: "Those who know the nest know it; those who rob, it possess it." It is not clear what the beekeepers have to do with a nest robber. Is the lad fearlessly snatching away the swarm of bees from the beekeepers? This is not visibly apparent. Is a political statement being deliberately covered up? The latest interpretation is that the apiarists were an allegory for the Roman Catholic Church. After the Reformation, the hives were neglected and clerics swarmed around erratically like bees, causing great suffering and disaster with the Inquisition and bloody assizes. The beekeepers could be interpreted here as informers of the Inquisition. The young boy would then be a victim of persecution who has saved himself by climbing a tree.

As the last figures of the dating are cut off, a date of 1567 is conceivable, around the time of the grisly trials and executions under the Spanish Duke of Alba (1507–1582). A relevant text by Philipp Marnix called *De Bijenkorf der H. Roomsche Kercke* (The Beehive of the Roman Church) did indeed appear, although not until 1569, but critical views of the events may have prevailed beforehand and been written down later.

The smallest painting by Bruegel shows two guenon monkeys in a deep window embrasure in a tower (ill. 135). The guenons are chained up, and have been eating nuts. As they almost fill the wall aperture, the impression of a prison window is given. It is possible to conjecture whether the monkeys also an example of veiled political criticism. We have no reliable texts, and other depictions of monkeys in Bruegel's *Dulle Griet* and his engraving *The Sleeping Dealer* allow no unambiguous evidence that could be applied here.

134 *The Beekeepers*, ca. 1568
Pen drawing, 20.3 x 30.9 cm
Kupferstichkabinett, Staatliche Museen zu Berlin –
Preußischer Kulturbesitz, Berlin

Beekeeping is not usually a gregarious activity, which is why the activities of the three beekeepers in protective clothing has been taken as an example of a series of actions. The lad who has climbed up the tree behind them provided occasion for the addition of the inscription bottom left, contemporary with the creation of the picture: "Those who know the nest, know it; those who rob it, possess it." (cf. ill. 138)

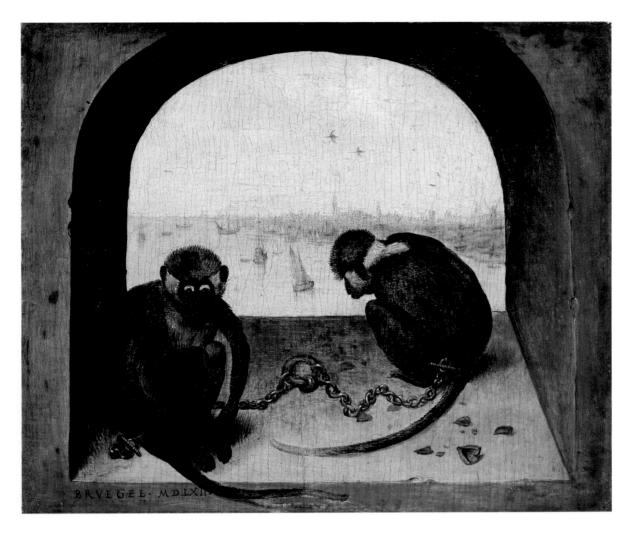

135 *Two Monkeys*, 1562
Oil on panel, 20 x 23 cm
Gemäldegalerie, Staatliche Museen zu Berlin –
Preußischer Kulturbesitz, Berlin

In the 17th century, the painting was called *The City of Antwerp with Two Monkeys*. This seems to prove the contemporary value of the city prospect in the background, at least for inventorying the painting. The successful rendering of the misty atmosphere over the Scheldt and the city is astonishing for the early date of the picture (1562). The monkeys are guenons, a rare type of monkey that was nonetheless popular with animal collectors such as Cardinal Granvella. Exotic animals were traded in the port of Antwerp.

The view out onto the Scheldt, and its most important port Antwerp, cannot be mere chance, however. Thus the prison-like frame of the cute animals can be related either only formally or in content to the critical situation of the town from 1560 to 1567, a time when economic decline, failed harvests, iconoclasm, and the Inquisition were unhappily acquiring an increasing stranglehold.

The *Cripples*, too, are interpreted differently in their separate picture compared with their incidental appearance in the *Battle of Carnival and Lent* (ill. 136, 57). In the Carnival picture, they were principally recipients of alms, as were the beggars, the lame, and the infirm, or they earned their keep possibly as entertainers performing a grotesque dance. The legless cripples in the Louvre picture, however, who have also been seen as madmen, have foxes' brushes pinned onto them, an attribute with many meanings and topical references. Fox tails were a sign of the mendicant orders, which did much to care for the poor, with whom cripples were undoubtedly ranked. The latter were treated as equivalent to beggars, and their simultaneous appearance in the Carnival picture is not accidental. In the Carnival, they traditionally took over the street and mixed with entertainers and jesters. There is a sign of this in the Paris painting as well: one of them on the right has jester's bells on the stumps of his legs, and on the left another supports himself on his crutches and

tosses both legs in the air. All of them are wearing cobbled-together caps or hats, and two of them appear to be singing. In comparison with the earlier painting (ill. 57), the surroundings are not urban, despite the buildings in the background. The ground is covered with grass. The plain brick walls of two houses have no aperture on the left, and on the right only a door with a simple rain hood and a small window high up. The implications of this are that this is possibly a monastic courtyard. The nun carrying a key on the right supports this idea. Only in recent times has there been mention of a rule for interpreting the depiction of the poor, cripples, and the aged, and even jesters too, to the effect that they were negative self-portraits of the bourgeoisie and aristocracy – clients commissioned as subjects the very things they wished to fend off.

Bruegel's last painting, which represents a single individual proverb but also probably goes beyond this, is the *Birdnester* in Vienna (ill. 138). If the work is viewed without any prior knowledge of Bruegel's visual language, the first impression is one of physical presence and gesture. A young peasant lad is drawing the viewer's attention to another lad behind him, who has climbed up a tree. The former seems to be looking the viewer opposite him in the eye, and has probably overlooked the ditch in front of him. The drama lies not only in the fact that he is just about to fall into the water, a danger that the viewer recognizes but he does

not. The effect is intensified by the perspective of the depiction of his body, which seems to be already leaning out of the picture. His legs, particularly the left leg, are extremely foreshortened. This clearly presents what art historians call Bruegel's "monumental late style," in which the influence of Michelangelo is thought to be detected (ill. 137). It is not quite clear why the three dimensional quality of the late figures has to be derived from an Italian ideal. The themes and their figures can only be compared in individual aspects, never as a whole. Possibly Bruegel's interest in optics was his actual problem of depiction, besides which iconographical matters and the question of Italian influences become unimportant. It could be queried whether the voluminous body of the lad in the center of the picture should be regarded as all solid

flesh and bone or as distortion such as is produced by a convex mirror. A question of this sort would then involve a consideration of other figures, such as the Cockaigners (ill. 132).

It has been suggested that the painting of *The Birdnester* is a visual representation of the proverb "If you know the bird, you do not have it. If you catch it, you have it." But what is the point of the unstable position of the witness in the picture, shortly before the fall? Is it not absurd to expose the one who knows to a danger, when at the same time, in a secondary meaning, the timid worthy one has to fail? The surroundings are countryside; on the right the channel continues towards a fish pond. Behind the pond is a farmhouse, in front of which people and chickens are visible. On the right, horses are returning to their

136 *The Cripples*, 1568
Oil on panel, 18 x 21.5 cm
Musée du Louvre, Paris

The cripples convey the impression of a dance. Not all their legs or prostheses touch the ground. The proportions of the limbs are not in order, mouths are open. Despite the poor laws, beggars and the incapacitated were a great problem in the 16th century. Among the population, cripples were viewed with downright hatred, many of them having earlier been marauding soldiers. Disabled, they tended to seek refuge in the towns, because they could not expect any help in the country.

137 Michelangelo Buonarroti
Jonah (detail of the ceiling of the Sistine Chapel),
1508–1512
Fresco, 13.7 x 12.2 m
Cappella Sistina, Vatican, Rome

The simplified construction of the volume of individual
parts of the body, their perspective in the orientation of the
room, and their pronounced twisting and turning, appear
to be comparable with Bruegel's late works with their
monumental figures. On the other hand, these features
were absorbed and developed by Netherlands Mannerism
in general.

stables. The distance of the dwellings and the plainness
of the landscape together lend it pastoral features,
which reflect on the rather clumsy lad as well. At the
same time, we notice the sack lying behind him in
front of the expanse of landscape. Is it an additional
contradiction that the lad already has his prey in the
bag? Such questions – as also, for example, the question
as to the real expressive value of the "simple face"
(possibly an expression of stupidity, peasant cunning,
or melancholy) – cannot be answered conclusively.
Perhaps the painting was deprived of the key to its
interpretation when it was trimmed at the edges.
Nonetheless, although we cannot provide a conclusive
interpretation, the work has great artistic charm. We
do not need to explain, as so often, that Bruegel's
intentions included contradictory elements and ambi-
guity. It is part of his creativity not to have an intellec-
tual program. The artist senses that it is the tensions
and contradictions he sets up that keep the attention of
the art-lover on the picture. Even without being able to
solve the riddle, we can still be amazed and be puzzled
and laugh.

Bruegel's art was continued in the painting of his
sons, partly in copies which were more or less faithful,
and partly in variations on various compositions by
their father. Copied several times were *The Triumph of
Death, The Wedding Dance in the Open Air* or even *Visit
to the Smallholding*, where the original by Pieter
Bruegel the Elder has been lost. There are more than
two dozen copies of the *Sermon by John the Baptist*
(ill. 140), six of which were signed by Pieter Brueghel
the Younger. Indeed, in this single instance, the quality
of his painting is so close to that of his father that it is
debated today which is the original. There are art histo-
rians who have doubts as to the genuineness of the
Budapest painting, which is here described as the work
of Pieter Brueghel the Elder (ill. 89). However, that
would mean that the original was lost. Where the sons
could produce their copies, whether they copied an
original jointly, and how further replicas were made
from the first one, is largely unresolved.

Jan and Pieter introduced all kinds of new topics
into the woodland landscapes of their father. On the
one hand, they adopted the compositional diagonals of
their father in the "overview" landscapes, on the other
hand they also made use of compositions that were
wooded on only one side. Borrowings of isolated
motifs can also be found in the sons' pictures. Thus Jan
Brueghel's *Wooded River Valley with Road* (ill. 139) has
individual motifs in common in with *The Return of the
Herd* (ill. 103) from the *Months* series by his father,
such as the river on the right hand side and the attempt
to introduce striking weather effects. However, the
selection in the work of the son seems rather arbitrary:
yellow light falls on the river through a gap in the
clouds too intermittently and without distribution in
the various depths of the landscape, while the people in
front of the dark woodland path are lit from front left.
The figures are not further developed, but reduced in
size. The three harvesting girls on the road are reminis-
cent of another *Months* picture by Bruegel, *Haymaking*

(ill. 100). They are walking in the opposite direction,
and here the oldest of them is in the middle. But other-
wise – in the pitcher, rakes, sunhats, and gathered
clothes with a white blouse – the correspondences are
close. Two of them are looking out of the picture, but
this gaze has lost its effect because, strangely enough,
both women on the edge of the picture are looking to
the right. The element of surprise in the direct gaze at
the viewer is lost. Here it looks more like heedless curi-
osity, because the road is stony.

In his 1635 landscape *The Return from the Fields*,
Rubens gave the motif greater gravity, and in various
landscapes continues to treat not just the return from
the fields, but also the weather conditions prevailing
(ill. 141). The picture was done at an age when he was
already suffering from gout and no longer had any
major commissions. A handcart has been added, but
the numerous scenes of labor have been omitted in
favor of the motif of the return. A deep horizon
simplifies the landscape, but also develops it atmos-
pherically. The light looks subdued and of the late
afternoon. In this respect, Bruegel the Elder's influence
was still being felt far into the 17th century, the great
age of such landscape specialists as Jacob Ruisdael
(1628–1682). Much of what van Mander was able to
write in his *Grondt*, the didactic poem discussing
painting, was oriented, consciously or unconsciously, to
Bruegel's landscapes. And yet there is hardly a painter
further removed from the theory of art than Bruegel.

In many of Bruegel's principal works, frontiers were
crossed in a way that could no longer be accepted in a
time of pronounced specialization according to defined
genres. The increasing academicism of painting caused
interest in Bruegel to dwindle over the centuries. This
was of little wonder as almost every one of his works
seemed to flout academic rules. The farm landscapes
and the large and small proverbial pictures, whose posi-
tion in the genres of painting must have seemed too
undecided to later ages, were quickly forgotten. Later
still, his peasant pictures were regarded at worst as
genre painting, because this was a low-ranking genre,
and at best, their creator was adjudged a late depicter of
medieval life. At any rate, his figures ran counter to
expectations of the Renaissance and even Mannerist
styles to such a degree that temporarily he was consid-
ered as an eccentric of little interest. He was allowed to
have had a part in creating the genres of landscape and
genre painting, but the internal connections within his
pictures were not understood.

Between the classification of genres and his disqual-
ification as old-fashioned, there appeared to be no
possibility left for Bruegel's manifold innovations to be
brought into harmony with the skills of a landscape
painter. His linguistic games and picture puzzles, his
visionary depictions – whether apocalyptic, Biblical or
historical, classical or literary, or motivated by the
vernacular language, faith, and culture – but also his
eye for the ordinary man, always profited from his
skills as an arranger of reduced landscapes that were as
complex as they were expressive. This talent certainly
did not make him easier to understand and categorize.

138 *The Birdnester*, 1568
Oil on panel, 59 x 68 cm
Kunsthistorisches Museum, Vienna

The puzzle of the gesture with which the young man relates to the
birdnester has not yet been solved. Whether he is already sure of his
prey, which lies besides him on the ground in a sack, or whether he
only "knows" the nest, as in the proverb, while the other is possessing
it, cannot be decided. Either way, he is on the point of falling into the
brook. Bruegel's painting technique lends the late figures a wholly
individual surface, making the clothes look like a second skin. The
broad hips of the bird thief, but also the curved course of the bank of
the brook together with the curved bank in the foreground and the
bare landscape with a low horizon, convey the impression of a convex
distorting mirror.

139 (next page) Jan Brueghel the Elder
Wooded River Valley with Road, 1602
Oil on copper, 33 x 47.5 cm
Kunstmuseum, Öffentliche Kunstsammlung, Basle

This painting is representative of a certain type of wooded
landscape in which, unlike that seen in the *Gloomy Day*
or *Haymaking* (ills. 98, 99), there is no longer a
transition from the foreground through the center
ground to the background.

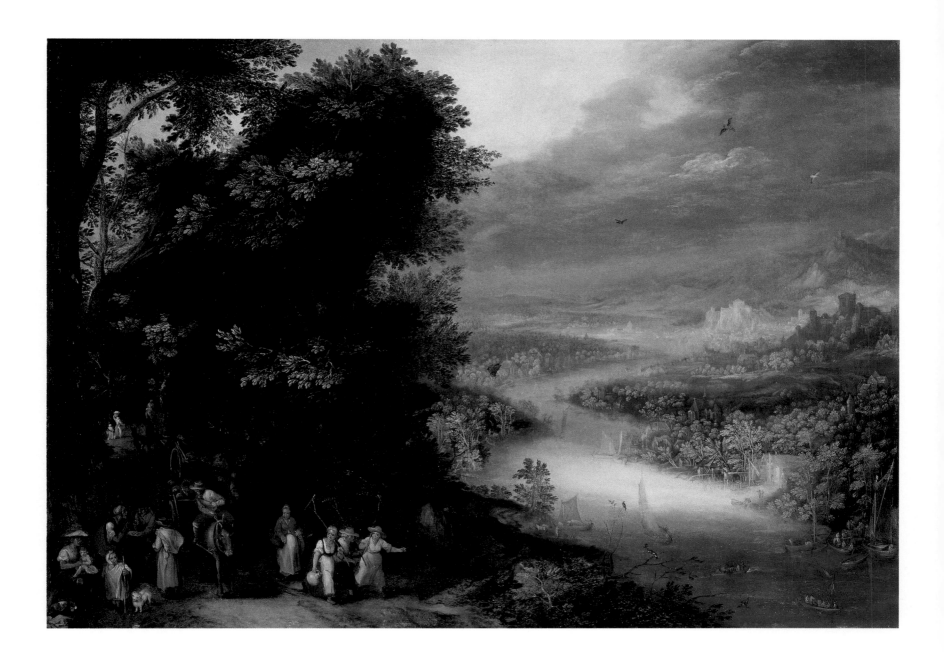

Any mention of Bruegel's breaches of rules implies two things: firstly, that there actually were fixed rules, and secondly, that Bruegel himself did not want to keep to them. Yet the artistic development of a painter around 1550 was no doubt determined less by acts of will than by radical changes in culture and religion. Some trades declined, and their masters and apprentices had to search for new work. Within the painters' guilds, that was particularly valid for the two trades that still echo strongly throughout Bruegel's work. One was book illumination, whose main product, the books of hours, found itself in crisis in the post-Reformation period; the other was altar painting which, in a time of repeated iconoclastic attacks, had hardly any clients at all. It is highly probable that Bruegel had roots in both trades, because their respective subject matter, pictorial patterns, and compositional rules seem a matter of course to him, indeed they were so familiar that he could freely and deftly adapt them for use in his own new themes. This is how things were with the early landscapes based on stories from the New Testament, which were conceived in succession to Patinir's landscapes. It applies particularly to the grandiose landscapes that can be seen in the *Months* series, in which calendar miniatures from books of hours by Simon Bening turned into an unexpected high point in panel painting.

Not until the 20th century did it prove possible to regard the visual language of Bruegel's pictures and the merciless representations of human beings not just as an original response to the Italian stylistic hegemony, but as an independent, Netherlandish humanism. The painter's curiosity sprang from the new horizons of the knowledge of his day, but was reinforced by a vacuum, that is the absence of ecclesiastical commissions. The truth games of the works that are based on visual language certainly drew strongly on a tradition-conscious analysis of older Flemish painting, the essence of which Bruegel reviews in the visual language of his works. He would not have become a painter if he had not been able to create, from what he had both seen and experienced, new pictures that dealt with problems of his time without their becoming tracts.

140 (opposite, top) Pieter Brueghel the Younger
Sermon of John the Baptist, 1601
Oil on panel, 111 x 175 cm
Rheinisches Landesmuseum, Bonn

Johannine Baptism had become an important Christian topic in the 16th century, because of its implications for the historical Jesus. The subject painted was not the baptizing but the preaching John. This replica by Pieter Brueghel the Younger is based on his father's original.

141 (opposite, bottom) Peter Paul Rubens
The Return from the Fields (detail), 1635
Oil on panel, 122 x 195 cm
Galleria Palatina, Palazzo Pitti, Florence

Not until the work of Rubens did any independent further development of Bruegel's landscapes come to fruition. Both the returning women harvesters and the mood of the landscape draw closely on Bruegel's *Haymaking* in Prague (ill. 99). The landscapes are not commissioned works but led solely by artistic interest.

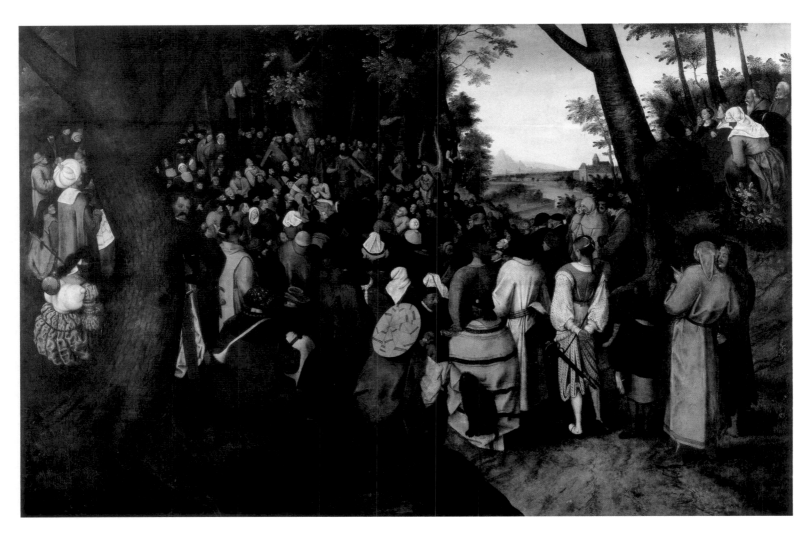

CHRONOLOGY

1525/30 Bruegel born in Brabant. The name can be associated with several villages, but none of them are in the vicinity of Breda, which was named as his hometown by contemporaries.

1551 First documented mention of a work by Bruegel. Jointly with Pieter Balten, he paints the outside of the wings of an altar for the Glovemakers' Guild of Mechelen, which has not survived.

1552 Registration with the St. Luke's Guild of Antwerp; works for a now unknown merchant called Hanns Franckert, with whom Bruegel was also on terms of friendship and was said to have accompanied to country fairs. *Landscape with the Parable of the Sower* presumably also dates from this year.

1552/53 Journey to Italy and first dated drawings. Prolonged stays in Rome and Naples. View of the Rhône Valley and an Italian landscape with monastery, presumably also collaboration with Giulio Clovio in Rome.

1556/57 The series of twelve printed Great Landscapes launch Bruegel's collaboration with the printer and publisher Hieronymus Cock. The Virtues and Vices series is begun and completed three years later.

1559 First multi-figure oil paintings produced with secular themes: Carnival, Lent and the proverbs.

1560 *Children's Games* painted.

1562 Bruegel paints Biblical subjects such as the *Tower of Babel* and the *Suicide of Saul*, but also gloomier works such as *The Triumph of Death*, *Dulle Griet*, and the *Fall of the Rebel Angels*.

1563 After marrying Mayken Coecke, the daughter of Coecke van Elst, he moves with his wife to Brussels. Contrary to all probability, in 1604 van Mander named Coecke as Bruegel's teacher. End of the Third Council of Trent with the Catholic declaration of tenets.

1564 Birth of son Pieter. Bruegel paints the *Procession to Calvary*.

1565 Creates his only series of paintings, the *Months*, which includes *The Hunters in the Snow*, *The Gloomy Day*, *Haymaking*, *The Corn Harvest*, and *The Return of the Herd*. Niclaes Jonghelinck signs a security giving the City of Antwerp a charge on these paintings in case his friend Daniel de Bruyne defaults on a loan. *The Procession to Calvary* and a *Tower of Babel* are also mentioned as being in his possession. Bruegel paints his only mythological works, the *Fall of Icarus* and the *Vices of Apelles*.

1566 Bruegel produces the work, *Numbering at Bethlehem*.

1567 The Duke of Alba enters Brussels. *The Wedding Dance in the Open Air* is painted, also the *Adoration of the Magi* and the *Land of Cockaigne*. Bloody Councils against heretics.

1568 Birth of his second son, Jan. The important peasant pictures painted. Several small-scale pictures produced that are based on early paintings: the *Two Monkeys*, *The Misanthropist*, *The Birdnester*, *The Old Peasant Woman*, and *The Cripples*. Bruegel's figure style changes, drawing in an ironical manner on Michelangelo's more monumental style.

1569 Bruegel dies from an unknown cause. According to van Mander, from his deathbed he destroys any politically dangerous drawings, in order not to expose his family to danger.

1570 Cock publishes the *Four Seasons* after Bruegel's death, of which Bruegel did *Spring* (1565) and *Summer* (1568). In the following year, all designs were republished or first published.

GLOSSARY

Alba, Duke of (1508–82), one of Emperor Charles V's most successful generals, he became the instrument of Philip II's tyrannical occupation of the Netherlands in 1567. He was personally responsible for the establishment of the Bloody Councils, which led to the execution of 18,000 people (according to his own claim) for "heresy" over the following five years, in response to which the pope awarded him the title of Defender of the Catholic Faith.

Allegory (Gk. *allegorein*, "say differently"), a metaphorical illustration which represents abstract concepts or ideas in the fine arts and literature, either by means of human figures (personification) or scenes.

Anabaptist (Gk. "baptized again"), a sect that developed in Saxony ca. 1520; they rejected infant baptism, and insisted on adult re-baptism. They preached equality and the community of goods, but this soon degenerated into wild licentiousness. The movement died out in Germany after the siege of Münster of 1535, but continued in a more respectable form in the Netherlands.

Apelles (ca. 330 BC), Greek painter. His works, which unfortunately survive only in literary descriptions, were experimentally reconstructed by Renaissance painters. He was noted in particular for the remarkable realism of his paintings.

Apocalypse (Gk. *apokalyptein*, "reveal"), the Revelation of St. John, the last book of the New Testament. The wrath of God descending upon the earth is depicted in three visions; in the form of terrible natural catastrophes, in the battle between the forces of good and evil, and in the union of a new Heaven and a new Earth in the Heavenly Jerusalem. The announcement of the Second Coming of Christ at the end of the world was intended to console the persecuted Christians and also prepare them for the horrors connected with the event.

Apocrypha (Gk. *apocryphos*, "hidden"), Jewish or Early Christian additions to the Old and New Testaments excluded from the Canon of the Bible.

Attribute (Lat. *attributum*, "added"), a symbolic object which is conventionally used in paintings and sculptures to identify a particular person, especially saints, in a work of art.

Béguines, béguinage (Lat. *beguinae, begginae*) The *béguines* were devout women organized into a movement in the see of Liège in 1170 and orally recognized by Pope Honorius III (1216–1227) in 1216. They lived ascetic lives in a monastic-style community (*béguinages*) but without taking vows. Their name derives from the gray (*bigio, beige*) apparel that distinguished them from ordinary citizens. The movement became popular in the 13th century particularly in Germany (Lower Rhineland, Bavaria) and France, and then later in the rest of Europe, where they devoted themselves to the care of the sick. Accused of heresy because of their Quietist mysticism, they were systematically persecuted by the Church and banned by Pope John XXII (1316–1334), as a result of which they gradually disappeared at the end of the Middle Ages.

Book of hours, a medieval prayer book for lay people containing suitable texts for the seven canonical hours or offices. During the Middle Ages and Renaissance they were often illustrated with sumptuous illuminations. The perpetual calendar at the front was often particularly lavish, illustrated by scenes depicting the Labors of the Months and zodiacal symbols.

Calendar (Late Lat. *calendarius* or medieval Lat. *calendarium*) Perpetual calendars often preceded books of hours, and were illustrated with the Labors of the Months. Pieter Bruegel the Elder was obviously very familiar with the book of hours tradition, and works such as the *Months* are a development of it.

Calvary (Lat. *calvaria*, "skull"), the place of skulls, the Latin name for Hebrew Golgotha. In painting, the place where Christ was crucified, and often represented in Processions to Calvary scenes.

Camaieu (Fr. *camée*, "cameo," Lat. *"gemma,"* jewel), a painting technique on canvas, wood, porcelain, or glass that confines itself to shades of a single color, sometimes with white highlights. In the 16th century, the technique known as *grisaille* (that is, gray on gray) was particularly popular. It was used in painting to imitate sculpture.

Catholic Reform, term from Church history referring to the renewal of the entire Church, considered necessary by a broad section of the Church as early as the late Middle Ages. As reform programs such as those agreed by the Councils of Constance (1414–1418), Basle (1431–1437 and 1448), or the Fifth Lateran Council (1512–1517) brought no lasting results, it was not until the Protestant Reformation forced this step that the pope and the Roman Curia made targeted moves against internal injustices such as misuse of office, decay of morals, the sale of indulgences, and extremes of saint and relic worship. Following Pope Paul III's bull *Lætare Jerusalem* of 1544, the Council of Trent was summoned, which in three sessions promulgated long-overdue reforms in the Church. While the term "Catholic Reform" is mainly applied to the process of internal church reforms which continued after the "Reformation" into the 17th century, the term "Counter-Reformation," current since used by the historian Leopold von Ranke (d. 1886), is applied to those measures, particularly violent ones, undertaken by the Catholic Church against the "Reformation." The Peace of Augsburg of 1555 placed an obligation on Catholic princes to impose Catholic regulations in their territories and enforce the Counter-Reformation. The effects of this were felt not just in Germany but also in France, England, and the Spanish Netherlands.

Color perspective (Lat. *perspectiva [ars]*, "the art of seeing through clearly"), the optical creation of depth in a painting by the use of color rather than line, by reducing the intensity of color in proportion to the distance from the foreground.

Copper engraving The oldest form of incised printing. Lines are incised in the copper plate following an original drawing. The inciser is generally an experienced craftsman rather that the artist who drew the original drawing, so that the lines in the engravings tend to be simpler than the original.

Devotio moderna (Lat., "new piety"), a religious reform movement founded in Deventer by the mystic and popular preacher Gerhard Groote (d. 1384), which sought to replace the religious obligations of community and objective ties with an individual, internalized piety based on Christ. The principal obligations were reading the Scriptures and contemplation. The movement became popular in the 15th and 16th centuries in Western Europe.

Etching Differs from engraving in that the agent that makes the incisions is acid, not the needle that does the actual drawing. The drawing is etched with the needle through an acid-resistant etching ground; the needle merely exposes the areas to be incised by the acid. The technique was devised in the early 1500s by Daniel Hopfer of Augsburg. Compared with the linear, even style of an engraving, the lines in an etching are much freer, which allows for more differentiated shading and also the creation of painterly effects.

Exegesis The interpretation and exposition of classical and Biblical texts. In medieval times, it included the interpretation of Old Testament events in terms of the New Testament events that they "prefigured." Exegesis also includes explanations of allegorical references.

Genre painting Painting of typical scenes and occurrences from everyday life. In the academic hierarchy of painting in the 17th century, it was viewed as the lowest category of painting, the highest form being history painting.

Golden Legend (or *Legenda Aurea*), a collection of Early Christian stories concerning the apostles and saints, which was compiled by the Dominican monk Jacobus de Voragine in the second half of the 13th century. This was enormously influential as a sourcebook for both medieval and post-medieval Christian art.

Grisaille (Fr. *gris*, "gray," *grisailler*, "to paint gray"), painting in monochrome, a type of painting that deliberately omitted colors and only used stone colors, shades of gray or brown. It was often used in paintings to imitate sculpture.

Heresy (Gk. *hairesis*, "chosen"), in Christian thinking belief in a faith or confession different from the accepted teachings of the Christian faith.

History painting The representation of persons or events of historical importance, in legends, in the Bible, or classical mythology. Reckoned the highest genre of art under the academic rules of the 17th–19th centuries, because history painters had to be masters of all other genres (portraits, landscapes, still lifes, and genre).

Humanism (Lat. *humanus*, "human"), philosophical movement that started in Italy in the mid-14th century, and which drew on antiquity to make man the focal point. In humanism, the formative spiritual attitude of the Renaissance, the emancipation of man from God took place. It went hand in hand with a search for new insights into the spiritual and scientific workings of this world. The humanists paid particular attention to the rediscovery and nurture of the Greek and Latin languages and literature. To this day the term denotes the supposedly ideal combination of education based on classical erudition, and humanity based on observation of reality.

Iconoclasm (Gk. *eikon*, "likeness"), the deliberate destruction of religious pictures on the grounds that the pictures themselves are venerated, and are therefore idolatrous.

Iconography (Gk. *eikon*, "likeness," and *graphein*, "to write, describe"), originally the study and identification of classical portraits. In art history, refers to the systematic investigation of the subject matter and symbolism of images.

Illumination The art of painting as used in manuscripts and early books. Originally the term referred just to the practice of applying gold or silver highlights (especially to initial letters), but now refers to all manuscript and early book painting.

Lamentation A non-Biblical subject showing Mary surrounded by angels, John, holy women, and others after the Crucifixion. More of a devotional image than an event, it was especially popular in northern Europe in the 14th and 15th centuries.

Landscape painting The earliest landscapes appeared in the murals of imperial Rome (Biblioteca Vaticana, Rome), but the subject was subsequently discouraged by anti-naturalistic trends in classical art and western painting of the Middle Ages. Not until the second half of the 14th century did a tentative interest in representing spatial depth reappear, along with the painterly rendering of objects. Landscapes, as such, became acceptable in Flemish-Burgundian miniatures of the early 14th century. At the same time, a discernible effort, particularly in the panel painting of Jan van Eyck and Dierick Bouts, was made to convey the natural background as a totality and liberate it from its previous formal rigidity. The first purely landscape painting dates from 1473, a pen drawing by Leonardo da Vinci (1452–1519) now in the Uffizi in Florence. Successors to deal with the subject were Giorgione (1476/78–1510), Dosso Dossi (ca. 1486–1541/42), Albrecht Dürer (1471–1528) and Albrecht Altdorfer (1480–1538); their attention was directed in part at reinforcing the mood and painterly charm of the landscape. This tradition was continued by Pieter Bruegel the Elder, who was the first to take seasonal differences of nature as his subject, Gillis van Conixloo (1544–1606), and Paul Bril (1554–1626). They created naturalistic, self-contained landscape pictures that ushered in the great age of Dutch landscape art.

Loggia (It.), a gallery or room open on one or more sides, its roof supported by columns.

Mander, Carel van (1548–1606), Flemish humanist, painter, and art historian. He wrote *Het Schilderboek* (The Book of Painters) in 1604, on the model of the artist biographies (*Lives*) written by Giorgio Vasari (1511–1574).

Mannerism A style of art between the Renaissance and the Baroque, that is the period between 1520/30 to 1620. Mannerism moved on from the ideal proportions and forms of composition developed in the Renaissance. Pictorial settings became more dynamic, the human body developed excessive length and was depicted in anatomically contradictory positions. Compositions became over-complex, the lighting effects irrational and strongly theatrical, while color was detached from its strictly object-related distribution.

Mantle An overcoat, worn open, popular during the second half of the 15th century and during the 16th century, and often lined with fur along the hem and around the collar. It reached to the knee or foot, depending on the social class of the wearer.

Mendicant orders (*Lat. mendicare*, "to beg"), arose in the 13th century as a counter-movement to the increasing worldliness of the Church. Members of the orders were typified by an ascetic way of life and the renunciation of all personal property. Their particular strengths were pastoral care, preaching, and missionary work. Mendicant orders include the Franciscans, Capucins, Dominicans, Augustinians, and Carmelites.

Miniature (It. *miniatura*, Lat. *miniatus*, "colored with red lead"), small, mostly colored (illuminated) paintings or pen drawings in medieval manuscripts and books, that were either incorporated in the text or took up a whole page for themselves.

Netherlands In medieval and early post-medieval times, the whole Dutch/Flemish-speaking area. Belgium and Holland, as we know them today, developed from the religious partition of the area after the Reformation, with Belgium the mainly Catholic area and Holland the mainly Protestant area. In 1384, the Netherlands became part of the Duchy of Burgundy, but in 1493 came under the control of the Habsburg Emperor. From 1520 to 1550 the Dutch-speaking Habsburg Emperor Charles V tried to contain the spread of the Reformation, but in 1555 he passed control to his son Philip II, who, besides being a Catholic zealot, was entirely Spanish. Philip's rule of the Netherlands was a bloody disaster, and led to the northern part (now Holland) gradually shaking off Spanish control from 1580 onwards. The southern (Flemish) part remained under Spanish rule until 1711, though Habsburg control lasted until 1815. Belgium declared its independence in 1830.
Pre-Renaissance and early Renaissance art from the area is usually described as Flemish.

Oil paint, a paint used in art that consists of drying oils, other substances, and color pigments that will not dissolve in the oil. The main drying oils used to bind the color pigments were linseed, poppyseed, and walnut oil.

Panel painting, a portable painting on a rigid support (usually wooden boards). It was not until the 15th century that canvas began to replace wooden panels. Bruegel was evidently brought up in a conservative tradition, and rarely used canvas.

Parchment (Gk. *Pergamon*, classical city in northwestern Asia Minor, modern Turkish Bergama), animal skin steeped in a calcareous lye that replaced papyrus as a durable surface for writing and painting in the 4th century AD. Usually sheep or goat skin was used, although fine parchment (*vellum*) is made from newborn calf or lamb skin. Parchment and vellum were used in medieval illumination for codices, documents, and manuscripts. From the 12th to 16th centuries, parchment was sometimes used on panel paintings as a coating before the paint ground was applied.

Parergon, a subordinate part of a major work, such as the map in Vermeer's painting on page 26 or Ortelius' historical map which is attached to his great atlas.

Personification The representation of abstract ideas in human form, in allegorical art.

Perspective (Lat. *perspicere*, "see clearly"), the method of representing a three-dimensional object on a flat or nearly flat surface. Objects and figures are depicted as much as possible in accordance with the optical conditions in which they are actually seen by the observer.

Prefiguration (Lat. *prae*, "before," *figuratio*, "shaping, forming"), the supposed anticipation of New Testament events and circumstances by events and circumstances in the Old Testament, for example the Twelve Prophets prefigure the Twelve Apostles, so that they form a type/anti-type dichotomy.

Replica (Fr, *réplique*, "reply, response, imitation"), a copy of an original work that endeavors to reproduce the original exactly. Often done by the artist himself (or his workshop) with a commercially popular painting.

Repoussoir (Fr. *repousser*, "to push back") Figures or objects in the foreground of a picture (for example tree stumps or fragments of architecture) that serve to create an impression of depth, and to some extent also lead the eye towards the main event thus "pushed back."

Romanists (Late Lat. *Romanistae*, "followers of Rome"), term for a group of Netherlands painters, graphic artists, engravers, and tapestry weavers in the 16th century who spent greater or lesser periods of time in Italy (Rome or Venice). Their style is an odd blend of local traditions with stylistic features of Late Renaissance Italian painting, Mannerism (Raphael and Michelangelo), and classical antiquity. The style began around 1510 with Jan Gossart, called Mabuse (1478–1533/1536) and lasted until Bruegel's older contemporary Frans Floris de Vriendt (ca. 1516–1570).

St. Luke's Guild, a guild is a craftsmen's commercial association of medieval origin. In this case it was of artists, whose patron is the Evangelist St. Luke, who according to legend painted a portrait of the Virgin.

Stoicism (Gk. *stoa*, "pillared porch, hall," here the *stoa poikile*, where the followers of Zeno gathered), a philosophical tradition established by Zeno of Citium (336–264 BC). In around 320, he left Cyprus for Athens to attend the philosophical schools, eventually establishing his own school at the Painted Porch (*stoa poikile*). The essence of his philosophy is that happiness can only be attained by those who follow the appropriate ethical precepts, acquire the basic virtues (justness, courage, equanimity), avoid vices, and control their personal interests and passions.

Topography (GK. *topos*, "place," *graphien*, "to write, describe"), description of a geographical locality, if possible it would include a precise record of all details.

Top view A form of perspective in painting that places the viewer above the level of the objects depicted. A "bird's-eye view" is a high variant of this.

Typology (Gk. *typos*, "shape, pattern, model," *logos*, "science, knowledge"), the doctrine of the correspondences between the Old and New Testaments, based on the view that the New Testament is the fulfillment of the Old.

Vanishing point, central point in a perspectival composition upon which a set of lines, which are actually parallel, appear to converge.

veduta (Ital. *veduta*, pl. *vedute*, "view"), type of landscape painting or drawing that attempts to render a view of either a city or landscape in as objectively correct and naturalistic a way as possible. A later development of this were the *vedute ideate*, which depicted fantasy landscapes or cities with imaginary buildings.

Vitruvius Pollio, Marcus Roman architect whose ten books of architecture formed the basis of Renaissance architectural theory.

Vulgate The standard Latin translation of the Bible by St. Jerome (347–419/20 AD), used generally from the 8th century, and the philologically revised version reimposed by the Councils of Trent (1545–1563) as the only authentic Bible for matters of faith and morality.

SELECTED BIBLIOGRAPHY

Buchanan, Iain: "The Collection of Niclaes Jonghelinck, the *Months* by Pieter Bruegel the Elder (Documents for the History of Collecting 10)." *Burlington Magazine* 132, London 1990, pp. 541–550.

de Jong, Jan , Mark Meadow, Herman Roodenburg, and Frits Scholten. "Pieter Bruegel." *Nederlands Kunsthistorisch Jaarboek* 47, Zwolle 1996.

de Tolnay, Charles. *Pieter Bruegel l'Ancien.* Brussels 1935.

Exhibition catalog. *Story of a Metropolis, 16th–17th Century.* Hessenhuis, Antwerp 1993.

Exhibition catalog. *Breughel, Pieter Breughel the Younger, Jan Breughel the Elder, Flämische Malerei um 1600, Tradition und Fortschritt* (3 vols). Kunsthistorisches Museum, Vienna 1998.

Falkenburg, Reindert: "Pieter Bruegels Kruisdraging. Een proeve van 'close reading'?" *Oud Holland* 107, The Hague 1993, pp. 17–33.

Fraenger, Wilhelm: *Der Bauern-Bruegel und das deutsche Sprichwort.* Erlenbach, Zurich, Leipzig 1938.

Friedländer, Max Jacob. *Early Netherlandish Painting,* Vol. XV. Pieter Bruegel, Leiden 1937.

Glück. Gustav. *Bruegels Gemälde.* Vienna 1932 (4th impression 1937).

Grossmann, Fritz. *Bruegel. Complete Edition of the Paintings,* London 1973.

Hofstede, Justus Müller. "Zur Interpretation von Pieter Bruegels Landschaft. Ästhetischer Landschaftsbegriff und stoische Weltbetrachtung." *Colloquium Berlin 1975, Pieter Bruegel und seine Welt.* Berlin 1979, pp. 73–142.

König, Eberhard: *Simon Bening. Das Blumen-Stundenbuch clm 23/637.* Bayerische Staatsbibliothek, Munich. Commentary on the facsimile edition (in collaboration with Bodo Brinkmann), Lucerne 1991.

Mielke, Hans. *Pieter Bruegel. Die Zeichnungen,* Antwerp 1996.

Snow, Edward. "Meaning in Children's Games. On the Limitations of the Iconographic Approach to Bruegel." *Representations* 1, Berkeley 1983, pp. 27–60.

Stridbeck, Carl Gustav. *Bruegelstudien.* Stockholm 1956.

van Bastelaer, René and George Hulin-Loo. *Pieter Bruegel l'Ancien, son Œuvre et son Temps* (3 vols). Brussels 1907.

van Mander, Carel, and Constant van de Wall (translator). *Dutch and Flemish Painters. Translations from the Schilderboek.* New York 1936.

PHOTOGRAPHIC CREDITS